向裏向外逢着便殺

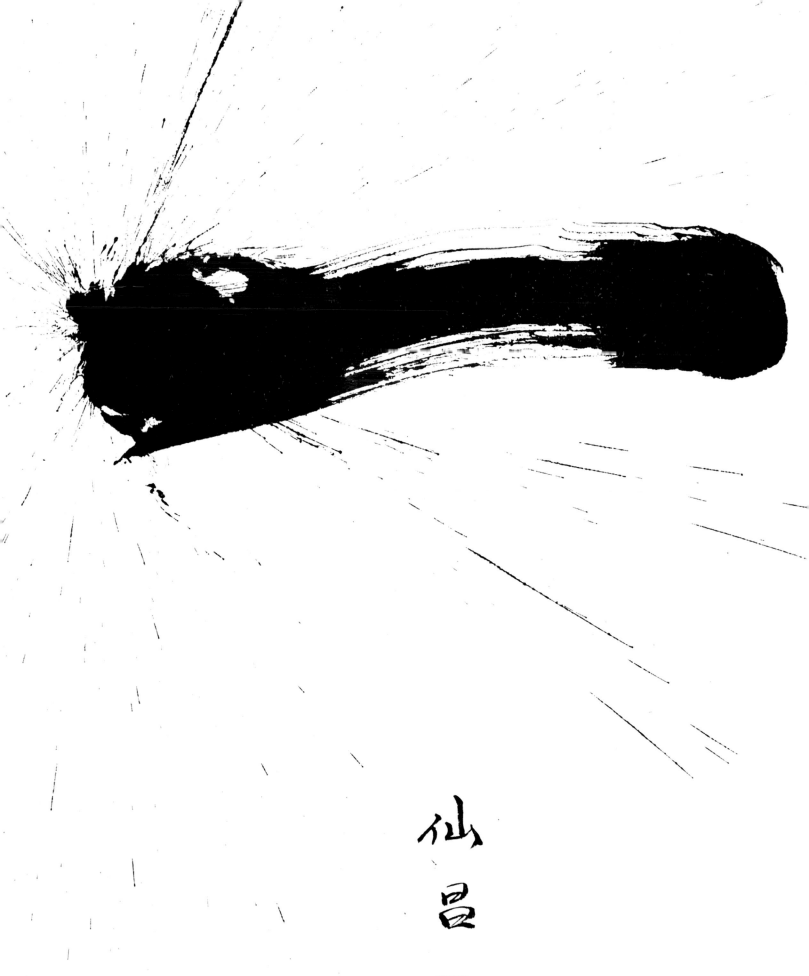

仙昌

SHODO

The Quiet Art of Japanese Zen Calligraphy

Learn the Wisdom of Zen Through Traditional Brush Painting

SHOZO SATO
FOREWORD BY GENGO AKIBA ROSHI

ZEN ADVISOR: Gengo Akiba Roshi
ASSISTANT TO AUTHOR: Alice Ogura Sato
CALLIGRAPHER: Shinya Fujiwara

TUTTLE Publishing

Tokyo | Rutland, Vermont | Singapore

Published by Tuttle Publishing, an imprint of Periplus
Editions (HK) Ltd

www.tuttlepublishing.com

Special thanks to Rev. Robert Yanasak for several of the
photographs in Chapter 9.

Library of Congress Cataloguing-in-Publication Number
2015514986

ISBN: 978-4-8053-1204-9

Distributed by

North America, Latin America & Europe
Tuttle Publishing
364 Innovation Drive
North Clarendon, VT 05759-9436 USA
Tel: 1 (802) 773-8930; Fax: 1 (802) 773-6993
info@tuttlepublishing.com; www.tuttlepublishing.com

Japan
Tuttle Publishing
Yaekari Building, 3rd Floor
5-4-12 Osaki, Shinagawa-ku, Tokyo 141-0032
Tel: (81) 3 5437-0171; Fax: (81) 3 5437-0755
sales@tuttle.co.jp; www.tuttle.co.jp

Asia Pacific
Berkeley Books Pte Ltd
3 Kallang Sector #04-01/02, Singapore 349278
Tel: (65) 67412178; Fax: (65) 67412179
inquiries@periplus.com.sg; www.tuttlepublishing.com

25 24 23 22 7 6 5 4

Printed in China 2204EP

PAGE 2: "Bokki, Spirit of the Brush" by Zakyu-An Senshō
depicts the ideogram for *ichi*, meaning "one." See pages
15–16.

RIGHT: *Mizu Itaru Kiyoshi Nashi Sakana* ("Water Reaches
Purity No Fish") by Zakyu-An Senshō. See page 151.

PAGE 6: *Sen Shin* ("Purify the Soul") by Seikō Hirata of
Tenryu-ji. See page 62.

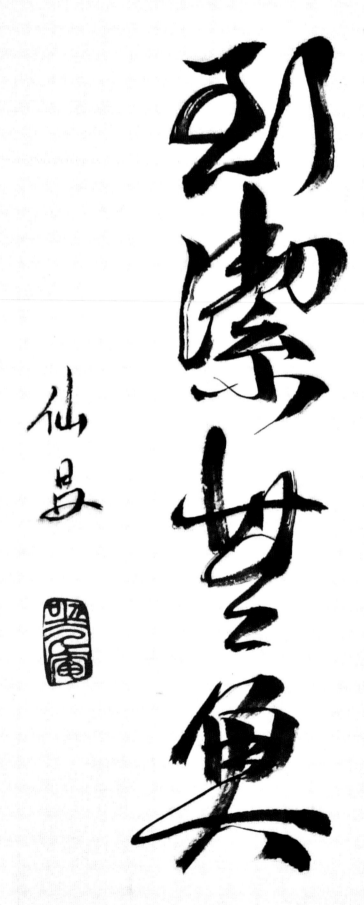

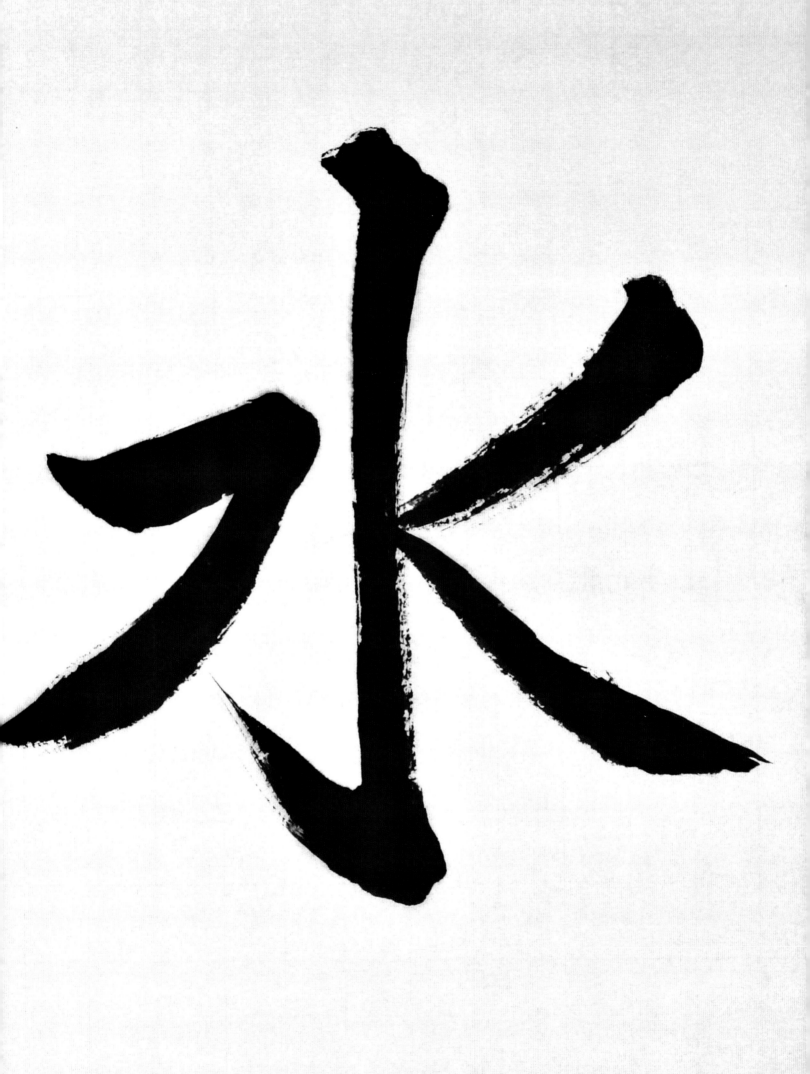

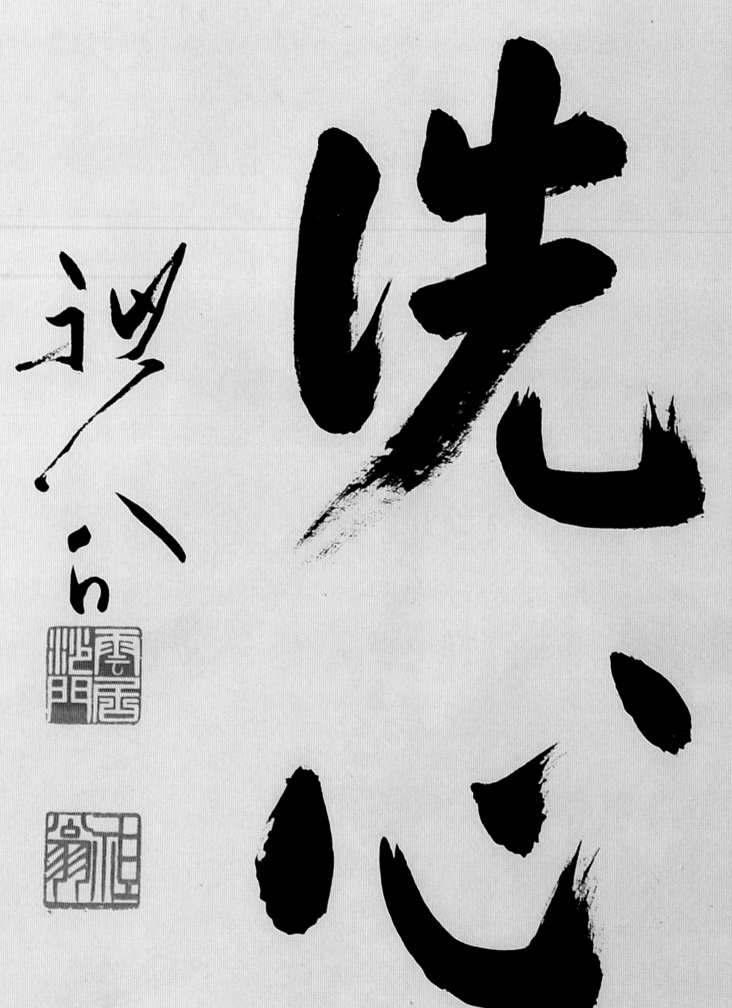

Contents

Foreword

Bokuseki are writings by Zen priests which also serve as an introduction to Zen philosophy. In my opinion, Professor Sato's concept to use these "statements" as a guide for shodo makes this one of the finest introductions to the art. Considering the *sho* (writing) of *bokuseki* brings to light the spiritual side of *sho* along with the source from which such writings come.

Each of the *zengo*, or statements from Zen philosophy, are written here in three calligraphic styles—*kaisho* (formal), *gyosho* (semi-formal) and *sosho* (informal)—and provides you with an opportunity to study and compare the works of Zen priests, professional *sho* artists, and other people whose interest led them to study the art of *sho*. The wide range of examples shows how individual personality is revealed through the practitioners' writing, and this makes this book an exemplary teaching tool.

There is great freedom and spirituality in the brushwork of the *bokuseki* written by the many well-known Zen priests in these pages. When written with a brush and sumi ink, ideograms impart vast depth in artistry. This is the beauty and charm that is being introduced through this book. Most importantly, while one is practicing the copying of ideograms, there is also the opportunity to ponder over the meaning of the Zen statement.

While there are many "how to" manuals on the shelves of bookstores that are designed to teach Chinese ideograms, commonly referred to as characters, the type of guidance offered in those books is aimed at mastering the most common ideograms in written Chinese, not at developing artistic style. Traditionally Chinese poetry has been used as a "copy book" source by shodo practitioners, serving as a model to follow for improving one's style. The person who instead uses *Shodo* as their guide or "copy book" will benefit by eventually developing a great understanding of the depth in philosophical understanding and the range in beauty and artistry of *ichigyo mono*.

Professor Shozo Sato has spent the greater part of his adult life in the United States, where he has dedicated his time to teaching and disseminating, both here and abroad, the traditional cultural arts of Japan. His unwavering resolve has helped the students in his classes and the public at large to develop an understanding of Japanese arts and culture. At every opportunity, he has lectured at and conducted workshops for civic and educational organizations and institutions. Depending on the interests and age levels of his audience, his chosen topics range from the theatrical arts and *ikebana* (the art of arranging flowers) to *chado* (the tea ceremony) and *sumi-e* (Japanese ink painting). His work invariably helps people see how these arts explain the foundations of Japanese culture: how the Japanese think, how they develop concepts and ideas, and how they create and express themselves.

Among Professor Sato's numerous publications, two recent books, *Ikebana: The Art of Arranging Flowers* and *Sumi-e: The Art of Japanese Ink Painting*, have been especially well received by teachers and learners. Over the years as he lectured and taught his courses on these arts and others, he became more deeply aware of how profoundly the traditional arts were rooted in Zen Buddhist philosophy, and that it was through Zen philosophy that the Japanese arts flourished and matured.

Zen philosophy and Zen aesthetics hold a unique position in the history of world culture. Today, across the United States, Zen Buddhism has been widely adopted. Thus this book comes at an opportune time. The person who begins the study of shodo through this book may well discover a freedom or release from certain attachments, especially to material things, and perhaps develop an interest in the dynamic processes of the mind as found in Zen Buddhism. Our world is filled with a material culture and many of our so-called "pressing needs" in daily life are based on that need. It is my sincere wish that readers will find the passage of release from materialistic social boundaries. Finally, I hope that this unique book will serve as a guide in many ways.

Gengo Akiba Roshi
Former Superintendent General, Soto Sect of Zen
North America International Missionary

Preface

ommunication through writing began in ancient times with pictographs and petroglyphs, and has continued down through the ages in many forms. Ideographs developed in ancient China are still being used for communication today, through the use of brushes, pens or the latest electronic devices, in countries that use the Chinese language such as The People's Republic of China, Taiwan, Korea, Japan, and others.

However, these same ideograms, when written with a brush under certain circumstances, are also used as artistic and philosophic expressions. This book is about how artistry and philosophy are transmitted through *shodo* (*sho*=writing; *do*=way), or the Japanese study of calligraphy.

Handwriting, whether used for ideogram-based languages, Roman-character based languages like English, or for any others, is uniquely individual, just as human oral expressions are. This unique expression of a human personality, which goes beyond "right" or "wrong," is seen in the variety of examples in this book. They range from fundamentally classic to abstract, from gentle to energetic.

Ichigyo mono (*ichi*=one; *gyo*=line; *mono*=category) in this book refers to the one-line statements from Zen philosophy that are used in the practice of shodo. These one-line statements have mostly been taken from treatises written by Zen monks and are considered to be the "core spirit" of their works. Because the statements are such brief abstractions, however, they often appear obtuse and incomprehensible. Through the practice of writing *ichigyo mono* over and over again, a student may gain a greater and deeper understanding of the philosophical meaning. These statements are universal in nature and can have interpretations that go beyond the boundaries of any one religion.

Two very important phases in my life, spanning two vastly different countries, influenced the writing of this book. As a young man I lived in Kamakura, Japan, the home of many temples of the Rinzai sect of Zen, built during the Kamakura period (1185–1333 CE). Living in the vicinity of Kenchoji, Engakuji and many other famous Zen temples, I became well acquainted with their occupants, from the young monks to the abbots, who taught me much about Zen philosophy. The seeds that led to my interest in Zen philosophy thus began in those early years. When I was nineteen, I also began to take lessons in chado, "The Way of Tea," under Kosen Kishimoto Sensei of Tokyo. I passed all the rigorous tests to obtain

a certificate as Master of Tea at the young age of 21. I was able to obtain such a degree at this age because even before preschool days in early childhood, my total focus was in the arts.

In 1964, I was invited to teach in the College of Fine and Applied Arts at the University of Illinois, Urbana-Champaign Campus. My brief was to develop a curriculum for the School of Art and Design on comparative cultures through the traditional arts of Japan. One part of the curriculum involved activities in the two-dimensional arts of *sumi-e* and *shodo* using the brush, ink and handmade paper (the first step was for the students to understand the fundamental differences between using a ballpoint pen and a brush and to observe how one line created with a brush had so much more visual impact). Another part focused on the study of Zen aesthetics through *chado*, "The Way of Tea." An *ichigyo mono*—a hanging scroll bearing a *zengo*, a one-line statement from Japanese philosophy—was always on display in the *tokonoma* or alcove of the tea room where I met my students, and discussion on the meaning of the *ichigyo mono* was an integral part of each lesson. The *zengo* selected for display were drawn from the 1,500 official statements in Japan, but were chosen based on their relative simplicity as well as their relevance to the occasion and contemporary American life. The paradoxical nature of these enigmatic statements always led to a great deal of meaningful discussion. The wall hanging was changed each week, which necessitated a very large collection. As budgetary restrictions made the purchase of such scrolls prohibitive, I began to write suitable *zengo* myself. Some fifty years have passed since then, but clearly the seeds for this publication were sown in those early teaching days. I still receive letters from former students thanking me for "sharing the treasure in a moment of enlightenment" and sometimes suggesting a new meaning for a particular *zengo*. Over the years, Zen statements in *ichigyo mono* have personally given me much spiritual encouragement and helped me develop a deeper understanding of the meaning of life. It is my hope that the *zengo* in this book will also be a guide leading to a moment of enlightenment for readers beyond the walls of a university course. This book has been written from the viewpoint of my capacity as a tea master, where all of the arts (including the craft arts) are a part of the discipline of chado, many of them living arts such as cooking and landscape gardening.

Bokki: The Spirit of the Brush

The combination of *sumi* (black ink) and brush used to create Chinese ideograms is called *shodo* or "The Way (*do*) of Writing (*sho*)." To create *sho* as an art form requires not only physical preparation but also mental preparation. The *sho* creator must learn breathing control and how to concentrate energy or *ki* (*chi*) in the lower part of the abdomen. (Since ancient times, the martial arts disciplines of Asia have required this same centering of a person's *ki* energy in the lower abdomen.) The *sho* creator, by concentrating and internalizing energy, can then pick up the brush and in a matter of seconds execute an ideogram. But those preparations are not needed when using the same tools for writing personal letters or business documents; for those prosaic tasks one can casually pick up a brush or pen and write.

In shodo it is considered sacrilege to go back and touch up the work. Any adjustment or touch-up would be apparent, and would interrupt the *ki*, and therefore the created work wouldn't be an honest representation of the artist's energy and personality.

In the preface it was mentioned that *sho* exposes the personality of the writer. (This phenomenon is not limited to ideograms, of course, as handwriting analysts in the West attest.) The act of grinding *sumi* ink on a stone is another way of transferring human energy to the writing of an ideogram. *Sumi* is created by burning oils of various kinds, and the soot is collected and mixed with animal glue. Because the soot is basically carbon molecules, when a stick of *sumi* is ground on the *suzuri* (grinding stone) with water, the extensive back and forth movements create static electricity in the liquid. *Sumi* ink that has been ground on a *suzuri* thus becomes charged with human energy (similarly, recall that our nervous system conducts electric messages to the brain) and when a *sho* artist who is using concentrated energy writes an ideogram using this ink, it is said that the lines contain *bokki* (*bo*=black ink, *sumi*; *[k]ki*=energy).

A very significant study connecting this type of energy and its physical manifestation was done by the highly respected Tanchiu Koji Terayama, director of Hitsu Zendo. The English translation of his book's title is *Zen and the Art of Calligraphy* (transl. by John Stevens; Penguin Group, 1983). In an effort to understand the importance of *bokki*, Terayama enlisted the assistance of scientists. He had small sections of shodo masterpieces from centuries past magnified to a value of 50,000x with an electron microscope. The researchers discovered that the carbon particles of *sumi* in a masterpiece showed a distinct alignment, while in a look-alike forgery of the same work, the carbon particles were instead scattered.

Down through the ages, the concentrated energy or *ki* of certain individuals has been transferred to their art, and that energy of the artist is called *kihaku*. A common expression in Japan is that "*unpitsu no kihaku*": power in the movement of the brush can be permanently recorded in a brush stroke. When an artist creates a work in a state of *kihaku* with the use of *sumi* ink, that work continues to provide strong impact and emotional appeal to receptive viewers across the ages.

When you visit a museum and see ideograms on display, *bokki* might not necessarily be obvious at first glance. The artwork may seem to be quiet in appearance. But when *ki* is present in an ideogram, it will spiritually affect the viewer. Each line or dot containing the full power of *bokki* will impact the viewer and add to his or her understanding of the statement and the source from which it comes. For this reason, *bokuseki* that is written by Zen monks focuses on the beauty of the ideogram, but also endeavors to reach the viewer's heart and soul with the power of potentially opening or expanding an individual's realization.

Obviously, such powerful ideograms filled with "the spirit of the brush" are not written easily. Students of shodo must constantly practice the strokes in the required order using *kaisho*, so that writing the ideogram correctly becomes second nature. Finally, then, without striving for the perfection, form and order of the strokes, the *sho* artist can create an ideogram that is permeated with spiritual beauty rather than merely visual beauty. This is the ultimate goal for all *sho* artists.

Many years ago when I was a preteen, my sumi-e teacher took me to a museum to see historic, famous sumi-e and *sho*. I still remember his admonition: "In order to appreciate the work, one's heart must be pure and receptive and then this ancient calligraphy will speak to you." This comment was strange to a naïve young

boy. Seventy years ago the understanding of how molecules and carbon electrons worked was not common knowledge; however the great artists from centuries ago must nonetheless have recognized that their power of *ki* did impact their work.

Look at the example on page 2, "Bokki, Spirit of the Brush" by Zakyu-An Senshō. It was written to convey the foundation of *bokki*. It depicts the ideogram for *ichi*, meaning "one."

The Chinese Roots of Shodo

The Chinese roots of Japanese calligraphy have a long history. Some 3,500 years ago in China, the hard surfaces of animal bones, tortoise shells and stones began to be inscribed with sharp instruments to produce documents for administrative purposes or with statements or predictions from the gods. These pictograms, chiseled in the form of a script based on squares of uniform size and using a limited number of angular lines or strokes administered in a particular order, were gradually systematized into ideograms similar to Egyptian hieroglyphics. Over successive centuries, the ideograms changed and evolved, becoming more abstracted. Ideograms began to be inscribed on the smooth surfaces of bamboo, boards, animal skins and handmade cloth. Often two or three of the original simple pictographs were combined to create a new ideogram with a special meaning. These multiple combinations, in turn, led to a more complex writing system. A single ideogram composed of modified pictograms now might carry with it a new special meaning.

The traditional and contemporary kanji in use today in academic writing number some 40,000. In modern Japan, some 2,000 to 3,000 kanji are used daily in newspapers, magazines, and other general reading materials.

Around 100 CE, China began to produce paper; *sumi* ink became more readily available, and a new kind of soft brush was created by combining types of animal hairs. It was a milestone: the incised version of writing could be replaced by the characters formed on smooth expanses of paper, with *sumi* ink and a soft flexible brush. The development of this latter tool, whose flexibility allowed variations in the thickness and curve of the lines of ideograms, brought about another style of writing, one that is similar to what we commonly see today. The writer was now free to write creatively in a personalized style.

Since then, generations of Chinese court nobles, government officials, priests and literati have left a multitude of writing styles whose nuances are a unique reflection of their individual characters and personalities. These writing styles, with their special brush movements, have been collected, systematically categorized and published in encyclopedic form. This tome is still commonly referred to today in China, Korea and Japan, as a guide for students of shodo to the variety of ways of writing individual ideo-

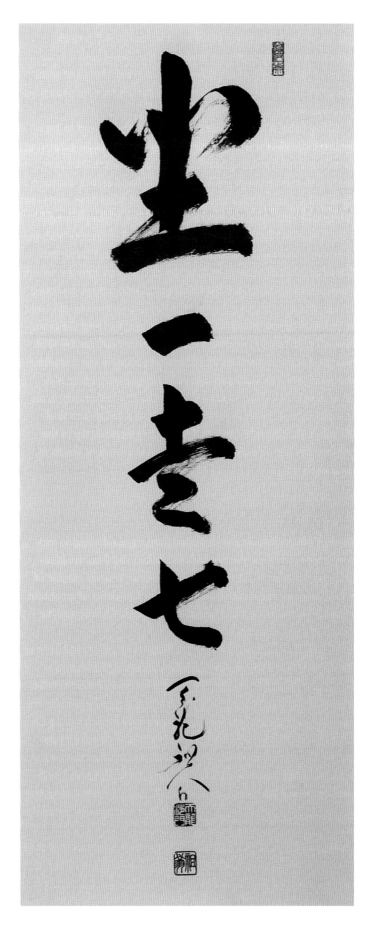

grams. In the book, first published in Japan in 1917 (see the Appendix for info on the 2009 edition, the "Shin Shogen"), the name of the writer and the time period is noted alongside each ideogram. This publication is a must in the library of anyone who practices shodo or other literary writing.

Calligraphy in the Chinese tradition was introduced to Japan around 600 CE where it became an essential part of the education of members of the ruling families. Royalty and the aristocracy studied the art by copying Chinese poetry in an artistic manner, developing it into a highly refined art. At the same time, a style of calligraphy that was unique to Japan emerged, primarily to deal with elements of pronunciation that could not be written with the characters borrowed from Chinese. Calligraphers in Japan still fitted the basic characters, which they called *kanji*, into the square shapes or block form that the Chinese had determined centuries earlier, but also developed a less technical, more cursive and freer style called *hiragana* and *katakana* (see page 16). Over the centuries, other influences came to bear on Japanese calligraphy. One was the flourishing of Zen Buddhism beginning in the Kamakura period (1185–1333 CE) and Zen calligraphy practiced by Buddhist monks. Another was the elevation of Zen calligraphy as an integral part of the tea ceremony, itself connected to Zen Buddhism, in the fifteenth century. Indeed, an essential step in the preparation for a tea ceremony is looking at a work of shodo to clear one's mind.

The Artistry and Philosophy of Bokuseki

As with other cultural arts in Japan, learning shodo begins with copying or following the Master's art. Schoolchildren use ideogram copybooks, while those who take shodo lessons outside of school also use these copybooks. Advanced students often obtain direction from the works of great shodo artists from across the centuries—or create their own.

The approach I have taken in this book is to expose students to shodo via the artistry and philosophy contained in *bokuseki*—writings such as documents, statements, essays and treatises that have been handwritten by Zen priests—and, more specifically the one-line statements from Zen philosophy known as *zengo*. In China, the term *bokuseki* means any handwritten document as opposed to materials printed with woodblocks, whereas in Japan it refers specifically to the writings of Zen priests. Moreover, in Japan there are nine categories of *bokuseki*, among them statements written by historically famous Chinese Zen high priests. Examples of these include certificates issued after disciples have completed their studies in Zen practice, or when disciples have received their Buddhist names and titles. Because there is a limited number of historically important *bokuseki* in Japan, today many living Zen monks, tea ceremony masters and professional calligraphers continue to create unique calligraphic styles and expressions.

One-line *zengo* encapsulate the essence of statements extracted from *bokuseki* essays, treatises and other writings. In essence, they are a crystallization or summation of the underlying meaning of Zen writings. They are expressed in a great variety of styles. A single ideogram may be written very large accompanied by smaller ideograms to complete the statement. Occasionally, a *sumi* ink painting may accompany the *zengo*. More unusually, a single ideogram or a short statement may be written in a horizontal manner as opposed to the more usual vertical presentation.

The way in which a *zengo* Zen statement is written vertically and mounted as a hanging scroll, as well as the way in which it is displayed in a Japanese tea room, is called *ichigyo mono*, a term which emerged in the sixteenth century. *Ichigyo mono* wall hangings containing *zengo* are the most revered of all the items on display in the *tokonoma* or alcove of a tea room. The one-line statement sets the tone for a particular tea ceremony and all accompanying items are selected to harmonize with it. Indeed, both the tea ceremony and Zen share the basic philosophy that all extraneous or redundant activities should be removed and in spirit and action the whole environment should reflect economy and minimalism.

At a cursory glance, the *ichigyo mono* on display appears to be a simple statement, but upon greater examination and reflection can reveal a profound philosophical truth. Guests who enter a tea room will first approach the *tokonoma*, study the *ichigyo mono* on display, then bow out of respect for both the meaning they glean from the statement and the thoughtfulness of the host for making such a fine selection. The bow of respect is symbolically the way to clear the mind of all extraneous thoughts in order to receive the full impact of the statement. Unsurprisingly, the spirituality imbued in the statement has given rise to the dictum "Tea and Zen are the same taste." But while the Zen philosophical approach is to simplify and remove unnecessary elements, in reality this is easier said than done. It is not simply a matter of indiscriminately removing one element or another; rather, each component must be evaluated carefully before elimination. This same Zen aesthetic concept can be found in the Noh drama, *haiku*, Zen gardens, black ink paintings and the tea ceremony. All these arts focus on stripping away unnecessary elements, retaining only what is salient and fundamental.

Spiritual enrichment through the practice of shodo is not the prerogative of well-trained Zen monks. Anyone who practices writing a Zen statement over and over again with a brush, learning to control the seemingly unpredictable outcome, eventually should gain greater insight into the meaning of the aphorism. This could be the moment when the enigmatic statement suddenly begins to make sense and through shodo a greater depth in understanding *ichigyo mono* realized. This is the main purpose of this

book—practice as a prerequisite to understanding.

Professional shodo practitioners follow a daily schedule of writing ideograms that employs their artistic visual sense to the highest degree possible. They seek to produce extraordinary beauty in the art of shodo in their careful selection of the type of *sumi* ink, the kind of handmade paper and the quality of "singularity" of the brush so that the desired effects can be achieved. Their skill in using the brush is, of course, the most significant. If a viewer at first glance feels that there is leftover space, careful examination will show that this is active empty space. The refined beauty on all levels that is the pursuit of the professional shodo artist, when combined with spirituality, will create works that will undoubtedly have an impact on the viewer. On the other hand, students of shodo obviously cannot compete with professional shodo artists in their skill and technique with the brush. Therefore, when an *ichigyo mono* is carefully scrutinized, the background and character of the creator must be taken into consideration. The respect and honor given to the work is because all aspects of personality and character are imbedded in the brush strokes. The viewer must retain an open mind and purity of heart and spirit to appreciate the *ichigyo mono* hanging in the *tokonoma*.

Generally speaking, people who have had little experience in reading *zengo* often struggle to comprehend their meaning. Not only do most *zengo* used in *ichigyo mono* come from ancient sources, written by famous Chinese or Japanese priests and teachers of Buddhism, Taoism, Confucianism and others, but the one important line singled out from long sutras and treatises requires some knowledge of the whole. Without prior knowledge of the historical background and context in which the line was taken, interpreting *zengo* can be a challenge. Indeed, taken out of context, *ichigyo mono* can be as ambiguous as the contemporary conversation of couples or grandparents. Exchanges such as "I'm for fish" or " I'm for chicken" can be puzzling unless understood that these are comments made on the way to a restaurant. "My daughter's is a boy" or "My son's is a girl" is equally enigmatic unless one understands that this conversation is between two sets of grandparents discussing the gender of their grandchildren.

Since ancient times, literature in Japan has always been regarded as secondary to the practice of Zen. This is reflected in the expression *furyu monji* (*fu*=not; *ryu*=standing; *monji*=literature), meaning that literature should not stand out and was secondary in Zen practice. *Zenki* (*zen*=silent meditation; *ki*=opportunity) was of paramount importance. In the process of constantly pursuing an answer to a *koan*—an enigmatic Zen conundrum—the sudden moment of the breaking point or "realization" would come at unexpected times, often during common daily activities or during training. Whether such deep and significant meaning can be found in the practice of shodo is subject to speculation. Certainly, this is not universal for all practitioners of shodo. However, in writing Zen

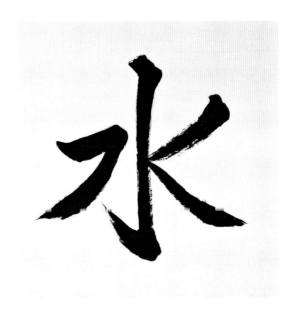

statements and in the attempt to understand their meaning, spiritual energy is expended and vital forces allow an individual to create a work that goes beyond the craft of the brush. The works of these individual artists borders on abstract art.

This book is about how to read and develop some understanding of *zengo*. Detailed explanations, guidance and notes on how the statements can be perceived are therefore included. Although the *bokuseki* samples in the book are works by well-known Japanese Zen priests called *zenji* (*zen*=silent meditation; *ji*=master), a title bestowed only by the Imperial court on priests who have been outstanding in dedicating their life to Zen Buddhism, a professional, contemporary shodo artist was specially commissioned to reproduce the *bokuseki* in the *kaisho* style to allow ordinary people to read and write the statements in either the formal, square *kaisho* or the informal, cursive *gyosho* style.

This book also incorporates, in Chapter 9, the work of neophytes from a variety of backgrounds who take weekly lessons in shodo in my studio. For many of them, practicing shodo is an extension of their practice of *zazen*. Their work has been deliberately incorporated so that a wide variation in individual styles and nuances can be seen in the writing of the ideograms. Included in the book are instructions for writing these ideograms if the reader so chooses.

If a greater perception or insight into understanding the essence of Zen is gained from either reading about or practicing the shodo in this book, all who have participated in its compilation will be greatly honored.

THE ART OF KANJI

The main difference between *shodo* (Japanese calligraphy) and Chinese calligraphy is that shodo employs three ways of writing characters—using *kanji* (ideograms) and *hiragana* and *katakana* (phonetic systems)—whereas Chinese calligraphy has basically retained a single method, termed *kanji* in Japanese, which is still used in China today. Moreover, the goal of Japanese calligraphy is not uniformity but the expression of individuality, an amalgam of the skill and imagination of the creator who has studied the combinations available made up of only lines or strokes.

Although written Japanese today may combine kanji, hiragana and katakana in a single sentence, within the kanji style there are several sub-styles that reflect differences in formality and purpose. .

As you will see, the *kaisho* style of writing an ideogram requires an architectural knowledge of the formation of the ideogram. The *gyosho* and *sosho* styles also require a sense of rhythm. But regardless of the calligraphic style used by the writer or the beauty and uniqueness of his or her creation, if an ideogram or series of ideograms cannot be read they no longer belong to the art of *sho*. This is because each ideogram has already been abstracted in the process of forming kanji. In shodo, the aim is to artistically elevate the kanji yet maintain the original meaning. To be able to do this, the shodo practitioner must be aware of the quality of each and every line, including those that might be accidentally created and yet are inherently exquisite. Strong lines instead of weak ones, bright lines instead of dark ones, clear lines instead of muddy ones, deep lines instead of shallow ones— all are prerequisites in shodo. One must also be aware that lines have a sense of rhythm as well as a sense of solidity or weight. Within the given space of white paper, the ideogram contains a three-dimensional massiveness that expands into untouched white space. At the same time, the practitioner must be able to exhibit a personalized technique that is both skillful and ingenious while expressing the meaning of an ideogram. The creative process in shodo, as in many other arts, is in many ways a "spiritual purification" of the creator.

What Is Kanji?

The Japanese term *kanji* derives from the ideogram for *han*, meaning "word from China." This refers to the Han dynasty of China (207 BCE–220 CE).

Kanji was brought to Japan from China and Korea during the sixth century. The Japanese had already developed a spoken language by that time; therefore, for the sake of convenience, these newly-arrived ideograms were given two different pronunciations: the original sound from its Chinese use, and the Japanese way of pronouncing that same vocabulary item's meaning. A major distinction between the kanji writing system and an alphabet-based writing system is that a single ideogram of kanji is a "word" carrying a specific meaning.

Two additional systems which are purely Japanese were developed from *kanji: hiragana* and *katakana*. These are phonetic systems, and are used like the English alphabet, in that each symbol in and of itself has no meaning. In the Japanese writing system, kanji, hiragana and katakana are combined to write sentences.

While both of the forms can be traced back to the original kanji, *hiragana* was developed from the *sosho* (cursive) style of writing, to become a graceful, flowing, semi-formal writing style known as the "grass" style. The graceful hiragana was commonly called the "women's style" of writing.

Katakana, in contrast, was developed from what is known as the *kaisho* style, and reflected one simple portion copied from a kanji ideogram. Therefore the katakana symbols are more square in shape.

During the Heian period in Japan (794–1185 CE), all official documents by government officials, Buddhist priests, and in fact by all males, were written in the "square" *kaisho* style of writing. Moreover, only Chinese ideograms and compositional styles were used.

This separation of writing systems into male and female styles is unusual in the history of a written language. Until the latter part of the Muromachi period (1333–1573 CE), a combination

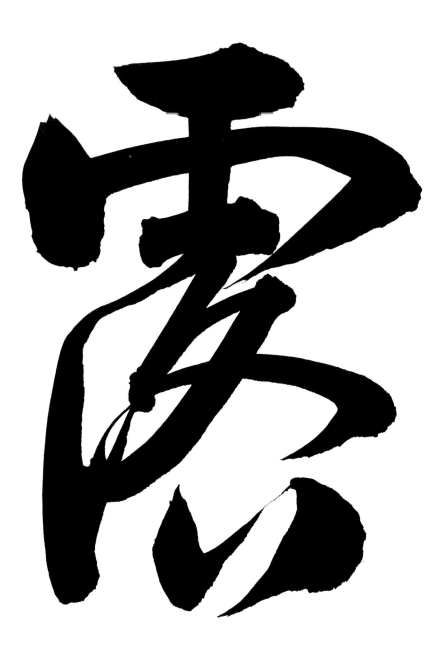

Ro or *Tsuyu* (meaning "Dew" or "Dewdrop," "Vain" or "Ephemeral") in the *sosho* style.

of kanji and katakana was used to write in Japanese. But today katakana is reserved solely for writing foreign words.

Korea, too, used kanji for writing but in 1443 the Korean king Sejong simplified the writing system in order to increase literacy in his country. He developed a system of writing based on the sounds of the Korean language, with symbols reflecting how the tongue, lips, and throat were positioned for each sound. *Hangul* is today a phonetic system of 24 main symbols; and while Chinese characters are still used in Korean academia, the general public writes and reads using hangul.

Until printing technology became easily available in Japan, *katsujitai*, or the woodblock method of printing, was the norm. A faithful version of each ideogram was hand-carved in reverse on a block and then hand-printed, so that the printed form of a kanji matched the handwritten form. In contemporary times, kanji have been specially designed (kanji were modified as necessary) so that every character is sized to fit a standard, uniform amount of space, and thus even if the characters are printed very small, texts remain easy to read. Many young people in Japan are so accustomed to reading printed materials in this style that their handwriting replicates this form. But this uniformly-spaced style should most certainly be avoided in the art of shodo.

The Cultural Revolution in China (1966–76) brought about new changes in writing. The traditional ideograms using many strokes to create one word were simplified by eliminating certain lines, and thus a new style of kanji was developed and continues to be used in Mainland China. During this same period in Japan, kanji was also simplified by eliminating strokes in certain ideograms. Today, the traditional way of writing Chinese ideograms is found only in Taiwan and certain other Asian countries. However, for the artist of shodo—whether in China, Japan or Korea—the traditional style of kanji is still used.

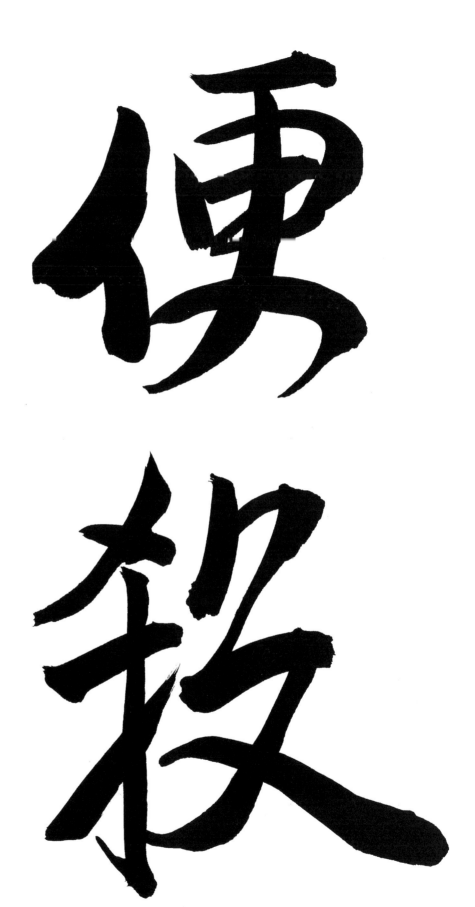

The top ideogram, *Ben*, means "convenience" or "service" but also means "excrement." The lower ideogram, *Korosu* or *Satsu*, carries the meanings "kill," "slaughter" or "restrain." Both are in the *gyosho* style.

Writing Styles

There are five basic styles commonly used in Japan today for writing *kanji*. They are *tensho* (seal style), *reisho* (scribe's style), *kaisho* (block style), *gyosho* (semi-cursive style) and *sosho* (cursive style), which all appeared in China before the end of the fourth century. In addition to the Chinese ideograms, the Japanese, in the 8ᵗʰ century, developed *hiragana* and *katakana* where one small portion of an ideogram was taken to represent a phonetic sound more suitable for the spoken language of Japan.

REISHO 隷書

Reisho is sometimes referred to as the "clerical script" or "scribe's style." The Chinese Emperor Shin Huang Ti of the Tsin dynasty (221 BCE) ordered the consolidation all of the existing styles of ideograms into a standard *reisho* form based on pictures in order to make writing more accessible to the masses. This style, which is highly linear, was considerably influenced by the *tensho* style or "seal script," a formal calligraphic style created a generation earlier for carving ideograms on stone tablets or monuments as well as on ornamental stamps or seals for signifying ownership. Although the strong decorative aspects of *tensho* were adapted for *reisho*, they were considerably simplified, with fewer strokes and in a slightly more cursive style. The *reisho* style is thus both decorative and easy to read, even for the average person.

Although traditional or classic *reisho* had less ornamentation and was much simpler, some embellishments were eventually applied to it. The ideograms in *reisho* were also longer horizontally. Unique to *reisho* is that when making the horizontal line, the beginning of the line is rounded, but the end of the line goes up like the bow of a ship. Today, however, the *sho* artist will write *reisho* with much more freedom than in the past, injecting his own personality.

Using the brush in a particular way for the beginning and ending of each line is a unique aspect of *reisho*. Example (**a**) at left of the ideogram *ichi*, meaning "one," comprises a horizontal line. The brush is held perpendicular to the paper. As it is pressed down, it is pushed to the left to make the circular head; it is then moved to the right; after pressure is applied, the brush is lifted upward to create a taper.

Reisho continues to be used today, especially in shodo exhibitions featuring Chinese poetry, and is popular for company and product names because of its relative simplicity and legibility. The *reisho* style is also commonly employed by carvers of stone seals, especially official seals, which often function as official signatures in Asia.

The example (**b**) at left shows the ideogram for "dream" in the *reisho* style. In the grouping at left (**c**), the ideogram at the top is an early version of *mu* ("nothingness") in a classic Chin dynasty (221–206 BCE) *reisho* style. The ideogram in the middle is the same ideogram written in a contemporary style with embellishments. The ideograms in the last line—"guest," "elderly lady" and "crow"—come from Chinese poetry of the Chin dynasty and have much more ornamentation.

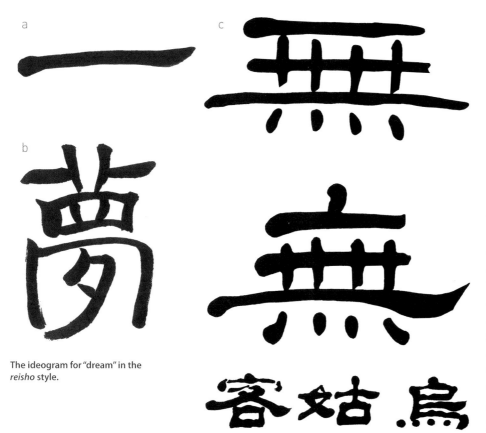

The ideogram for "dream" in the *reisho* style.

KAISHO 楷書

Kaisho literally means "correct writing." It is a simplified form of *reisho* and is the form used in both China and Japan for everyday writing. Often called the "block script," *kaisho* is the easiest style to read because of its precise nature. This derives from the fact that the form and number of strokes are placed in a prescribed place and sequence within a fixed area. The ideogram for *kaisho* itself (see the heading above) can also be interpreted to mean that each stroke has a "fixed" or "set" position. The left side of the first ideogram is a tree or wood; the right side means "everyone" or "all."

Writing in *kaisho* is similar to walking up a staircase one step at a time. The order in which the lines are to be placed must be strictly followed line by line. In copybooks, the ideogram strokes are numbered and the strokes must be followed in the correct order. For this reason, students often begin with the *kaisho* form when first learning shodo; it gives them a chance to practice the sequence of strokes while becoming used to handling the brush. Indeed, *kaisho* was developed after brushes made with animal hairs became commonly available.

All printed materials, such as newspapers, magazines and books, are printed in the *kaisho* style. A newly designed printing block system called *katsujitai* has been devised so that even small print can be easily read. In this style, each ideogram is made to fit a uniformly sized square block. Some ideograms have been adjusted to fit the block size.

Despite the overall uniformity of the *kaisho* writing style, slight variations do occur depending on the strength of the brush stroke, and this is permissible. Much depends on individual taste and choice. Although such terminology as "rigid and formal *kaisho*," semiformal *kaisho*" and "informal *kaisho*" is not part of the curriculum in a *sho* classroom, a "casual" or "relaxed" style is sometimes referred to.

In the traditional line for the *kaisho*

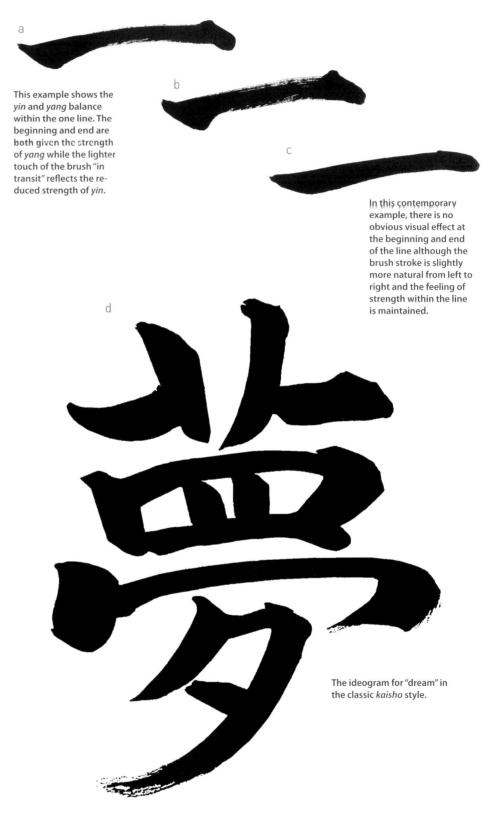

a

b

c

This example shows the *yin* and *yang* balance within the one line. The beginning and end are both given the strength of *yang* while the lighter touch of the brush "in transit" reflects the reduced strength of *yin*.

In this contemporary example, there is no obvious visual effect at the beginning and end of the line although the brush stroke is slightly more natural from left to right and the feeling of strength within the line is maintained.

d

The ideogram for "dream" in the classic *kaisho* style.

ideogram *ichi*, meaning "one," shown above, the brush is pressed down; slight pressure is applied before it is moved to the right; the amount of pressure is reduced "in transit"; at the end more pressure is again applied; then the elbow is turned slightly clockwise to create a knuckle effect.

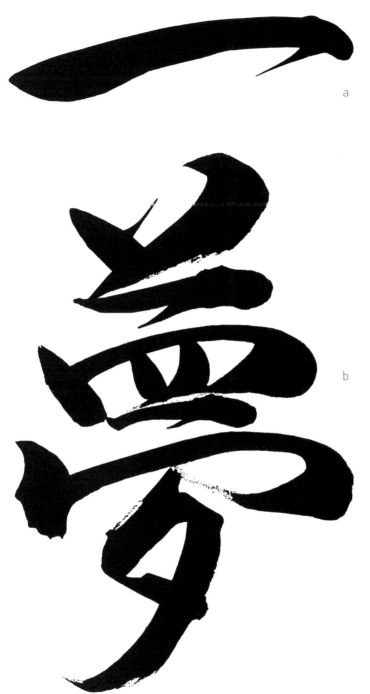

a

b

The ideogram for "dream"
in the *gyosho* style.

GYOSHO 行書

Gyosho is a semi-cursive style that literally means "traveling writing." Indeed, the ideogram for *gyo* (**b** above) translates as "motion." Writing in *gyosho* is faster than writing in *kaisho*, and because it is a less formal style the letters have a softer, more rounded appearance, with the individual strokes flowing together. When writing in

the *kaisho* style, the brush movement stops at the end of each stroke. In contrast, in the *gyosho* style the intention is to make a smooth transition from one stroke to the next. The beginnings, endings and turning corners of the strokes are thus not given the same emphasis as in *kaisho*, and the ending of each stroke or line tapers to a fine wisp. In addition, the complex lines within the *kaisho* ideograms have been simplified or even reduced, which makes writing smoother and speedier. Yet the formation of the ideograms are very similar to *kaisho* and anyone who can read *kaisho* can also read *gyosho*. However, a very important prerequisite of the *gyosho* style of writing is that one must know the order of the strokes and the form of the ideogram in the *kaisho* style, otherwise the ideogram cannot be read. Of major importance in the art of shodo is that one must be able to read the ideogram. If not, regardless of how beautiful it is, it becomes mere abstract art.

Because *gyosho* provides a sense of speediness and flexibility in brush movement in comparison with *kaisho*, it allows for the creation of very personal styles in forming ideograms. A change in the order of strokes is acceptable, as is adjusting brush strokes to suit one's own style, and for artistic creativity. This flexibility in *gyosho* allows the shodo artist the opportunity to produce remarkable works. For this reason also, most Japanese calligraphy is done in *gyosho*, including *bokuseki* writings by Zen priests.

The unique feature of the *gyosho* style is that the beginning and ending of a brush stroke must show the directional movement of the next stroke—where it came from and where it is going. In the example above of the ideogram for "one," the brush movement is started from the left and moves to the right; then, at the point of completion, the brush is lifted, leaving a wisp to indicate where the next line will begin.

SOSHO 草書

Sosho is the least formal style for writing ideograms in Japanese and is like writing in cursive in the West. Brush strokes and movement flow in minimized style with each line reminiscent of the wind blowing grasses in a meadow, or flowing water moving plants in a stream. For this reason, *sosho* is often called "grass writing." It more likely began as casual daily communication or notation, thus the personality of the writer was clearly evident. This aspect eventually led to this highly artistic and abstracted style of writing in contemporary times. The very great economy in brush movement provides a *sho* artist the opportunity to achieve full artistic expression to create many subtle nuances among the curving lines in an ideogram and to incorporate an important balance within the flow of line and active empty space. **However, in order to work in the *sosho* style, it is necessary to first master the order of the strokes in both the kaisho and *gyosho* styles.** Without a firm knowledge of these requirements, the purpose and effect of the highly simplified *sosho* lines will not be executed by the calligrapher, and the all-important visual improvisation in personal expression will not be successfully achieved.

Because *sosho* has become so personalized, the Japanese do not use it for everyday writing. In fact, *sosho* is so abstract that it can generally be read only by those trained in calligraphy who are able to appreciate its aesthetic qualities and free-flowing artistic style. During the Heian period (794–1185 CE) the phonetic system of *hiragana* was developed from the *sosho* style and was considered a woman's writing style. Today, professional calligraphers and Zen priests often use the *sosho* style of writing Chinese ideograms. However, because the focus is on the quality of the visual line and because innovations and modifications can radically alter ideograms, the general public usually finds *sosho* calligraphy difficult to read.

The beauty of *sosho* lies in its fluid brush movements. As shown below in the ideogram for "one" (**b**), it is the essence of *sosho* to continue the flow of line from the previous movement, and leave a trace which leads to the next line. The continuous flow in line quality, which is begun with the tip of the brush without pressure, moves naturally to the right, with the ending wisp of the stroke leading to the next stroke.

a

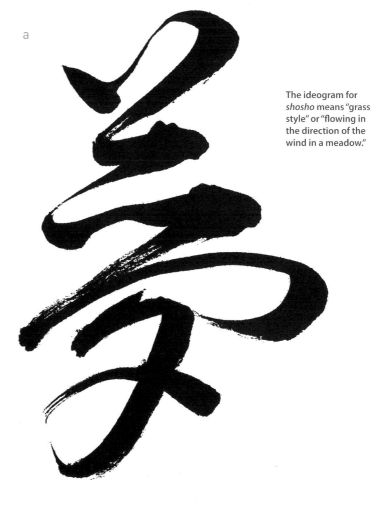

The ideogram for *shosho* means "grass style" or "flowing in the direction of the wind in a meadow."

b

"T-SHIRT AND BLUE JEANS"

The kanji ideograms have had thousands of years to develop and change, and continue to flexibly reflect the artistry of each generation. The legacy offered by well-known calligraphers to their contemporaries shows their unique personalities pervading their work, impacting the kanji style, and reflecting the tenor of the time.

Shortly after World War II, during the 1950s, the Japanese traditional arts began to change, influenced by a contemporary movement which was world-wide. This trend permeated even the traditional world of shodo: the individual personality and style of calligraphers began to be more strongly reflected in their work. No longer do these works belong in the category of depicting ordinary ideograms or kanji but they become transformed into abstract paintings, where ideograms are no longer limited in size in relationship to each other. When the avant-garde becomes the fashion, it eventually becomes a recognized genre or form. However, often it is difficult to read such work because both the *gyosho* and *sosho* style of writing have become so personalized. The recent trend which has become very popular in Japan is a category which I personally have named the "T-shirt and Blue Jeans" style. One of the great benefits of this style is that it is easy to read because it is based upon a *kaisho*-like clarity, although it is in *gyosho* style. However, this "T-Shirt and Blue Jeans" style goes beyond the traditional concepts of rules and order and methods of brush movement, to a freer form. While the meaning of the ideogram is visually retained, the overall expression can also be aesthetically appreciated in a new way. Each individual can create a personal style, which is the great appeal of this movement.

On pages 135–138 the *ichigyo mono* "Fresh Breeze Affects Serene Bamboo" is discussed. This work by Shinya Fujiwara of the Naniwa Shodo Association captures, in "T-shirt and Blue Jeans" style, the essence of feeling the cool breeze.

Sei Fū Shū Chiku O Ugokasu ("Fresh Breeze Affects Serene Bamboo") by Shinya Fujiwara of the Naniwa Shodo Kai

THE FOUR TREASURES IN SHODO

Chinese ideograms were brought to Japan during the sixth century along with Buddhism. However, in those early days, reading and writing were limited to royalty and selected members of the court. During the centuries that followed there were countless power struggles among the warlords. However, by the beginning of the Edo period (1615–1868 CE) with the rise of the Tokugawa Bakufu, Ieyasu recognized the many advantages of promoting aspects of Chinese culture, predominantly the philosophies of Confucianism (551–479 BCE) and Taoism (Lao Tzu, 604–531 BCE). The Bakufu (another name for the Tokugawas) employed teachers of Confucius to promote beliefs through reading, writing and even memorizing passages from the *Analects* of Confucius.

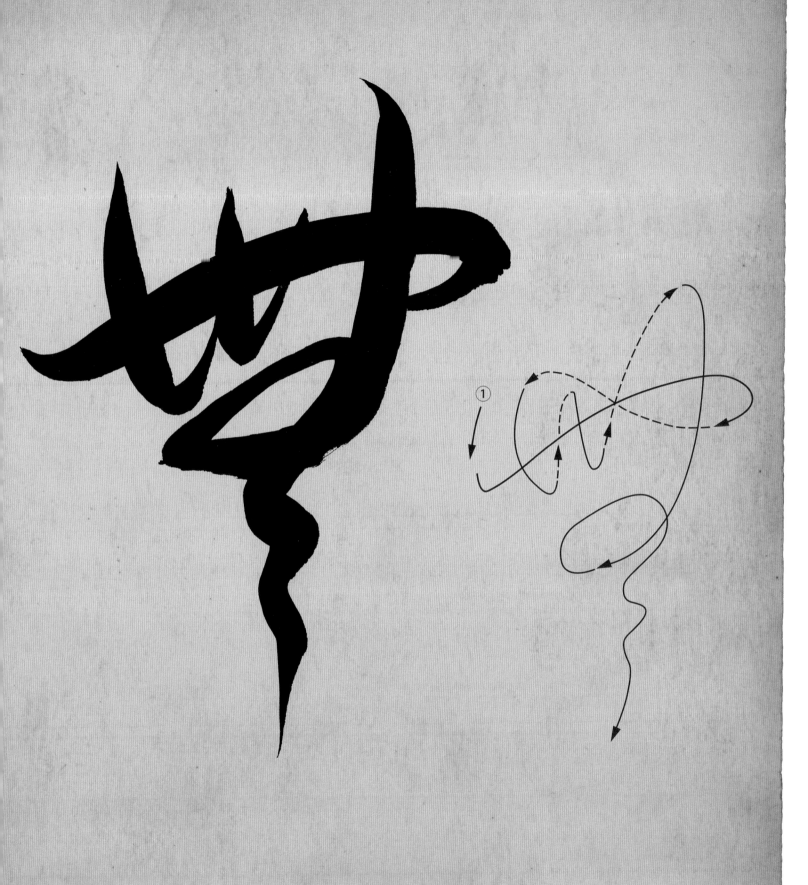

Zen buddhism, which had been brought to Japan from China during the Kamakura Period (1185–1333 CD), incorporated the philosophies of both Confucianism and Taoism and was very compatible with the sensibilities and approach to life among the warrior classes. The warriors and rich merchants who were retired gave rise to a class of the populace called the "literati" or *bunjin* (*bun*=literature; *jin*=person). This class was well versed in reading and writing, and the *bunjin* were especially involved with creating paintings which were accompa-

nied by either Chinese or Japanese poetry.

They cultivated the arts of calligraphy, painting, and the Chinese style of drinking brewed green tea (added to the existing tea ceremony), all of which became important pastimes. The "four treasures" from the ancient Chinese—the brush, sumi ink, the grinding stone and paper—became revered items. An interesting object used in both shodo and painting, the *suiteki*, a miniaturized container to hold water, was no doubt inspired by the tea pot used in brewing green tea.

BRUSHES
Fude

Chinese ideograms have changed in style down through the ages. *Tensho* (carving style), *reisho* and *kaisho*: each distinctive style of writing requires a specific type of brush. In order to provide specificity for writing in each style, the combinations and variety in the bristles have changed. Today brushes are typically composed of various kinds of animal hair, but in the documented history of brushes, early brushes were

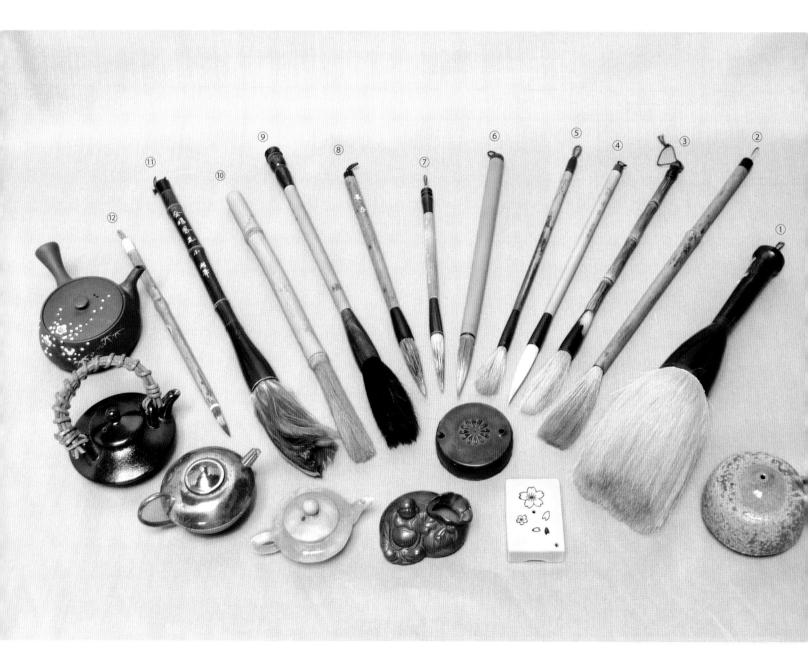

1: This big brush with a short handle is soft in hair composition, so is especially suitable for writing in *gyosho* and *sosho* styles.

2: This is a typical shodo brush with soft long bristles 3 in. (7.6 cm) in length.

3: This brush is good for *gyosho* and *sosho*. The bristles are soft and are 2.5 in. (6.3 cm) long, slightly longer than a standard brush's.

4: This brush, similar to brush 3, is still new (notice the pointed form of the bristles). The bristles are 2.5 in. (6.3 cm) long.

5: This is a common *sosho* brush, with bristles about 2 in. (5 cm) long.

6: This brush is new, as the bristles' form shows. It is good for *kaisho* and *gyosho*. In composition, the center and outer skirt hairs are coarser in order to provide "spring" when in use. In quality brushes of this type, the whiskers of small animals are placed in the center. The bristles are 2.25 in. (5.7 cm) long.

7: This Chinese brush with a green stone handle is also new and unused. Its blend of coarse hairs is used for writing small ideograms in *kaisho*. The bristle length is 2 in. (5 cm).

8: This brush, also new and unused, has bristles that are a mixture of raccoon and wolf hairs. Its head is 2.25 in. (5.7 cm) long, and it is a good brush for *kaisho*.

9: This brush, made with coarse hairs (bear, etc.), is good for writing large calligraphy in *kaisho* or *reisho* style. The Chinese name for it is "Dragon King." The bristle length is 3 in. (7.6 cm).

10: The bamboo brush was one of the earliest of brushes, before animal hairs were used for bristles. These fibers are coarse so can be effective in writing creatively in *reisho* or *kaisho*. Bristle length is 3.5 in. (8.8 cm).

11: Bird feathers are used as the bristles here. Calligraphers can foresee the unexpected line quality which might be produced, and will incorporate that feature in their creativity. The bristle length is 3.5 in (8.8 cm).

12: This small brush is purposely left sharply pointed and is used for writing a signature, or for copying the sutra. The bristle length is 1.25 in. (3.175 cm). Eight *suiteki* are also shown.

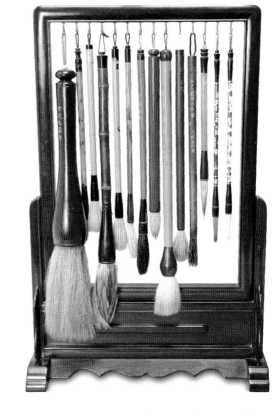

To store brushes after they have been washed, hang them upside down from the hooks of a special brush hanger; moisture will drip down and evaporate.

often made from such substances as dried roots of plants, fine fibers of plumes from pampas grass, or rice straw. These organic materials were made into bundles with the size and diameter determined by the needs of the user. Another type of brush was created from a stalk of bamboo where one end was gently crushed to release the fibers (see brush number 10 in the photo). This bamboo brush is still being produced for use today.

Brushes may be used for both shodo and sumi-e interchangeably. However there are exceptions, especially when considering the style. When writing in *sosho* style or "grass writing," using a brush with long and soft bristles is a desired feature. This facilitates the creating of the needed flowing and curved lines. This type of brush is not useful for sumi-e.

In writing in *kaisho* style, a brush with stiffer hair is required so that when the brush is lifted up after a stroke, the tip of the brush automatically returns to a point, a feature that most calligraphers look for. In the *gyosho* style a brush which is slightly softer than the one used for *kaisho* is recommended. As mentioned, *sosho* requires longer bristles; however, throughout the

centuries the saying has gone: "A master of calligraphy will not depend upon the quality or type of brush on hand but will create a masterpiece with whatever means is on hand." But for those of us who are practicing calligraphy or shodo, the use of an appropriate brush should help to improve our writing. With proper care a good brush can last for many years, so as an investment, a high quality brush is recommended. For detailed information on the composition of brushes, please refer to my book *Sumi-e: The Art of Japanese Ink Painting*.

INK
Sumi

Sumi is made from the burning of certain kinds of oils and minerals. When soot comes from that burning and is then mixed with a nikawa adhesive, a brown tone sumi ink is produced which is most suitable for common calligraphy. When pine sap is burned, the soot combined with nikawa creates a blue tone ink.

All black ink, in whatever form, contains adhesives. Traditionally the adhesive has been nikawa but recently a synthetic acrylic adhesive has been developed.

1: This is a very common type of sumi molded in stick form. While the shapes of sticks may be similar, there is a vast difference in quality. A quality stick of sumi ink requires years of maturing; therefore it may cost several hundreds of dollars, while a similar-looking stick may cost less than ten dollars. Inexpensive sticks are used for practice.

2: A disc-shaped stick made in China.

3: This expensive ink stick is covered in gold leaf. Sumi made from this stick will be thick and black; if you use it as light ink, the effect will be a brownish tone.

4: This ink stick is made from the soot of pine sap. The ink, when diluted with water, will have a cool gray-blue effect.

5: A red ink stick is for the instructor, who will use red for guidance and corrections in the studio or classroom.

6: There is a wide range of liquid blue tone ink being sold. This type is ideal for use as a thick ink. Blue tone inks are often highly condensed or concentrated, so a variety of tones may be created according to your needs.

7: For centuries the saying has been, "Black is black yet it encompasses all of the colors." With this ink, after the strokes of your calligraphy have dried, they will show a purplish tinge when light rays illuminate them.

8: This ink is very popular among calligraphers. Manufacturers have been able to create super-fine molecules of soot, allowing a work to have unexpected depth in black ink. It is highly concentrated, so for general use, the proportion should be 2 to 5 parts water added to one part ink.

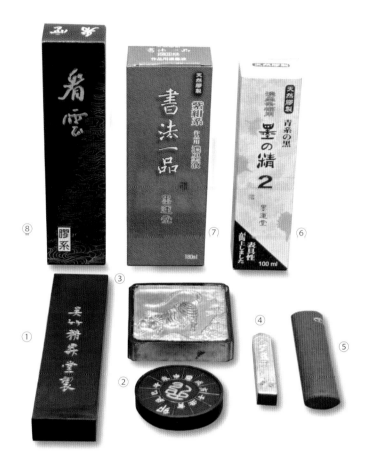

Nikawa has been used for centuries as an adhesive for Japanese painting pigments and fine wood work. It is made from bone, skin and other parts of animals and fish. This substance is cooked down for many hours; it is strained and refined over and over again to create a transparent or semi-transparent light orange colored adhesive.

It commonly comes in a a small cube-shaped form or as a liquid. Nikawa-based sumi ink will require a longer drying time before the work can be mounted or backed with backing paper. When inexpensive liquid black ink is used, the ink tends to bleed or run during the process of mounting the work.

PAPER
Washi

For beginners in shodo, outdated newspapers are commonly used for practice. One can also purchase tablets or reams of newsprint paper. But once one reaches a certain degree of proficiency in writing ideograms and is able to create subtle effects like the nijimi effect or dry brush effects, it is advisable to use better quality paper. Art supply stores usually carry paper especially made for practice in calligraphy. Common practice paper is called *hanshi* and there is a wide variety in quality and price.

Originally hanshi was handmade from the fibers of cedar. The large sheets were cut in half, hence the name *hanshi* (han=half; shi=paper). Generally the size is 13 x 9.5 in. (33 x 24 cm). Commonly used for large works, *zenshi* is the standard size of paper: 54 x 27.5 in. (137 x 70 cm). *Hansetsu* is zen-shi cut in half vertically. It is commonly used for calligraphy or bokuseki (work by Zen monks) that will be made into wall hangings.

SEALS AND STAMP PADS
Inkuni, Shuniku

In the West, signatures are used to attribute an artwork to a particular artist. In Japan, a calligrapher signs his or her work with an *inkan* seal or "chop." Generally, the ideogram for the calligrapher's surname is done in white with a red background, and the given name is done in red with a white background. The choice of size and choice of red line or white, and whether to use both seals on the same piece of calligraphy, depends on the size and manner of the work. Similarly, the choice of color of the pigment in the stamp pad (*shuniku*) used, which ranges from red to orange red to brownish red, will depend on whether a modern or antique effect is desired.

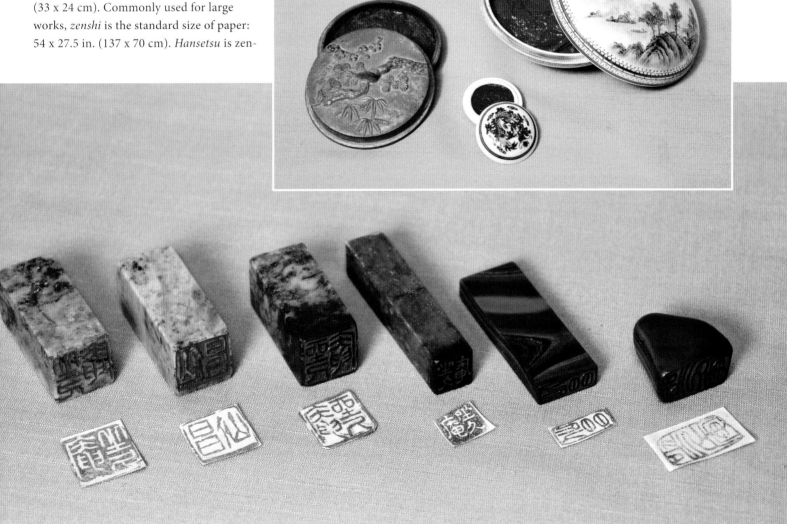

MASTERING THE BRUSH

If you have never used a sumi brush before, there are many books for beginners, available from Asian and general art and craft websites and supply stores. My book *Sumi-e: The Art of Japanese Ink Painting* also contains complete information. To fully appreciate the creation of your own *zengo* works, it is essential to have a strong foundation in the basic brushwork techniques.

Another reason it is important to master the use of the brush is that the characters in shodo can be written only once. There is no question of altering, touching up or adding to them after they have been written, as such touch-ups will be discernible to the viewer. To a trained eye, the difference between skillful and poor use of the brush is immediately obvious. In a good piece of calligraphy, there is a natural balance in both the characters and the composition as a whole. There is a rhythm to the whole work. Straight lines are strong and clear while curved lines are delicate and mobile. There is variation in the thickness and thinness of lines. The amount of ink on the brush, or the lack of it, is also consistent throughout the work, and the characters are of a scale that brings the work alive.

HOLDING THE BRUSH

In our modern world, the most common writing tool is a hard-tipped pen such as the ubiquitous ballpoint pen that makes thin, even lines. As the fingers move horizontally across the paper, the hand scarcely leaves the surface of the paper. There is almost no up or down movement. The brush, in diametric contrast, introduces an artistic dimension that is impossible to achieve with a hard-tipped pen. Not only is the brush flexible because it has been constructed from a combination of animal hairs to meet the needs of the user, but total arm movement is necessary as the

METHOD 1 Hold the handle of the brush lightly yet securely in your hand, with the thumb and middle and ring fingers providing the main support.

METHOD 2 The ring finger placed firmly at the back of the handle will provide more stability.

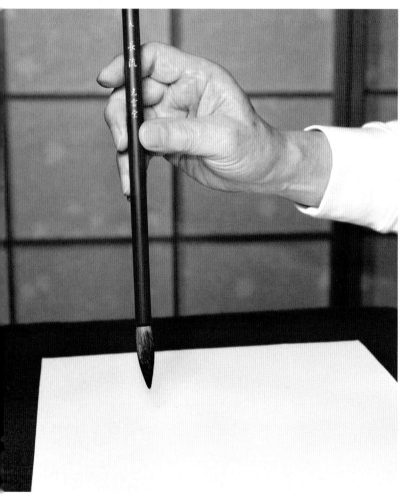

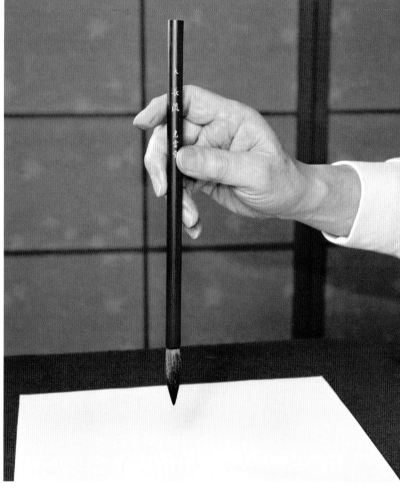

brush goes up and down. With a brush, a variety of lines can be created, from narrow to wide, short to long and certain effects can be obtained, such as when using a dry brush or a very wet one. The kind of *sumi* ink used and the quality of the handmade paper also have a bearing on the variety of lines achieved.

Whether one is a beginner or an experienced shodo practitioner, there is always an element of excitement and pleasure in the visual effect a brush has on handmade paper. In shodo, the results of the brush strokes will reflect the essence or the state of mind of the creator. Within the lines, a multitude of sentiments and attitudes will affect the outcome. Since the brush constantly moves up and down, creative expression in line quality is expanded. This is the foundation of shodo. One must constantly be mindful of the "variations in line" which will be incorporated in one ideogram. Therefore, learning how to move "the brush in hand" is the biggest challenge for the beginner of shodo.

In calligraphy, the brush must be held exactly perpendicular to the paper—which is very different from holding a ballpoint pen! There are a few standard methods of achieving this by varying the positioning of the fingers and thumb. For all the methods shown below, the elbow should be raised to a horizontal position throughout.

BREATHING

In *sho*, while the brush is in motion you should be aware of your breathing: when you inhale, when you exhale. Usually the sequence is to inhale, hold breathing, move the brush and begin gradually exhaling; finish exhaling when one section of the ideogram is completed. In the art of *sho*, spirituality and physical activities have to coincide, therefore breathing control is of utmost importance.

METHOD 3 Here, all the fingers with the exception of the little finger support the handle of the brush.

METHOD 4 Now, even the little finger is used for securely holding the handle.

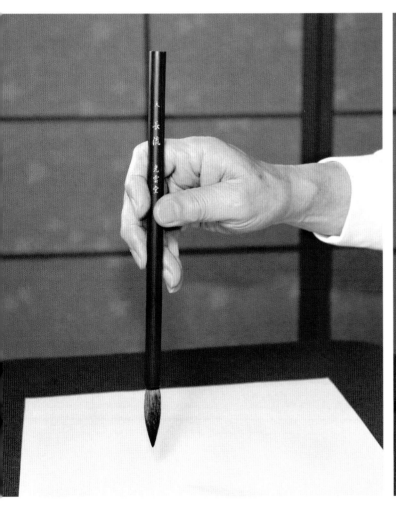

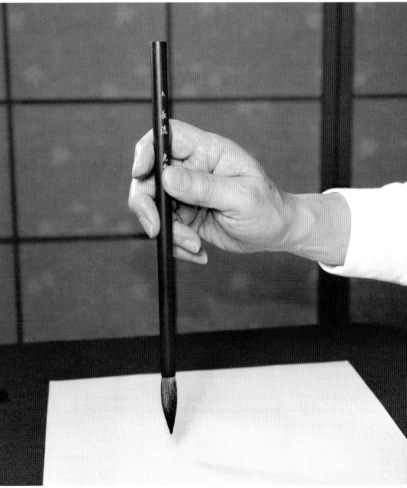

Useful Information for Basic Brush Strokes

There are many different schools that teach shodo, ranging from public and private institutions to various shodo organizations. Each employs its own method of transmitting basic knowledge in the use of a brush. Here is a very brief summary, using kanji examples, of certain basic brush strokes which recur time and time again in writing ideograms

1 The ideogram for **dai 大** uses three different strokes.

2 Wide to wide stroke: Begin the first stroke by giving the brush a little pressure: then as the brush moves to the right and is "in transit," reduce the inner energy slightly. For the completion of the stroke at its far right end, again give pressure; lift the brush, turn your elbow clockwise and move the brush slightly up. This movement will create the formation commonly called a "bone joint" or "knuckle formation."

3 Wide to narrow stroke with a taper: To begin, hold the brush at a 45-degree angle in relation to the paper. Begin this line in a similar manner as the completion of the first stroke: that is, make a "bone joint" form. Then move downward creating a slight curve during the "in transit" portion, and complete the stroke with a taper by lifting the brush but keeping the brush tip in contact with the paper until completion.

4 Narrow to wide stroke: Begin the third line with the tip of the brush at the top, and gradually press down while "in transit." Then at the end of the bottom of the line, press the brush down, then lift the base of the brush as the tip gradually maintains the form. In this stroke, the bottom part of the taper is almost horizontal. Some teachers of *sho* may not stress it, but my experience is that creating this form is difficult for beginners especially, so while the brush is being lifted, turn your elbow slightly clockwise to create more mass at the base for a sense of stability.

5 This is the ideogram for **hi** "sun" or **nichi** "day." 日. This ideogram appears many times in *ichigyo mono*.

6 Horizontal line with upright line down: Begin the top horizontal line from the left; move right, then change the direction, turning 90 degrees (down). In your first tries, you should practice without creating the obvious "bone joint" effect. The "bone joint" effect is representative of the *kaisho* style of writing. (Obtain it by using the movement described in **2** above on how to end the line.)

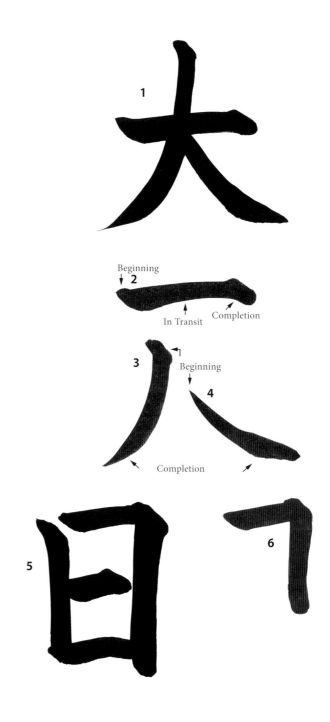

1

Beginning
↓ **2**
In Transit Completion

3 Beginning

4

Completion

5

6

7 This is the ideogram for **yama** 山, which means "mountain." Begin with the tallest center line.

8 Upright line with right horizontal line: Then begin the next line by moving down, then change direction, treating the corner the same way as explained above for stroke **6**, but this time the arm movement reverses for the turn, and the tip of the brush will go counterclockwise.

9 This ideogram, **aoi** 青, means "blue or azure" and is composed of two different ideograms. The top half (A), read independently, is the ideogram **shu** or **omo** which means "principal" or "chief" in *katsujitai*, the orthodox style. The lower half (B) of the ideogram **aoi** is read as **tsuki** ("moon") and **getsu** ("month") 月.

10 The basic version of the upright line: notice its beginning, "in transit" and completion features. This stroke appears in 9(A) above.

11 Upright line with a hook: the brush should stay perpendicular until it almost reaches the bottom. Then the brush veers to the left and is lifted to make the point. Beginners often tilt the brush handle when making curves, but the brush handle should remain perpendicular.

12 Upright line with a left taper is also a part of the character for "moon" as seen in 9(B). Bring the brush down, and at the point of making the hook, turn your elbow slightly toward the body to create this "knuckle" effect. The brush tip remains on the paper until the last.

13 Three horizontal lines together can be read as **mitsu** or **san** 三 meaning "the number 3." When three lines are put together, the common practice and unwritten rule is that the top horizontal line curves slightly up at both ends; the center horizontal line remains horizontal; and the lower line which is the longest goes down at each end with its midpoint rising higher. Each stroke should have a *beginning*, an *"in transit"* section, and an *ending*, as previously practiced.

14 Two horizontal lines of the same length are often used in ideograms, and are not necessarily curved.

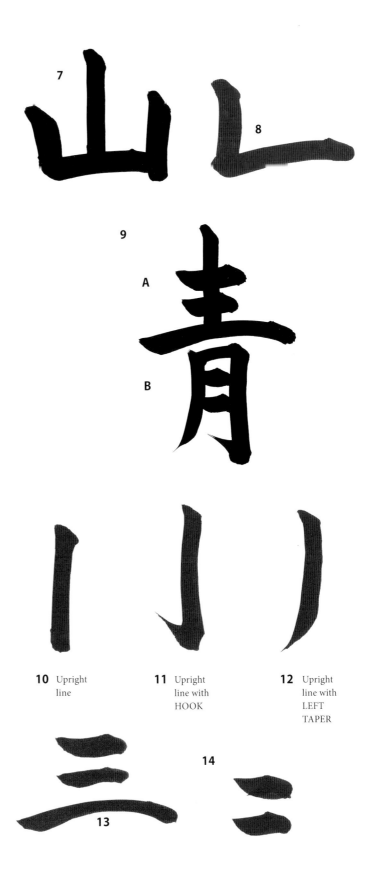

10 Upright line

11 Upright line with HOOK

12 Upright line with LEFT TAPER

13

14

15 This is the ideogram for **nami** or **ha** 波, "wave." (The three dots, when they are a part of an ideogram, indicate a liquid.) The righthand part of the ideogram when read separately means "skin."

16 Three dots: When the three dots appear in an ideogram, the common practice is that the middle dot moves slightly to the left to create a triangular formation. These dots are actually the imprint of the brush itself. For the first dot, simply place the bristles at a 45-degree angle but remember to keep the brush handle upright, then lift up to form the teardrop shape. For the second dot, leave a slight tail as the brush moves up. To form the third dot, press down, then gently lift up while leaving the tip of the brush in contact with the paper.

17 In this **horizontal line with hook,** at the end the line, change direction, then gently lift, keeping the tip in contact with the paper.

18 Wave tapered line: This stroke is similar to stroke **4**, however the difference is in the slight "wave-like" beginning and its 45-degree angle. This narrow-to-wide stroke that ends with a narrow tip is commonly called the wave tapered stroke.

19 This is the ideogram for **te** or **shu** 手, and means "hand."

20 This upright line is difficult because of the curve: make your spine the center to hold steady, and gently twist your whole arm and torso clockwise to make the curve, then make the hook to the left.

21 The ideogram **kami** or **shin** 神 means "god."

22 For this line, as explained above, turn your elbow toward you to create the knuckle. Then come in and down, aiming for the left bottom corner. About two-thirds of the way, begin to lift the brush up to make the stroke's tip.

23 This is an upright line with tapered end. Bring the brush tip toward yourself.

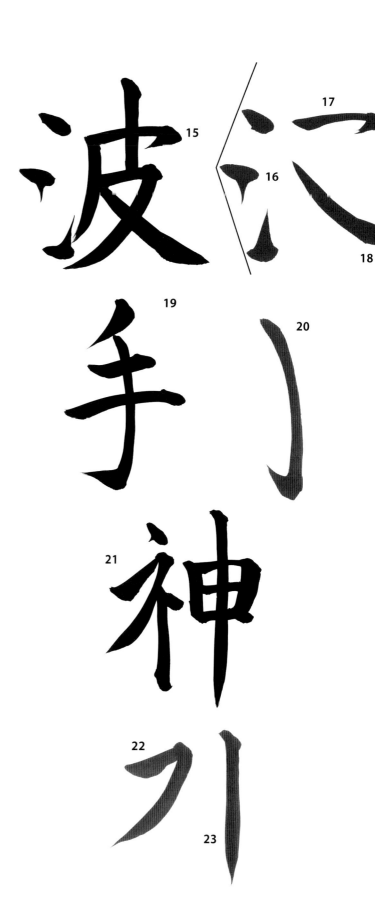

24 The ideogram **mono** or **butsu** 物 means "things."

25 This stroke is similar to stroke 22 but the major difference is that the down stroke is more perpendicular with a curvature and hook.

26 This is the ideogram for **fu** or **kaze** 風 which means "wind."

27 The wide to narrow tapered stroke is similar to strokes 3 and 12. Begin by making a knuckle effect; then come down for the tapered curve.

28 For the second line, after you complete the horizontal portion, change the direction of the brush and come straight down slightly toward the left; raise the brush slowly and turn right; press down again and make the hook with the tip turning slightly to the left.

29 This is the ideogram for **kokoro** or **shin** 心 which means "heart."

30 This is a shallow curve to right with a big hook. Begin with the tip of brush and gradually lower it while the arm is moving to the right for the curvature. At the end of the line, your brush bristles should remain at a 45-degree angle. Press down; then move the brush for the turn and gradually lift the base of the brush to create the point.

31 Different dot styles: Creating dots differs depending upon the calligrapher. In this case this dot is more square.

32 This dot is in the form of a raindrop.

33 When two dots are placed together, commonly they face each other in a circular position.

ONE IDEOGRAM
ZENGO 一字篇

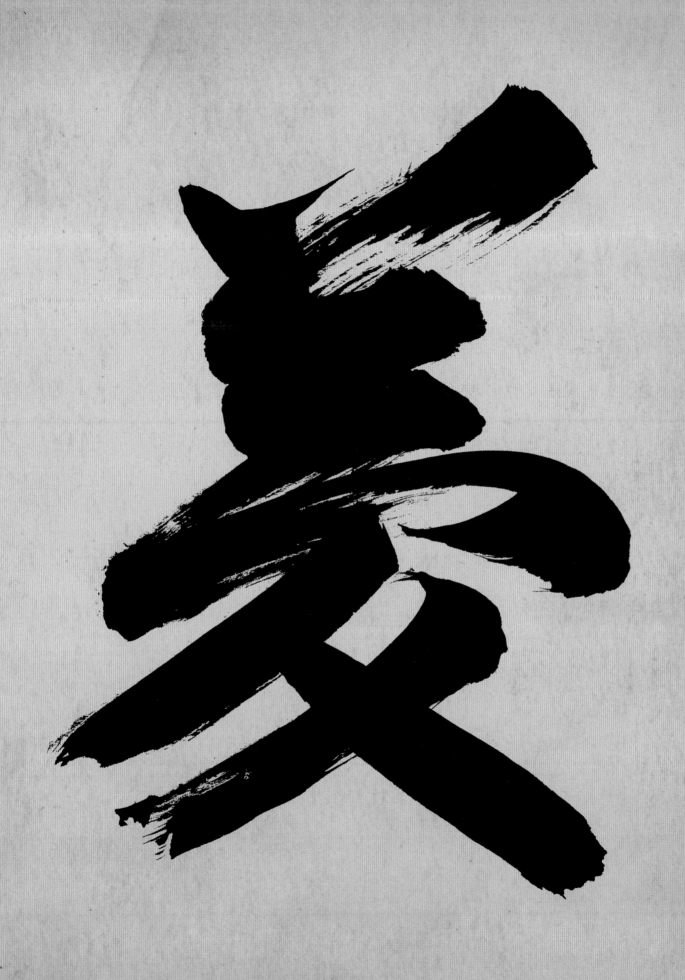

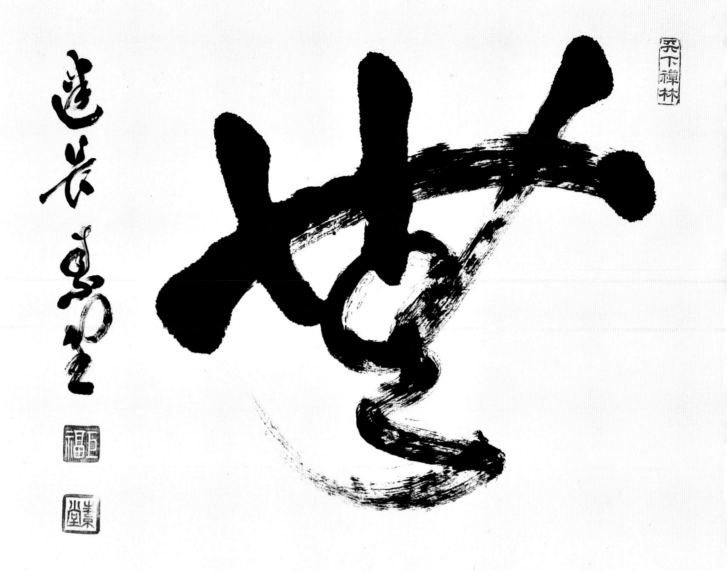

Mu ("Nothingness") by Sodō Minato Roshi of Kenchō-ji, Kita Kamakura

Mu ("Nothingness")

For many masters of Zen and many artists of *zengo* (statements from Zen philosophy), the ideogram *mu* or "nothingness" expresses the most fundamental ideology of Zen. It is the heart of Zen, the crystallization and summation of the teachings of Mahayana Buddhism.

Mu means to transcend dualism, in other words to go beyond having or not having, to go beyond rationalism and logic to a state called "absolute nothingness." This "nothingness" is the same as the Buddhist teaching of "emptiness." The Heart Sutra in Buddhist teaching, *shikisokuzeku, ku sokuzeshiki,* means "form is emptiness, emptiness is form" (色即是空，空即是色). *Mu* is not a denial of existence, but "nothingness" itself is the essence and foundation of existence. All individuals exist with both a destiny and a chance in Buddhist teaching. That worldview or outlook is in itself *mu*. A person who has fully absorbed an understanding of *mu* and practices it is called an enlightened person. Common sense tells us that all the things exist as opposed to "nothingness." But this fleeting existence is transcended by an understanding of the meaning of "nothingness."

An enlightened person has a physical body and a soul, and therefore experiences and acknowledges the common human sentiments. However, in Zen philosophy, the understanding of the idea that both

existence and non-existence must be surpassed is symbolized in the ideogram *mu*. A total understanding or realization of this is called *satori* or enlightenment.

Intellectual exercises do not bring answers in Zen. The more one takes time to analyze, the more confusion comes in the thought processes. In the process of writing the ideogram *mu* in the *kaisho*, *gyosho* and *sosho* styles, a new awareness can be realized. Minato Roshi's "*Mu*" shouts "renunciation" from the bottom of his soul. This ideogram exudes his force of power.

It is in a *sosho* writing style and contains great inner energy, which separates his work from others written with ordinary *sosho* brush movement. Each line, especially the horizontal line and the two upright lines, is as powerful as *kaisho*. The third upright line begins strong but as the ink dried out, the artist came down, made a circle and then the zigzag ending. That movement is clear evidence that the *sosho* style was selected here. If, with a fingertip, you trace the order of the brushstrokes using the diagram of the *sosho* ideogram on page 41, the dynamic qualities of *sosho* can be understood.

Mu ("Nothingness") in Zengo

These are examples of *mu* starting with a *gyosho* style (1) and ending with a *sosho* style (4).

1. This style of writing is similar to the *gyosho* example on page 40. The major difference is that the fourth upright line crosses the horizontal line and connects with the three dots.

2. In this sample, dots are used as substitutes for the upright lines.

3. One horizontal line in the center serves as a substitute for the two horizontal lines. The upright lines are reduced to three lines and the lower dots are now upright.

4. In this example, for compositional purposes the simplified single horizontal line is a better choice. Notice that the top part of the above samples have been eliminated.

Mu ("Nothingness") in the Kaisho Style

The *kaisho* style, as discussed in Chapter 1, is the most precise of the styles used by calligraphers because the lines or strokes that compose an ideogram are written in a prescribed sequence and placed in a prescribed position, an order which must be strictly adhered to.

At first glance it appears as if the straight lines move across evenly. But in the art of calligraphy, one must be aware of the subtle curve and direction each line contains. The completed lines then intimate a tension between the lines, and provide the overall effect of strength in the ideogram. Notice that in the three major horizontal lines and four shorter upright lines here, there is a minute and individual directional angle for each line. This individualized formation also applies to the dots.

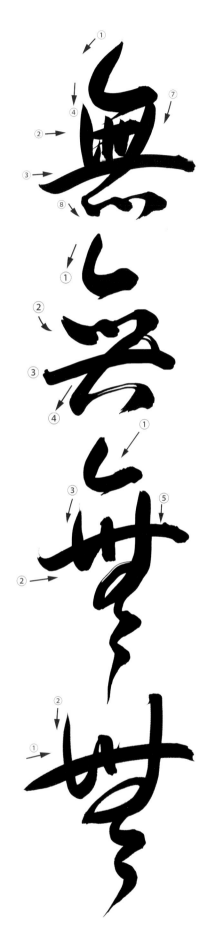

Writing "Nothingness" in Kaisho

Step 1 The brush must be held completely per-pendicular to the paper. As the brush touches the paper, press down slightly, then move the brush down toward the left. As you move the brush down, gradually release the pressure and lift it up to make a point at the end. The tip of the brush must touch the paper until the last moment in order to achieve the correct taper.

Step 2 Begin the topmost horizontal line mid-way along line 1. Keep in mind that when the brush contacts the paper in *kaisho*, you must give it *yang* energy and repeat this at the end. As the brush moves to the right, make the line move up slightly.

Steps 3–4 These lines are the same *kaisho* line as the first horizontal line.

Steps 5–8 The upright lines bisecting the central horizontal line are angled so that the space between them is slightly reduced at the bottom. This gives visual tension to the finished ideo-

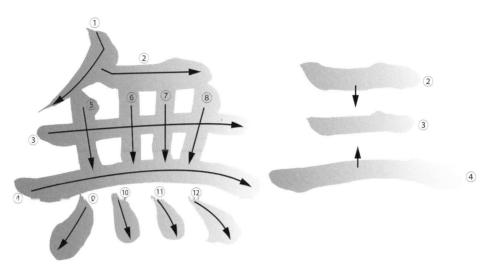

gram. Each of these upright lines must have *yang* strength. These lines should connect with line 4.

Steps 9–12 Most *sho* practitioners leave some space between horizontal line 4 and the dots. The first dot (9) is an important accent. Begin with the tip of the brush and move it left to

form a slight curve.

The three horizontal lines shown alone form the ideogram for number "3." However, lines 2, 3, and 4 are similar. In basic composition in writing ideograms, the top line curves down at midpoint and the bottom should curve up at midpoint to give the form a certain tension.

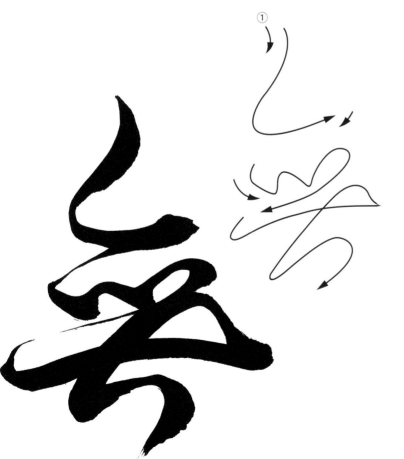

Mu ("Nothingness") in the Gyosho Style

The major difference between *gyosho* and *kaisho* is that in *gyosho*, the beginnings, endings and corner-turnings in the lines are not given the obvious emphasis seen in *kaisho*. The whole purpose behind the origi-nal development of *gyosho* (see page 40) was to make a smooth transi-tion from one stroke to the next. Often the number of strokes have been reduced to make writing smoother and speedier. Yet the forma-tion of the ideogram is very similar to *kaisho*, and therefore *gyosho* ideograms, too, are easy to read. Adjusting the brush strokes to one's own style is acceptable, especially when done for artistic creativity. Zen priests and sho practitioners like to use *gyosho* because it allows for the creation of a personal style. A very important aspect in the *gyosho* style of writing is that one must know the order of the strokes and the form of the ideogram in *kaisho*; otherwise the ideogram cannot be read. Essential to the art of shodo is that one must be able to read it—other-wise, regardless of how beautiful, it becomes abstract art.

In *gyosho*, the important point in brush movement is that the begin-nings and endings of the strokes will show the direction for the next line in movement: where it came from and where it is going. This is a unique feature of the *gyosho* style. We can take as an example the ideogram for "one," which is a single horizontal stroke: you begin the brush movement from the left and move to the right, then at the point of completion, you lift the brush and leave a wisp to indicate where the next line will begin.

Mu ("Nothingness") in the Sosho Style

When a *sho* artist or Zen priest decides on the ideogram to use in a statement, usually he or she will consult a dictionary like the *Go tai ji rui* or the *Shin Shogen* for inspiration (see Appendix, "For Further Reading"). Only after planning the overall compositional effects will the writing begin. For example, this one single ideogram, *mu*, can be written in thirty different styles, testament to the fact that this ideogram has been popular among the literati, Zen priests and *sho* practitioners over the years.

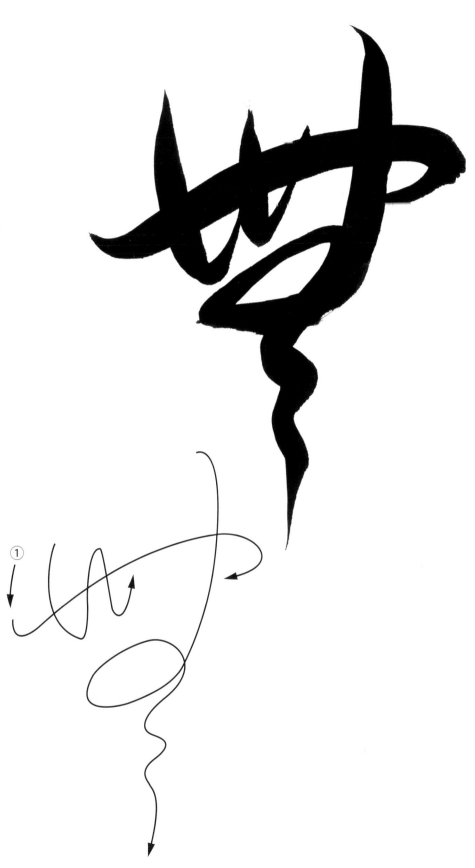

Mu or Yume ("Dream")

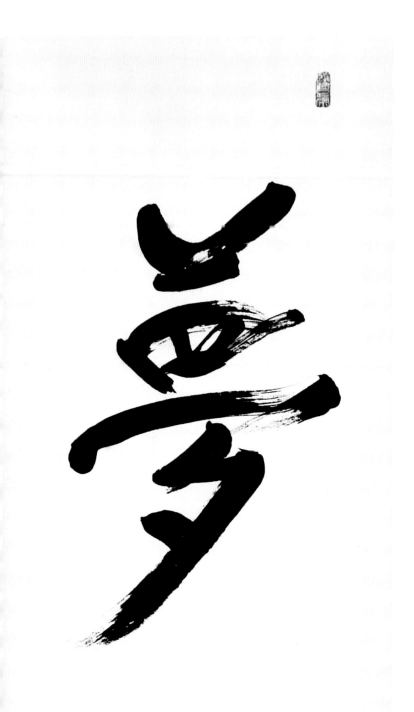

All deep attachments must be released. Scholarship, honors and even enlightenment must be left behind. Life itself is filled with empty dreamlike symbolisms, so at a memorial tea ceremony for instance, this *ichigyo mono* is often on display. Many meanings may be found in the *ichigyo mono* of "dream." When we are young the dream is about the future, that great hope for life to come. When one is asleep, dreams are an experience removed from the reality of life, be it the foretelling of future events or some fantasy removed from daily experiences. It may be a dream within a dream, such as when in your dream you are telling others about that dream. Dogen Zenji noted in his essays titled *Shohoganzo* that a dream within a dream is the true world to which the Buddha pointed. Our life is like a dream, an illusion within a bubble or like a fleeting dream. Life in this world is temporary and provisional. Realistically speaking it is beyond grasping and holding which is called "empty." As in a a dream if the goal is to grasp and hold, this fantasy in greed becomes a nightmare.

The ideogram of "dream" has been written by many a Zen master and often appears in Zen literature. Sōhō Takuan Zenji (1573–1645), a famous Zen monk who lived through several periods of major change in Japan's history, created a large ideogram of "Dream" accompanied by this statement: "Miroku Kannon Bosatsu will appear on this earth 36,000 days and 100 years later to save people who are not able to receive Shakamuni's guidance and will lead people to happiness. Are Miroku and Kannon [Goddess of Compassion or Mercy] a dream? Shakamuni will say "As it is" and one will eventually understand."

Mu or Yume ("Dream") by Sōgen Asahina Roshi of Enkaku-ji, Kita Kamakura

In this *ichigyo mono*, the brush movement is unique in the way that the second section from the top results in the ideogram for "eye": a dry brush stroke extends the outer end of the strokes to form an eye shape. Below this, in the long horizontal line, the same brush movement is used to produce a three-dimensional effect.

In daily conversation, the same word when used in a different context may take on a different meaning. Just as the spoken word can carry multiple meanings, in *shodo* the writing is highly personalized and the visual image carries with it a wide variety of sentiments and thoughts. When an ideogram is written as a crystallization of Zen philosophy or a guide in understanding Buddhist philosophy, the general public may often have difficulty in reading the words because of the uniquely personalized style of writing. Sōgen Daikō Roshi's *sosho* style ideogram of "Dream" is one that may cause initial difficulty. At first glance, one might wonder how the ideogram is to be read. A strong and powerful brush movement is seen from the beginning first dot at the top left; then the brush is moved consistently without loss of energy until the end. The brush movement goes from left to right and right to left, concluding with the line that faces the right bottom. In appearance this ideogram is not a felicitous dream but is more like a *kei saku*, the Zen monk's "single blow with a stick," admonishing: "Cut out the dreams."

Mu or *Yume* ("Dream") by Sōgen Daikō Roshi of Daitoku-ji, Kyoto

Sōgen Daikō Roshi's ideogram of "dream" is an example of a unique *shoso* style of writing. Initially, it is difficult to decide how the ideogram should be read. Starting with a strong and powerful brush movement at the first dot at top left, the calligrapher has moved the brush consistently from left to right and right to left without loss of energy until concluding with the line at the bottom facing right. In appearance, this ideogram is not so much a felicitous dream as a *kei saku*, a Zen monk's "single blow with a stick" admonishing "cut out the dreams."

A comparison of the differences in writing styles between the two *zenji*— Sōgen Asahina Roshi and Sōgen Daikō Roshi—reveals the unique style of Daikō Roshi's writing.

This is one of the most interesting aspects of the study of *bokuseki*. As an art form in *shodo*, the same ideogram can be expressed in as many different ways as the spoken word. But if the order of the brush strokes is changed to one's own style, then others will not be able to read it and the ideogram will no longer be considered the "art of *sho*" but abstract art instead.

Mu or *Yume* ("Dream") in the Kaisho Style

When *kanji* is written purely for artistic purposes, the traditional or classic style of a generation earlier is commonly used (see Chapter 1) rather than the style of simplified contemporary *kanji* used in everyday writing. Compare the simplification (bottom right) with the larger traditional way of writing (right). The top section of the traditional ideogram comprises two horizontal strokes. In the contemporary ideogram, a single long horizontal line (A) is bisected by two upright lines.

Writing "Dream" in Kaisho

Step 1 For the topmost horizontal stroke, move the brush from left to right, applying a little more pressure at the beginning and ending of the line.

Step 2 Make the same type of line for the first upright except change the direction—upright, from top to bottom.

Step 3 Follow Step 1 for this upright line.

Step 4 This line is similar to Step 2 but care must be taken to overlap the vertical where the lines join.

Step 5 Follow Steps 2 and 4 for this upright line.

Step 6 Start at the top of the Step 5 upright line and move to the right applying additional pressure. Before coming down at an angle, apply more pressure at the corner to make the "knuckle-like" form. This is a brush movement unique to *kaisho*.

Steps 7–9 These three lines should be narrower than the previous lines.

Step 10 This short upright line is in the shape of a teardrop. Using the tip of the brush, make contact with the paper then press down almost as if printing in the shape of the bristles.

Step 11 This long horizontal line with a sharp hook at the end should be thinner. To make the hook shape successfully, apply pressure at the end of the horizontal line then lift up the brush with the tip remaining in contact with the paper. This provides balance to the left and right sides of the line.

Step 12 This is similar to the hook line but is slightly longer and tapers to the left.

Step 13 Make a short horizontal line then move down to the left and end with a taper.

Step 14 Moving the brush from left to right, make the short line that completes this part of the ideogram, which means "evening."

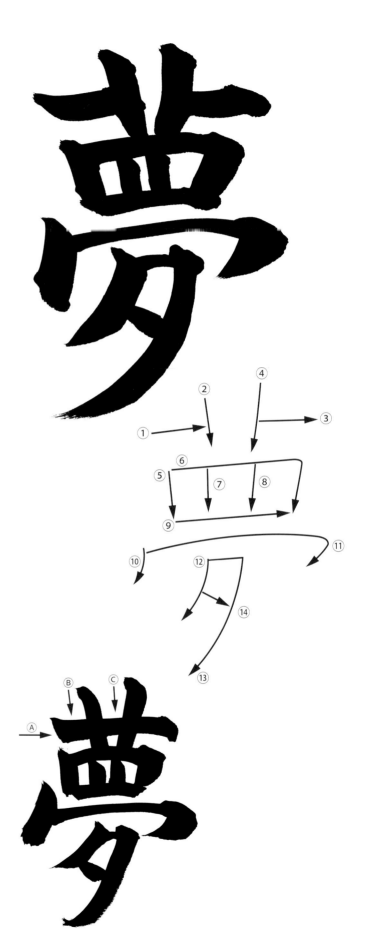

Mu or *Yume* ("Dream") in the Gyosho Style

As noted elsewhere, the essence of the *gyosho* style is that the beginning and ending of a brush stroke must show the directional movement of the next stroke. Another example of "dream" in the *gyosho* style is on page 20 in Chapter 1.

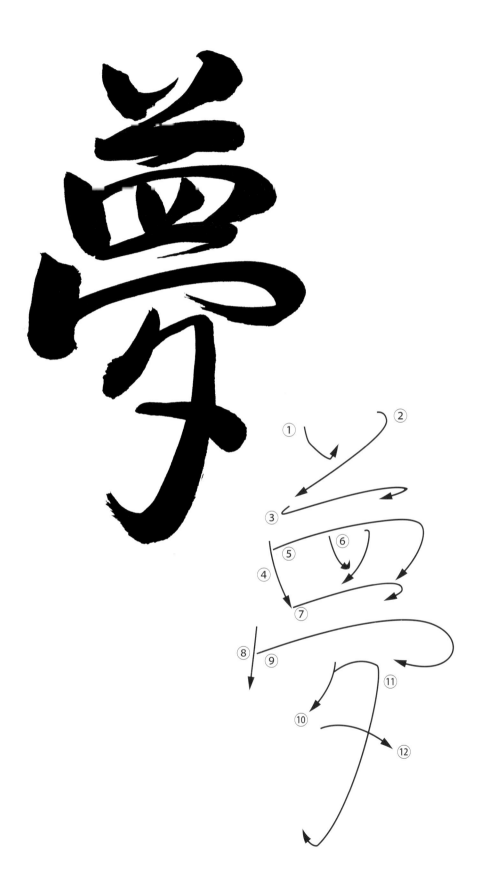

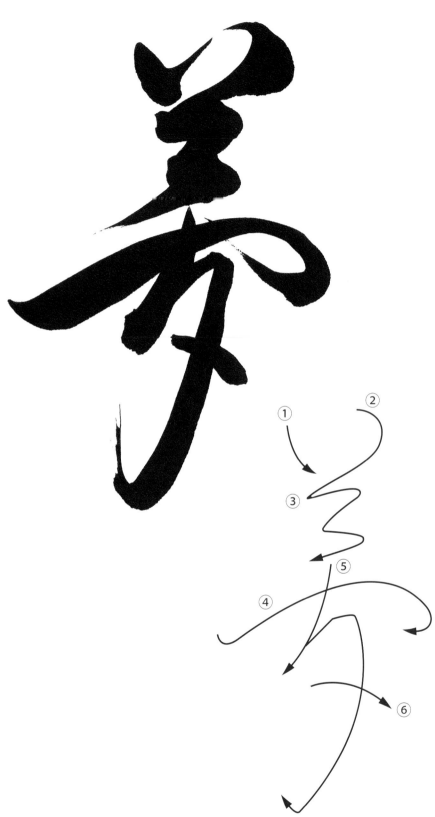

Mu or *Yume* ("Dream") in the Sosho Style

If a comparison is made between "dream" in the *gyosho* style on page 45 and the *sosho* style here, it is apparent that lines 4–7 in *gyosho* create the horizontal ideogram for "eye" while in *sosho* the steps have been simplified to form one horizontal line. Moreover, line 8 in *gyosho* has been eliminated in *sosho* and instead is hinted at by the entry of line 4 as it becomes slightly stronger. This creates a balance between left and right. The basic concept in the *sosho* style of writing is that Steps 1–12 in *gyosho* must be become firmly imprinted on the mind to allow for the continuous movement from Steps 1–6 in *sosho*. From point to point, pressure must be applied to give shape to the ideogram. When a softer brush is used for writing in the *sosho* style, smoother transitions can be achieved in the lines. Another example of "dream" written in the *sosho* style can be seen on page 21 in Chapter 1.

Hanatsu ("Release")

Consideration or thought with prudence, discretion, judgment and deep attachment are among the traits of an enlightened person. *Hanatsu* means to be released from these traits and, as such, is synonymous with the idea of "nothingness." The concept is exemplified below in the work of the late Eishi Sakuta, a renowned Japanese calligrapher whose work covered a wide range of styles, from classic to contemporary, including *hiragana* (see page 16). The late president of the Naniwa Shodo Association, Eishi Sakuta was active in introducing the art of *shodo* to students from both the United States and Canada.

Hanatsu ("Release") by Eishi Sakuta of Naniwa Shodo Kai

In this work, Eishi Sakuta demonstrates a complete understanding of the meaning of the word *hanatsu*. The creative energy and flow displayed in his brush movements indicate that he was in a state of *mushin*, literally "the mind without mind" or "no-mindedness," when writing the ideogram. In Zen Buddhism, this is a mental state analogous to that entered by Zen monks when deeply involved in creating *bokuseki* writings. In composition, the ideogram is not placed in the center but is moved up, thereby creating active empty space. The beauty of the work also lies in the quality of the lines and the empty spaces as well as in the contrast between the *nijimi* (bleeding/blurring) and dry brush effects. The artist's unconventional placement of his red seal is the ultimate creative "stroke" in this calligraphic work.

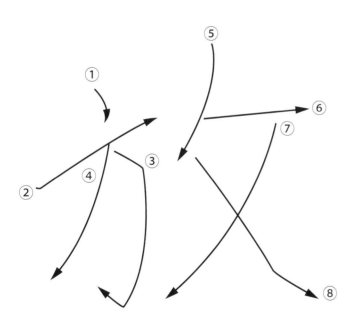

Hanatsu ("Release") in the Kaisho Style

Although the lines and dots in the block-like *kaisho* script are placed in a specified order, an individual's character and personality invariably influences the rendition of the final result. This is, in fact, what the art of *shodo* is all about. Unlike printing with blocks, which is a purely mechanical process and therefore devoid of personality, in *shodo* a person must constantly strive to improve, adjust and also evaluate each line, its placement and the effect of the surrounding empty space. This requires continual and constant practice and evaluation.

Writing "Release" in Kaisho

The ideogram *hanatsu* is an example of how one can make adjustments to the presentation of lines. For example, the line in Step 2 is commonly horizontal but here it has been slanted to contrast with the more horizontal line in Step 6.

Step 1 Starting at top left, use the tip of the brush to create a dot.

Step 2 Moving from left to right, apply a little more pressure at the beginning and end of the slanted line.

Step 3 Beginning just below the center of line 2 and in alignment with the dot in Step 1, move the brush down to the right, then curve down vertically, ending with a hook.

Step 4 The beginning of line 4 also begins directly under the dot in Step 1. Move the brush down to lower left. The left side of this ideogram (Steps 1–4) can be read independently as "direction."

Step 5 Begin this line slightly higher than the dot in Step 1. As with line 4, move the brush gently downward, veering to the left, and finish the stroke with a tapered effect.

Step 6 This horizontal line moves from left to right. Apply pressure at the end.

Step 7 This line is similar to lines 4 and 5 but is longer. To successfully create the tapered end, lift the brush until only the tip remains on the paper.

Step 8 It is very important to know where to begin line 8 because many lines come together at this juncture. Begin with a thin line using the tip of the brush before moving down to the right. Increase pressure to make a wider stroke. End the line with the base of the bristles on the paper then keep the tip in contact with the paper to create the taper. The right-hand side of the ideogram, when written independently, means "ranch" or "open land."

Hanatsu ("Release") in the Gyosho Style

As mentioned earlier, the *gyosho* style of writing emphasizes economy of brush movement. At the same time, the formation of the ideogram should be legible to anyone who can read the same ideogram in *kaisho*.

Writing "Release" in Gyosho

It is useful to compare the *kaisho* ideogram before writing its *gyosho* counterpart.

Step 1 In comparison with the dot in *kaisho*, the dot in *gyosho* should impart a sense of agility or flexibility achieved by the movement of the brush ending with a directional trace or thin line.

Step 2 Following the previous thin directional line, the brush tip should touch the paper and then move to the right with strength. It is important not to show an accented "knuckle" ending as in *kaisho*.

Step 3 Starting midway along line 2 but in alignment with the dot in line 1, move the

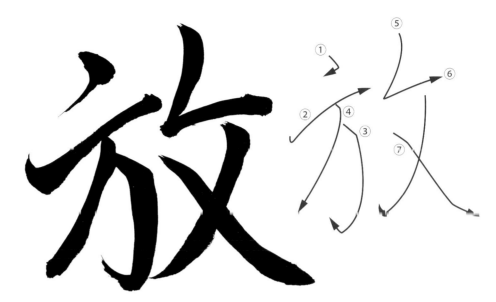

brush down to form first a squared and then a curved line, ending with a hook. Take care not to use your fingers to turn the brush.

Step 4 Start line 4 directly above line 3. Touch the brush to the paper then move down at a gentle angle to bottom left. This is a slightly shorter line than line 3.

Step 5 Continue the arm movement of line 4 in a clockwise motion to the beginning of line 5.

Begin line 5 by moving down toward the left, stop then move to the right to make a V shape. Note that the stroke does not extend down to stroke 3 as in *kaisho*.

Step 6 Move the brush down to bottom left creating a slight curve.

Step 7 Finish this line, which crosses line 6, with a tapered "wave brush stroke" effect. Apply slight pressure at the end.

Hanatsu ("Release") in the Sosho Style

As noted earlier, the artistic and highly abstract nature of the cursive *sosho* writing style is the result of a minimal number of fluid brush movements, making the style ideal for individual expression in calligraphy.

Writing "Release" in Sosho

Step 1 Begin with the tip of the brush at the top left of the paper, then press down and move to the right. At the end of the curve, do not turn the brush with your fingers but lift it so that the tip is still in contact with the paper, then move it up. Bring the brush down, overlapping line 1 at mid-point, then make a semicircular line, applying a bit more pressure to the brush to create a gentle curve, then move the arm clockwise to make the hook.

Step 2 Line 2 is a brush movement similar to a tick or the sign for "check." The important line is the bold one that moves downward, while the secondary line is the thin one that moves upward over the curved line, leading to the next step. It is an "energetic" lead for changing direction.

Step 3 As the line is completed, the ending should show a possible lead to the next ideogram. Again, remember this key point: The movement of *sosho* is similar to dancing a waltz.

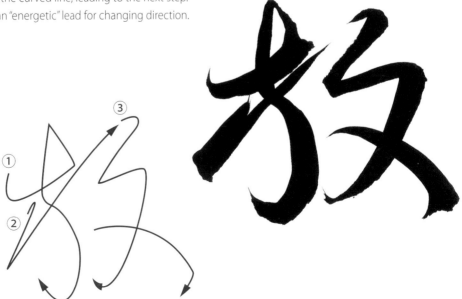

TWO IDEOGRAM ZENGO 二字篇

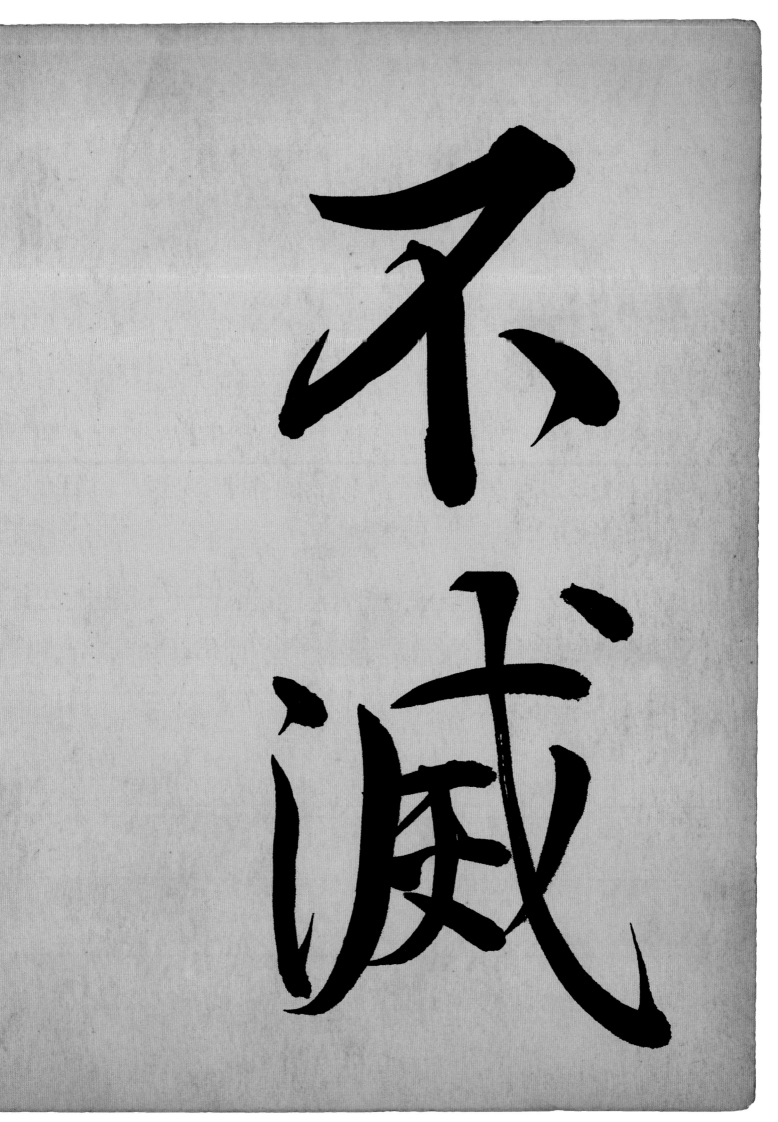

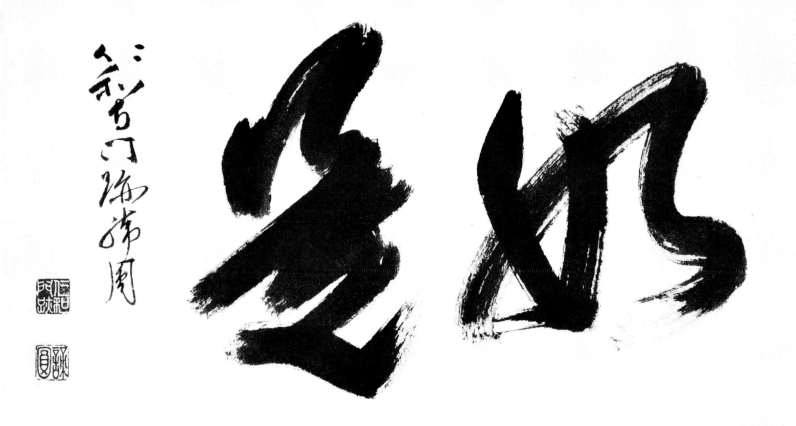

Nyoze ("As It Is") by the 41st Monzeki of Ninna-Ji, His Grace Taien Mori, Kyoto

Nyoze ("As It Is")

The two ideograms here express a very important and fundamental aspect of Zen philosophy—the idea of *nyo* ("like") and *ze* ("this") to evoke the association *nyoze* ("like this," "thus-ness" or "as it is"). There is a common American expression, "Well, that's what it is." Despite the various contexts in which this phrase is used, the meaning is always the same. Accept and agree with the situation as it is; no more, no less.

When Zen monks completed their training and received their formal document called *in ka sho mei*, the phrase *nyoze* was included. In life, one expends energy, spirit, knowledge and capability to create something, and yet despite supreme effort, the results or achievement may be disappointing. What the mind sees and the reality of the result might be very different. One must learn to accept or reconcile reality "as it is." Unexpected results can be good or bad but one must learn to accept the limits. Learning to accept in obedience and with grace requires training. This is the essence of *nyoze*.

From birth, influences surround each one of us to shape one's personality: parents, siblings, teachers and other influential people. During the process of growth, one's facial and body features, mannerisms, tastes and so on keep changing with one's age and environment. However, according to Zen teaching, when a person passes the age of 40, those aspects are no longer from other influences. One's own daily activities will create character subconsciously. This embodiment is the honest representation of self. *Nyoze* is an important *zengo* which constantly reminds us to reevaluate "self."

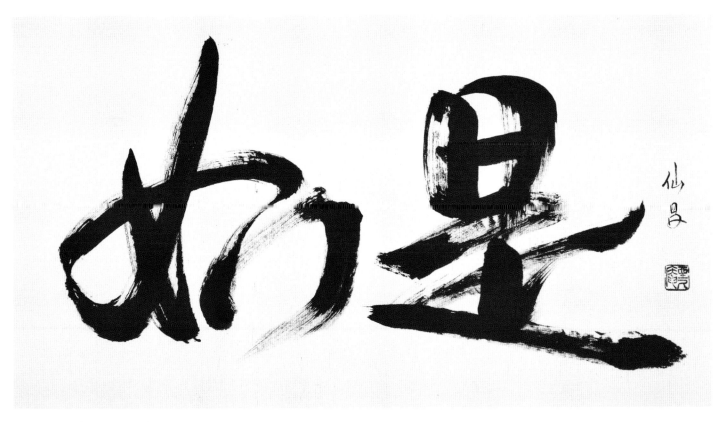

Nyoze ("As It Is") by Zakyu-An Senshō

Although short phrases of two or three ideograms in Chinese literature were originally written from the top down starting at the far right, with adjacent lines written top down to the left of the first and subsequent rows, in recent years Chinese literature is often written in a horizontal style, from left to right, as writing is done in the West. Writing Chinese ideograms horizontally, from left to right, is in fact not new. Often horizontal writing is found on traditional temple gates or buildings within temple complexes, on large plaques which are placed directly above entrances or doorways. Short phrases of two or three ideograms, such as *Nyoze*, would be written right to left in the traditional manner. But the above is written left to right, in contemporary style.

When these ideograms are written on paper or silk and eventually made into scrolls, the signature and title of the *sho* artist is written in a selected spot; underneath that there will be a square red seal with white lines, commonly used for the surname or title. Underneath that seal may be another, this one with red lines. Then, on the opposite side at the top, another small seal will be placed. It is called the *kanbo* seal. It indicates that from the *kanbo* to the surname, the space created by the writer is protected, and no one has the right to touch or alter it. *Kanbo*, therefore, serves as an "inspection gate" to protect the painting. However, in contemporary shodo, as in the example here, often titles and *kanbo* are skipped or eliminated.

A shodo artist may often use a pen name or an artistic title for a signature, and in that case a seal is used. In my case, *Zakyu-An Senshō* is the highest title that I could receive as a tea teacher (similar to a Ph.D. in tea). *Za*=sit; *kyu*=eternal; *An*=hut. *Sen*=Lineage of Certificated Teachers; *shō* is from my name, Shozo.

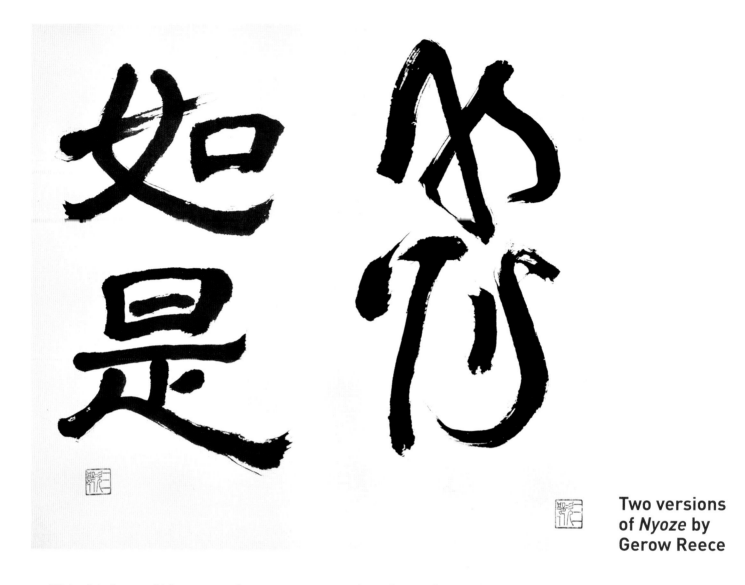

Two versions of *Nyoze* by Gerow Reece

This third set of ideograms for *nyoze*, arranged in the traditional vertical style, is the work of an American, Gerow Reece, who lives in Northern California and is a practitioner of the tea ceremony. He spends time in Japan continuing his studies in *sho* whenever he has an opportunity. As an American, it follows that he would experiment with methods and even use some letters from the English alphabet.

The ideograms on the left are *nyoze* in the *reisho* style, a precursor of *kaisho*. While it is not commonly used for writing *zengo,* his work is easy to read and is clear and beautiful. At first glance the ideograms on the right appear to be Chinese, but upon more careful examination one can read the top "ideogram," "AS," and the lower, "IT IS." Reece has effectively used his brush to create a new direction in writing *zengo* which, I hope, will inspire others in their creativity. He brings a fresh sense to American shodo. His poetry reflects the relationship of shodo and Zen:

> *In its reception of the fullness of what we so simply call now*
> *Zen practice deepens and seasons one's calligraphy.*
> *In its rigor and intimacy through frequent practice,*
> *Calligraphy inspires and invigorates Zen practice.*

Nyo in the Kaisho Style

Each ideogram will be taught separately here. The first ideogram is *nyo* which can also be read as *gotoshi* ("as they are") or *shitagau* ("will follow"). It is a combination of two separate ideograms: on the left side (Steps 1–3) is the ideogram for "woman" and on the right (Steps 4–6) is "mouth."

Writing *Nyo* in Kaisho

Step 1 Begin the stroke with pressure and then move downward to the left. At the point for turning, lift the brush but keep its tip on the paper, change direction, and move to the right bottom, gradually adding pressure to make the line wider at the bottom.

Step 2 This line is similar to line 1. Begin at a point that is about one-third of the way down the upper part of line 1. Aim for the left bottom, creating a gentle curved line. Lift up the brush to create a tapered effect.

Step 3 Move from the left to create an almost straight horizontal line. For artistic purposes, in the process of moving to the right, lift the brush up slightly so the center part becomes thinner. This concludes the ideogram for "woman."

Step 4 Directly underneath line 3, draw a straight line downward.

Step 5 Line 5 moves across and down. Do not turn the brush at the corner but lift the brush to create the "knuckle," then move down.

Step 6 Since this is the concluding line, give the end of the line pressure.

The ideogram for "woman," when written independently, is much flatter and the horizontal line longer. Lines for each ideogram, when they're combined to form new words., must be adjusted to meet the needs of the whole.

Nyo in the Gyosho Style

The lines of *gyosho* style flow more easily than for the exacting block-like *kaisho*. The movements of arm and brush are circular.

Writing *Nyo* in Gyosho

Step 1 Begin the line with more pressure, then gradually lift the brush and make a gently curving line as the brush moves down. Just before the brush moves up for the hook, give the brush more pressure; then as the hook forms it also gives direction to the next line.

Step 2 Begin with a narrow, then wider, line and end with a narrow line with a tapering end, which leads to the next step.

Step 3 This horizontal line moves from left to right and will cross both line 1 and line 2. Then, taper and change direction for creating the line 4.

Step 4 This line will stop at the bottom.

Step 5 After the step 4 line, almost as if the brush bounces up, begin line 5 with the brush tip, moving from left to right and curve down, ending with a narrow line without stopping from changing directions, but be aware of the corner.

Step 6 At the end of line 5, lift the brush and move it left to right for line 6. Since this is the *gyosho* style, do not make a big knuckle.

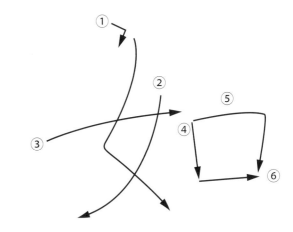

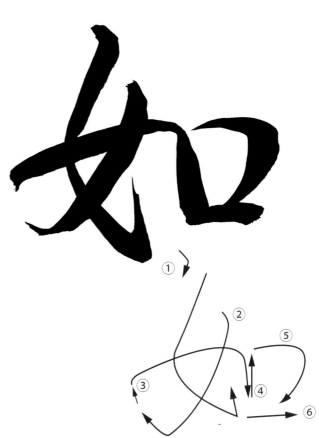

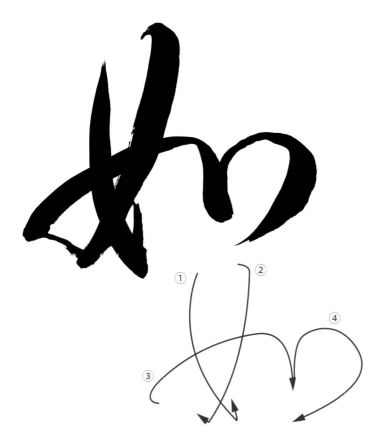

Nyo in the Sosho Style

Writing in *sosho* style is like the fluid movements in the steps of a waltz, and follows a continuous circular movement as the brush goes up and down. The important element in *sosho* is that each stroke connects to the next one while in motion.

Writing *Nyo* in Sosho

Step 1 As the brush comes down and touches the paper, the line gets wider. Do not use wrist movement. Then stop and create the tapered hook by lifting up the brush. The energy of the movement should carry on to the next step.

Step 2 The moment the brush tip touches the paper, immediately move the brush to make a wide stroke, crossing line l, and then as if in a bounce move to the next step.

Step 3 The moment the brush touches the paper, make a wider line with a gentle curve, and after you cross lines 1 and 2 make the stroke thinner as it curves down, and apply pressure.

Step 4 Begin with a lighter line to make the last circular form, ending with a taper. This changing of the square formation for the "mouth" ideogram into a circular form in two strokes is quite common in *sosho* writing, and is typical in the simplified way of writing "mouth."

Ze in the Kaisho Style

The ideogram *ze* ("is"), also read as *kore* ("this"), generally serves as a conjunction so it is rarely used independently. Since it is usually the connecting link, the style in which to write it depends upon the other ideograms in the statement.

Writing *Ze* in Kaisho

Step 1 Start the ideogram by holding the brush perpendicular to the paper, then move it down.

Step 2 Beginning at the top of line 1, move to the right; then, as if you are going to lift the brush, change direction 90 degrees and move the brush down. The fingertips should not be used to turn the brush to create this knuckle. That is a common beginner's mistake that you should avoid.

Step 3 Begin horizontal line 3 from left to right at the midpoint of line 1.

Step 4 This is the final line for the ideogram "sun." Because this line begins with overlapping line 1, the ending of the line does not have a knuckle effect.

Step 5 The beginning and ending of this horizontal line should have a *kaisho* effect. Here is how to ensure that. *Ze* is composed of two parts. The top part is the character for "sun," which contains its own energy. In the lower part, the energy is scattered. To hold the two parts' natures together, line 5 should be rendered most strongly in the ideogram. Key to the success in forming this ideogram is that the beginning of the line should be longer on the left, and the final stroke (line 9) will have the form to provide balance.

Step 6 Line 6 should begin at the center of the ideogram "sun." Overlap with line 5 and move down.

Step 7 Begin from the right, as if making a dot, and move the brush to the left. Then gently lift the brush up to create the tapered effect.

Step 8 Continue the flow of the motion for step 7, to begin the brush movement for line 8. Your arm should move to the lower corner, then gradually lift the brush up to create the taper. Then move your arm clockwise for step 9.

Step 9 Begin with the tip of the brush to move to the right bottom; press down to make the line wider. Gradually lift the brush but keep its tip on the paper to create the wave taper.

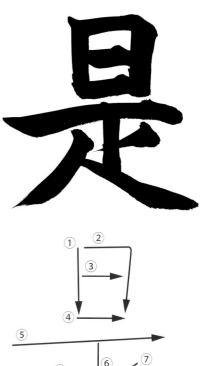

Ze in the Gyosho Style

As stated previously, the order of the strokes in *gyosho* is the same as for *kaisho*. The difference between the two styles lies in how to begin the brushstrokes, how to complete each stroke and how to move on to the next stroke.

Writing *Ze* in Gyosho

Step 1 Less emphasis is placed on the beginning and ending of this line.

Step 2 The horizontal line goes across, then curves downward. While the example shows a slight knuckle effect, many calligraphers may choose not create this but will simply change direction and move downward.

Step 3 The ending of line 3 shows direction to the next step.

Step 4 Line 4 casually slants upward and again the ending leaves a trace of a line that leads to the next step.

Step 5 This line, which is slanted, is another characteristic example of the *kaisho* style. (In a course taught on *kaisho*, the range in individual choices is usually termed "casual" or "relaxed" *kaisho*, which then leads to *gyosho* writing.)

Steps 6, 7, 8 Notice how the strokes each lead to the next line. They may be connected with a fine line.

Step 9 Notice the overlap at the beginning of line 9, and note the ending: apply pressure but do not make a wave taper as in *kaisho*.

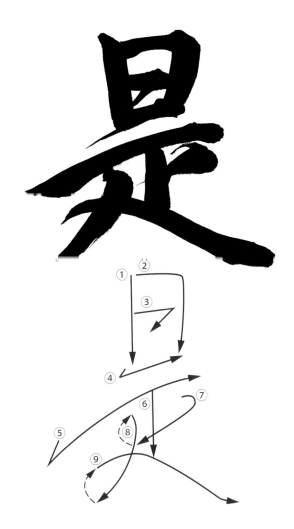

Ze in the Sosho Style

Since this ideogram is rarely written independently, the writing style depends upon the style of the other ideograms in the phrase. (This is why you'll find so many examples of *ze* in the "dictionary" of shodo titled *Shin Shogen*.) When writing in the *sosho* style, once you begin you should complete the entire ideogram with one breath. The brush movement continues from beginning to end. At the end of this example, there is a big hook facing up. However, there will be times when it is necessary for the tip to go down, due to the ideogram following. This can be seen in the five ideogram *zengo* in Chapter 7, for example, *Bu Ji Kore Ki Nin* and *Jiki Shin Kore Dōjō*.

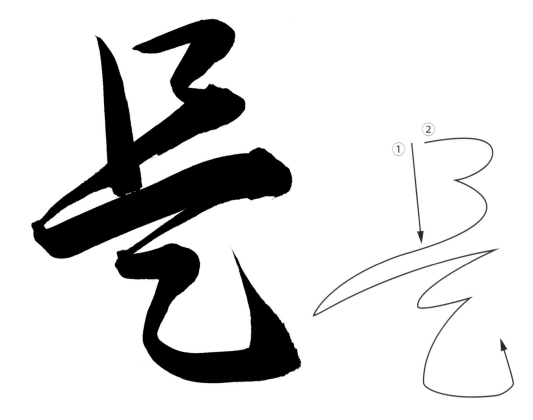

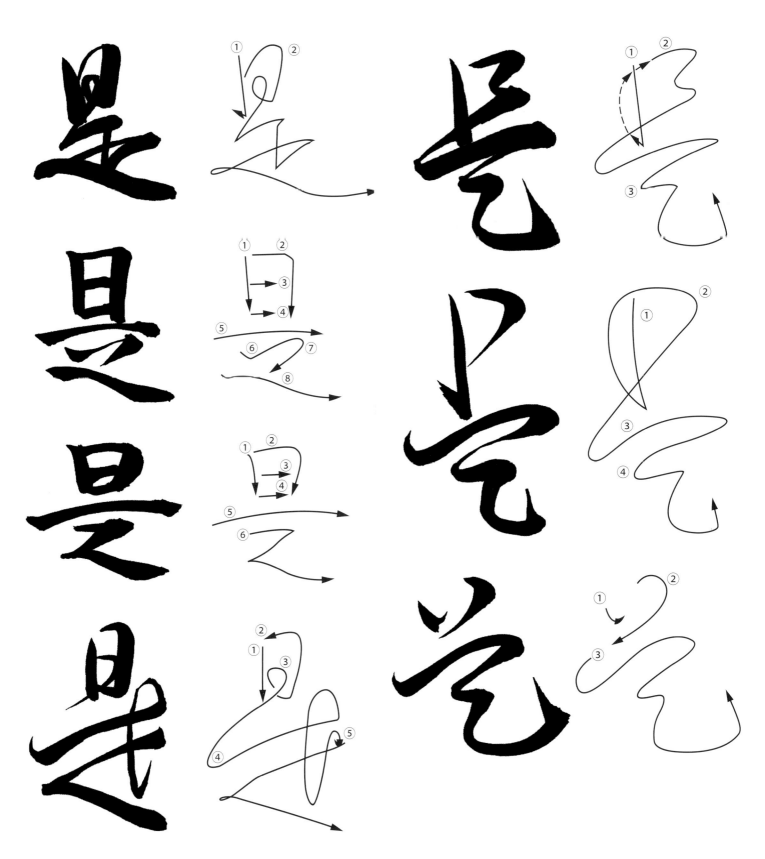

Variations on *Ze*

This ideogram is often found in *zengo* and there are many variations in how it is writ-
ten. In the examples here, notice the change in brush movement from the *gyosho*
style of the left column's examples to the *sosho* style of the right column.

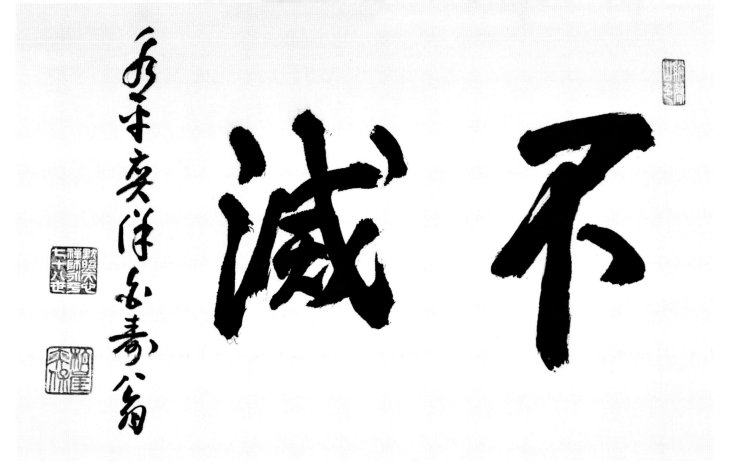

Fu Metsu ("Immortal" or "Indestructible") by Ekiho Sengai Roshi of Eihei-ji, Fukui-ken

Fu Metsu ("Immortal" or "Indestructible")

From time immemorial, humankind has undoubtedly been obsessed with immortality, the desire to live forever. These aspirations have led to explorations such as the search for the Fountain of Youth, to the building of great monuments for the afterlife or of places of worship to ensure the soul's immortality. Centuries ago in the Far East, Shakamuni Buddha, upon obtaining *satori* or enlightenment, taught that when life is given, death or extinction will follow, in other words, life invariably is followed by death. Likewise, all material creations will inevitably turn to dust. The challenge for each individual is how to make this life worthwhile, to find that essential element that will allow peace and tranquility within a limited time frame before the final moment. What is that "essential element" in an individual that will allow peace and tranquility in that last moment of life?

Beyond the material objects that can be touched and felt is the unseen world of thoughts and feelings which have given rise to such phenomena as philosophy, religions and ideas. The world of thought may have seemed to change over the centuries, however, the idea that there is something permanent continues. *Fu metsu* is the answer in the world of Zen.

During his long reign as the 78th head priest or abbot of Eihei-ji, one of the two main temples of the Soto sect of Zen Buddhism in Japan, Ekiho Sengai Roshi fostered the training of many Zen monks. He was also a great supporter of introducing Soto Zen Buddhism to the West. At the age of 103, he completed his mission in this world and entered eternal tranquility. This *bokuseki* was written during his 97th year. To the viewer who understands, the "power of *fu metsu*, spiritual immortality" is imparted here. The basic concept in Zen philosophy is *fu metsu* (*fu*=not been born; *metsu*=immortal)—"that which is not born, does not die" and therefore is immortal.

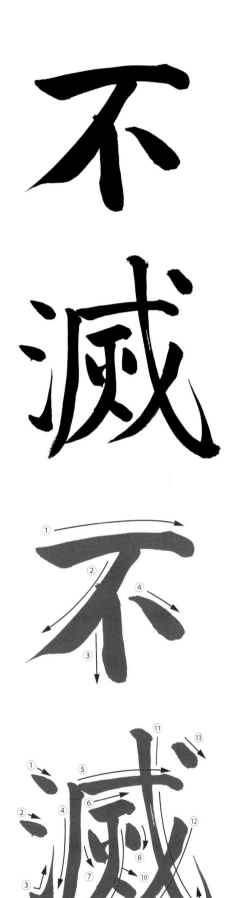

Fu Metsu ("Immortal" or "Indestructible") in the Kaisho Style

The ideogram for *fu* ("no" or "not") can be used in combination with many other ideograms. When combined with *metsu*, it carries the meaning "not been born." Regardless of its context, the ideogram is composed only of four strokes, whereas the ideogram for *metsu* ("immortal") is composed of thirteen strokes. For the sake of balance, the four strokes in *fu* are always wide and the thirteen strokes in *metsu* are narrow and thin. When an ideogram requires many strokes, there is a danger of it becoming bigger than it should be. Many hours of practice are needed to compose pairs or groups of ideograms in the correct proportion to each other.

Writing *Fu* in Kaisho

Step 1 Holding the brush perpendicular to the paper, use the tip to start the stroke from the left. Change to the base of the bristles as you move to the right in a slight curve. At the same time, lift your arm slightly so that the line becomes slightly thinner. Finish with *kihaku* (energy).

Step 2 Start line 2 at the center of horizontal line 1. Move down to the bottom left, changing the thickness as you go and ending in a tapered effect.

Step 3 Place the brush near the center of diagonal line 2 and come down straight; again, finish with *kihaku*.

Step 4 Create a teardrop-shaped dot, making sure to leave "active" empty space around it.

Writing *Metsu* in Kaisho

In this ideogram, the left-hand side is commonly called *sansui* ("water").

Steps 1–2 Hold the brush upright. Touch the tip lightly to the paper at an angle, then lift it up to make a teardrop shape. Make sure each of the dots is flat and is aligned vertically with the other.

Step 3 Follow the technique for steps 1 and 2, but while lifting the brush drag the tip upward to create a thin taper.

Step 4 This is the beginning of the left-hand side of this ideogram. Start the stroke just to the right of the first dot at the top and move the brush downward, making a slight curve at the bottom and ending with a taper.

Step 5 Maintaining the movement at the end of Step 4, bring your arm up in preparation for horizontal line 5. Start this at the top of line 4 and move right, making a slightly curved line.

Step 6 Make a short horizontal line from left to right below line 5.

Steps 7 and 8 Underneath line 6 on both left and right sides create a slightly more upright teardrop dot. These two dots form a pair and should curve slightly toward each other.

Step 9 As if writing the alphabet letter T, start line 9 in the center of horizontal line 5 and move the brush down. At the midway point, curve the line to the left. The tip at the end should not overlap with line 4 but just touch it.

Step 10 Slightly more than halfway along line 9, make a dot at a 45-degree angle. Excluding step 6, this ideogram has the meaning "fire" or "flame." Thus fire and water are incorporated in *metsu* ("immortal").

Step 11 This dynamic line should exhibit strength. Start the stroke above line 5, about two-thirds of the way along. With full strength, move downward in a curve toward the bottom right corner ending on a level with line 4. Make a big "fish hook."

Step 12 The arm movement should continue for line 12, which crosses line 11 and ends with a taper. The taper should parallel that of line 9 and end on the same level.

Step 13 Using the energy generated by line 12, move your arm up to make the short line 13 at an angle.

Fu Metsu ("Immortal" or "Indestructible") in the Gyosho Style

For visual effect, both ends of line 1 curve upward compared with the previous *kaisho* example where they curve downward. Lines 6 and 7, which were upright dots in *kaisho*, have also become one horizontal continuous line here, almost as if they are connected.

As previously mentioned, *gyosho* requires a sense of movement with the brush. Once the first line has been created, there should be continuous movement with the brush in a clockwise motion.

Writing *Fu* in Gyosho

Step 1 Hold the brush upright. The moment the tip of the brush contacts the paper, begin moving to the right with a slightly upward curve. Stop momentarily then change direction, moving back toward the bottom left. Stop again momentarily and lift the brush to create an upward taper.

Step 2 Starting with the tip of the brush, change the direction of your arm motion to make the brush go straight down, first in a narrow line then wider. Lift the brush at the end, moving your arm in a clockwise direction to the start of the dot in line 3.

Step 3 To create the dot, use the tip of the brush, lifting it up to make the point leading to the next ideogram.

Writing *Metsu* in Gyosho

Step 1 As usual, leave a point and move to Step 2.

Step 2 Start with a point made with the tip of the brush and move straight down. Make a hook and lift up the brush to form a tail.

Step 3 Continue the motion of line 2 to line 3, again starting with the tip of the brush then coming down gradually, aiming at bottom left and making a slight curve. End with a taper then make a circular clockwise movement with your arm to arrive at the start of line 4 near the top of the ideogram.

Step 4 Begin with the tip and move to the right in a gentle curve, smoothly lifting the brush down to the start of line 5.

Step 5 Make this a short stroke parallel to line 4.

Steps 6 and 7 Maintaining the rhythm, create these two dots in a single motion.

Step 8 From the center of line 5, bring the brush straight down then curve it left, ending in a taper that just touches the side of line 3.

Step 9 Move your arm up in a clockwise direction to make line 9, which crosses line 8 on a diagonal.

Step 10 Use the tip of the brush to begin line 10 then move it almost straight down, curving it to bottom right. Maintain the energy of the movement even though the line is narrow. Finish with a "fish hook."

Step 11 Slowly lift the brush in a clockwise motion and bring it down to make line 11, which crosses line 10.

Step 12 Create the final dot at the top of the ideogram.

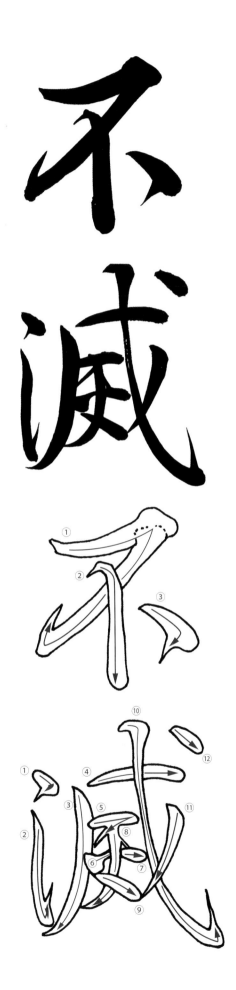

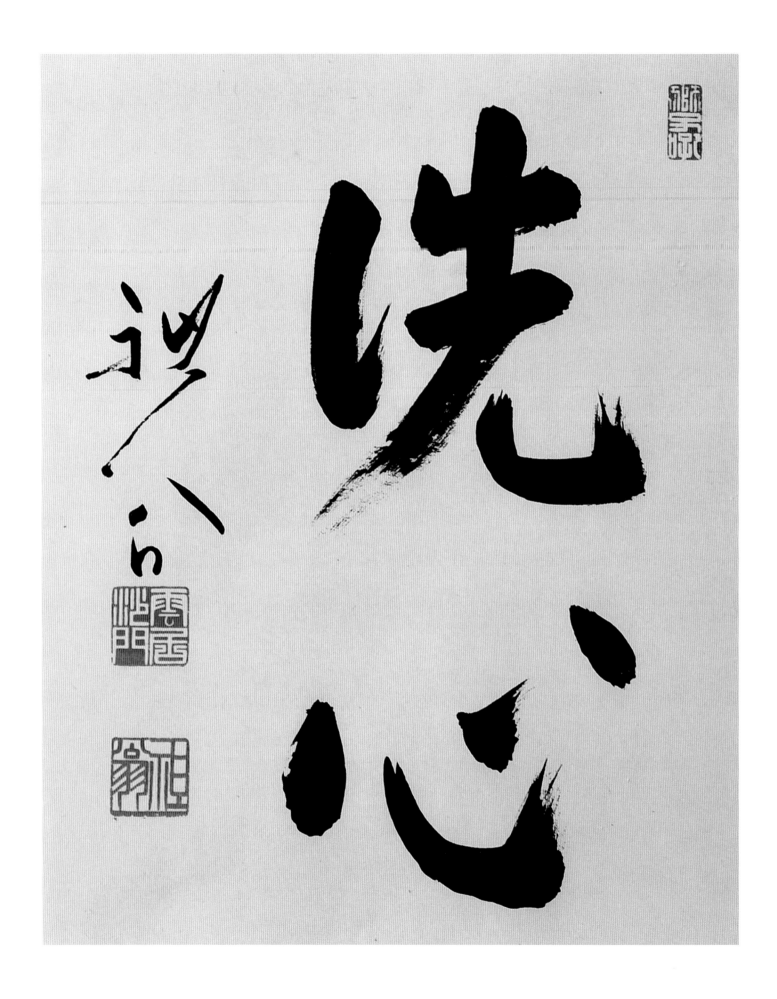

Sen Shin ("Purify the Soul")

Sen shin (*sen*=purify; *shin*=heart or soul) means to "wash the dirt and dust from your heart and soul." Wash off all worldly desires and confused imagination from your soul to purify it.

Daily washing or cleansing of the body is a habitual activity that requires little thought. However, cleansing heart and soul is not usually a part of that. In a publication called *Book of the Late Han* it is noted (in the chapter *Juntei ki)* that "when your spirit has been purified, then automatically, you will be refreshed." The collective notes of *zengo* say that each new day should begin with purifying and refreshing the spirit, or heart and soul, with the use of wisdom and intellect. This resolve to make life "pure" every day is expressed in the two ideograms *sen* and *shin*.

A visit to a temple or shrine in Japan requires ritual washing of the mouth and hands to begin the process of cleansing and refreshing for purification. Along the path to a temple entrance, an oblong stone basin overflowing with water constantly replenished from a spring bears a row of wooden dippers along its rim. Visitors take a dipper full of water, move away from the basin so that no water will splash back in, rinse their hands, cup their left hand to sip water to rinse their mouth, then run the remaining water in the dipper along the handle to clean it for the next person.

This practice of purification is also part of the tea ceremony Cleansing the mouth and hands before entering the tea room is a reminder to purify the soul. A person is refreshed and the senses are renewed and ready to appreciate the fine art on display in the tea room.

Sen shin is a reminder to make ourselves as clean as an untouched sheet of paper as daily activities begin. Commence by observing and reevaluating every element in your surroundings. This practice in awareness develops a humility which is foremost for mental and physical discipline, whether in a Zen temple or at home. In a Zen temple, the priests and monks give their full attention to daily activities such as cleaning the zendo, washing their clothes, preparing food, gardening, washing vegetables, giving each task at hand their full and undivided attention. The term for such activities is *sa mu* which means to develop self-awareness and readiness for spiritual cleansing. When full attention and concentration is given to any task, this form of meditation makes any experience a purifying act. Common daily activities provide us with many opportunities for such experiences when wisdom and intellect are used.

Sen Shin ("Purify the Soul") by
Seikō Hirata of Tenryu-ji, Kyoto

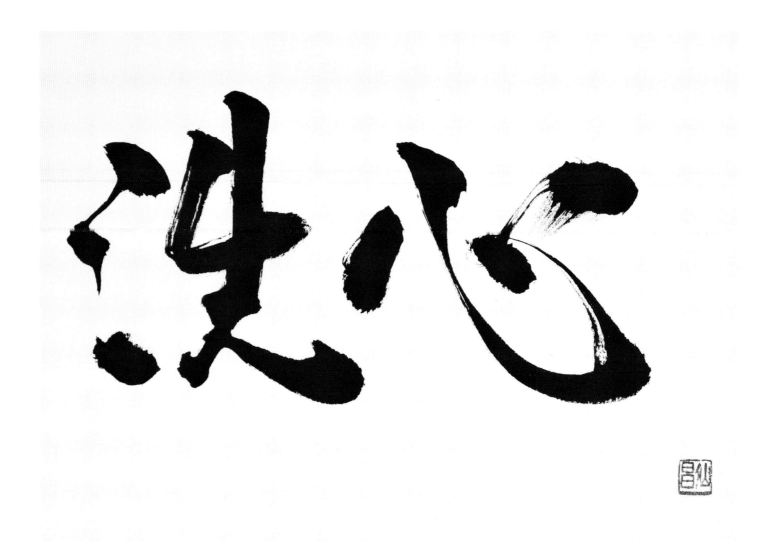

Sen Shin ("Purify the Soul") by Zakyu-An Senshō

The tea ceremony, so closely aligned with Zen, also provides such experiences. In preparation for the ceremony, the host must carry out similar activities such as cleaning the garden and tea room, selecting the equipment that is aesthetically pleasing and meets the requirements of the gathering and the tea and food to be served. Seasonal changes are also observed; in autumn for example, perhaps after careful tidying a few beautiful autumnal leaves may be scattered along a path for artistic accent. When all preparations are complete and the guests have entered the tea room, the host then will have a moment to sit, clear the mind of all extraneous thoughts, and take a deep breath for a moment of complete tranquility. The host must know how to retrieve an atmosphere of tranquility: this is the meaning of "not using hot or cold water" to purify the soul but to use wisdom for shifting to tranquility. When the host and guest meet, there should be no shadows of hectic preparation.

The work by Zakyu-An Senshō is a horizontal composition to be read from left to right. There is only one seal, without a signature. In this case, the constraint is to highlight the importance of the meaning of the words.

Sen Shin ("Purify the Soul") in the Kaisho Style

The last stroke (9) of *sen* and the stroke 2 in *shin* are similar in that the endings are tapered to a point. The major difference is that the stroke 9 for *sen* has a wide beginning and comes straight down, almost in the shape of an L. On the other hand, stroke 2 in *shin* begins with a narrow line, widens, and ends with a fine taper. Also, the line maintains its curvature as if it is one third of a circle. The third and fourth strokes for *shin* are formed by lifting the brush up to form the tip, and should be created as if facing each other.

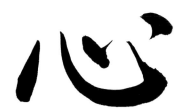

Sen Shin ("Purify the Soul") in the Gyosho Style

In the *gyosho* style, lines 2 and 3 for *shin* are connected but still the form attempts to maintain the *kaisho* positions. In the example for A, *shin* is almost a parallelogram in form; but in B the form is almost square and is more like the *katsujitai* form of today. The time period and the personality of the writer influence the style of writing. The square block form was commonly used during the Ming Period (1368–1644 CE) in China.

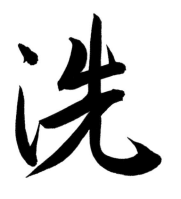
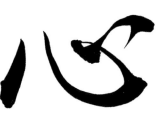
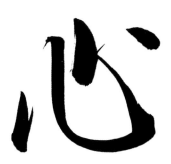
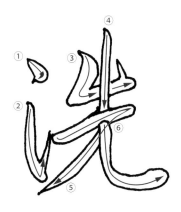

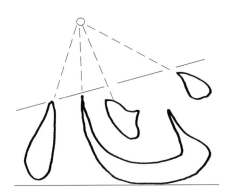

THREE IDEOGRAM ZENGO 三字篇

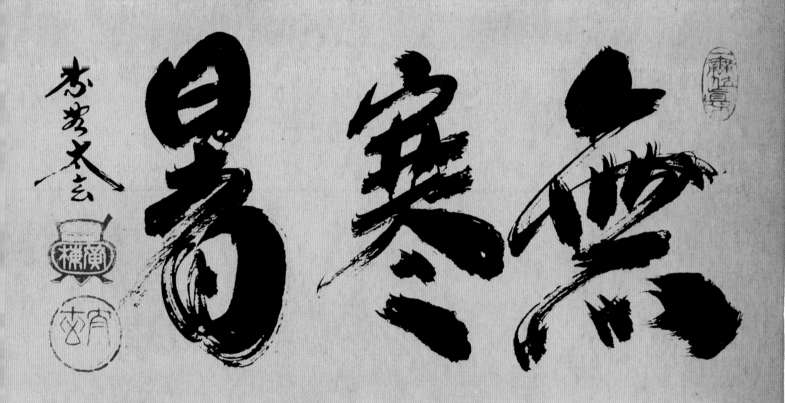

無寒暑

Mu Kan Sho ("No Hot Cold")

Under the bright sun of early summer, when one is enjoying a sport such as tennis with friends, with the immediacy of a ball coming at you which must be hit back, the discomfort of sweat-drenched clothes is barely felt because the activity demands concentration. Up in the high country, in deep snow, a skier who glides down a mountain slope fully alert to the moguls and other obstacles he has to negotiate, is quite oblivious to the cold. These two simple examples show that a person who is concentrating physically and mentally on an enjoyable activity can transcend physical discomfort.

Likewise, in the *zendo*, the weather may be unbearably hot or cold but there is no air-conditioning or heating, mosquitoes may be buzzing around, and one's legs may have gone numb and tingly. The body may be keenly aware of these conditions, but with total concentration one can overcome and transcend physical discomfort while contemplating the meaning of "nothingness." *Mu Kan Sho* represents the core of Buddhist teaching: when the focus is on life and death, reality takes on the true meaning of "no hot cold" or "no joy, no sorrow."

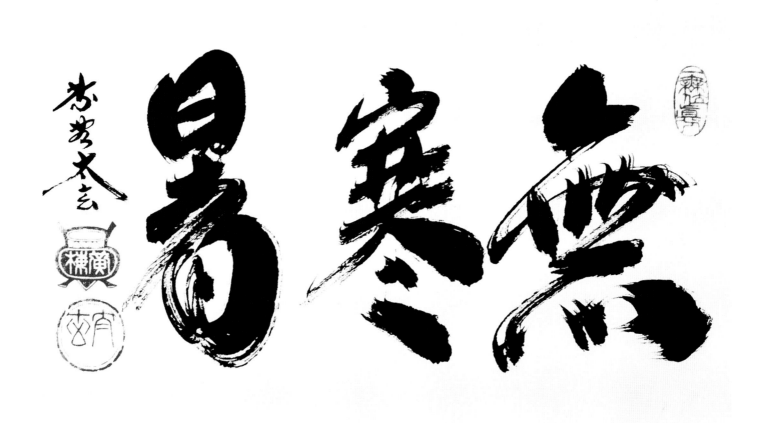

***Mu Kan Sho* ("No Hot Cold") by Gitō Taigen Roshi of Ōbai-In: Daitoku-ji, Kyoto**

Mu Kan Sho ("No Hot Cold") in the Kaisho Style

When it comes to writing three ideograms in a statement, the relative spacing and size of each ideogram is important. For instance, in the ideogram *mu*, the strokes 5–8 can be completely straight instead of being slanted. (See the earlier examples of *mu* in *kaisho*.) In this *mu*, the lines 5–8 gather toward the center bottom. This adjustment is made because the ideogram for "cold" which follows has a similar form in its strokes 4–7. It is common practice in the art of *shodo* to avoid similarities, so the upright lines in mu come to a point while the same form in *kan* is open.

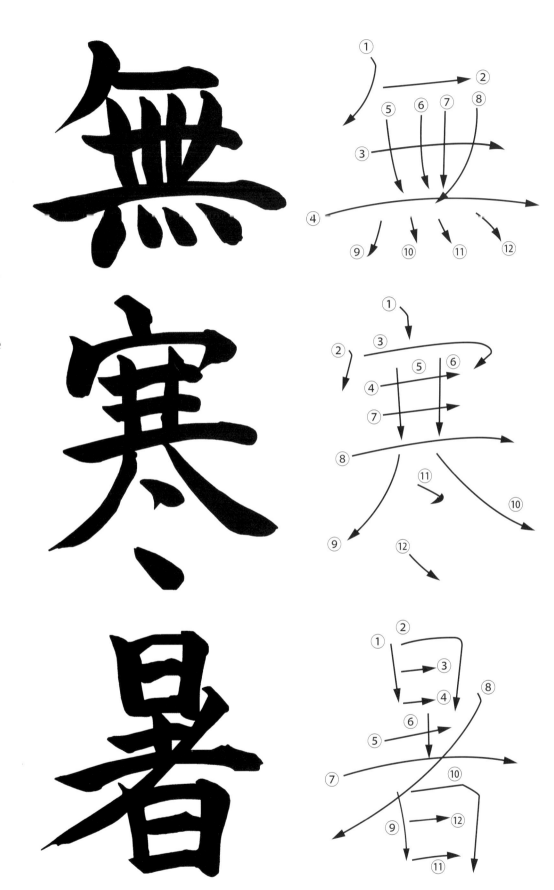

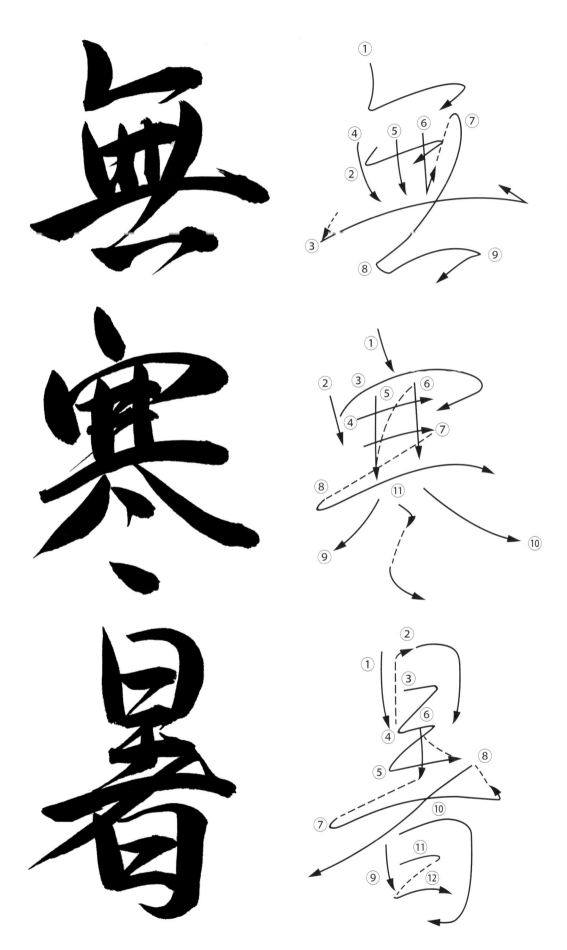

Mu Kan Sho ("No Hot Cold") in the Gyosho Style

The strokes 8 and 9 for *mu* have been simplified to two dots, creating artistic space. In the bottom part of *mu*, line 7 cuts through the midline of 3, thus making enough visual adjustment.

Kai Da Ko
("Release Beat Drum")

Gengo Akiba Roshi's *zengo* expresses a profound philosophical thought: Does the drum make the sound? Does the skin on the drum make the sound? Does the drumstick make the sound? If a person does not beat the drum with a drumstick there is no sound.

Skin on the drum, a drumstick, and a person using the drumstick: without these three elements working together the drum will not sound. So it is with Zen discipline. Results cannot be obtained without Buddha, teacher, and *unsui* (student monk); the three must become "as one," otherwise no sound of the drum can be heard.

The sound of the drum-the sound waves which impact you by removing or throwing off clouds from your spirit-is a metaphor for *bussho* (*bu*=Buddha; *[s]sho*=element), that which we come with when we are born. A chant of the famous Hakuin Zenji (the sixth patriarch of Zen), from chapter 44 of the *Hekiganroku* (Blue Cliff Record), states that "people are originally Buddha in a relationship as water and ice. Without water, ice cannot be made. Without people, Buddha would not exist. Sadly, people do not recognize this relationship within and search for something far away. All humans are born with *bussho*, which is a compassionate heart with love and respect. However, dirt and dust covers one's soul and *bussho* is smothered by it. Therefore, beat the drum of your soul and blow away the dust and grime so that *bussho* is alive within you."

Kai Da Ko ("Release Beat Drum")
by Gengo Akiba Roshi of Kojin-An,
Oakland, Calif.

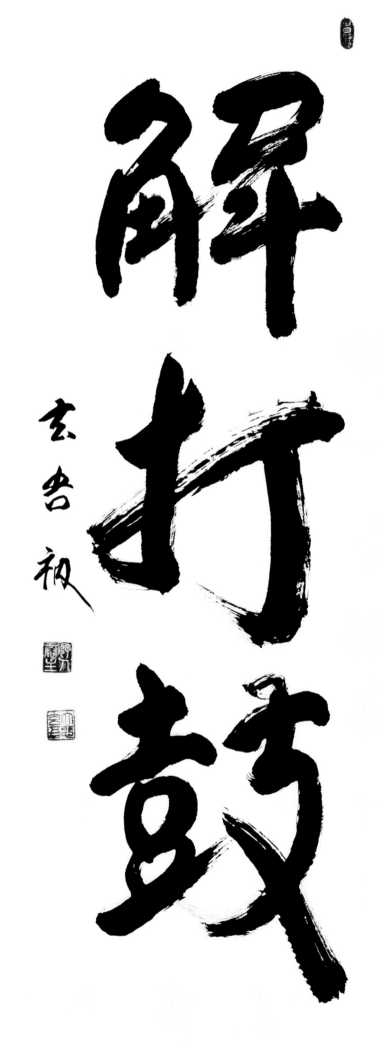

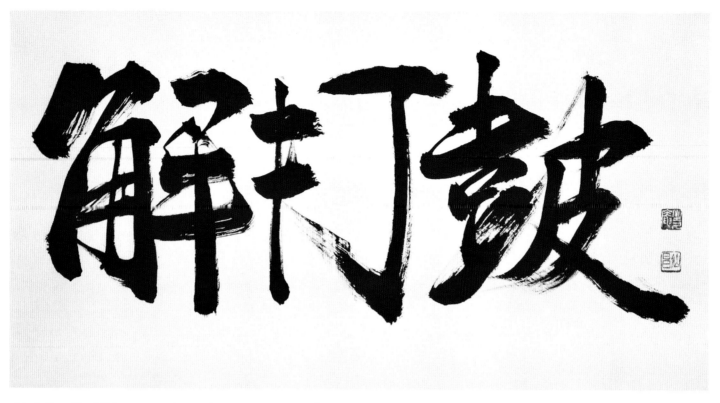

Kai Da Ko ("Comprehend Beat Drum") by Zakyu-An Senshō

The *zengo* shown above illustrates *Kai Da Ko* in a contemporary horizontal style, in contrast to the vertical style used in the work by Gengo Akiba Roshi (page 71). The ideograms here are read from left to right. Originally Chinese ideograms were written vertically, from top to bottom, with the brushstrokes showing obvious movement from one ideogram to the next (especially in the informal style of writing, *sosho*). But this cannot apply to horizontal writing. Therefore *kaisho* or *gyosho* styles are appropriate when writing horizontally. Note, too, the English translation used here; this exemplifies the fact that ideograms usually have a range of meanings, and may be translated into English in multiple ways.

Among the readers of this book there must be some who have attended a concert by the internationally famous Kodō group from Japan. Clad only in loin cloths and headbands, with bodies perspiring, they face their enormous sized drums, while seated on the floor with feet hooked under the drum stand for balance. The drum and drummer become a single unit. They never face the audience and use their entire body and soul, combined with physical strength, to beat the drum. The resonating sound waves' rhythm and volume mesmerize the entire audience. The Kodō group have a base camp on a small island in the Japan Sea. They live together communally and practice their drums and spiritual training together, very similar to the lifestyle of Zen priests.

Kai Da Ko ("Release Beat Drum") in the Kaisho Style

When writing in *kaisho* style, regardless of the number of strokes, keep each ideogram similar in size.

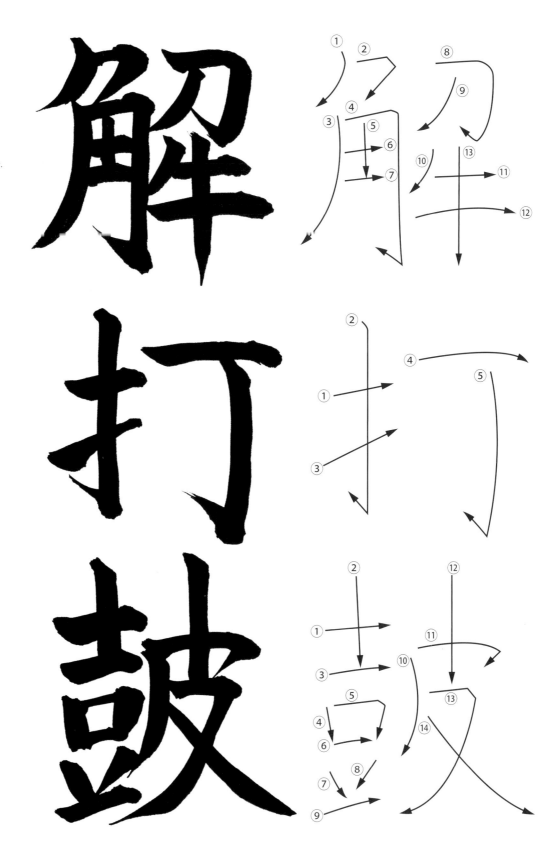

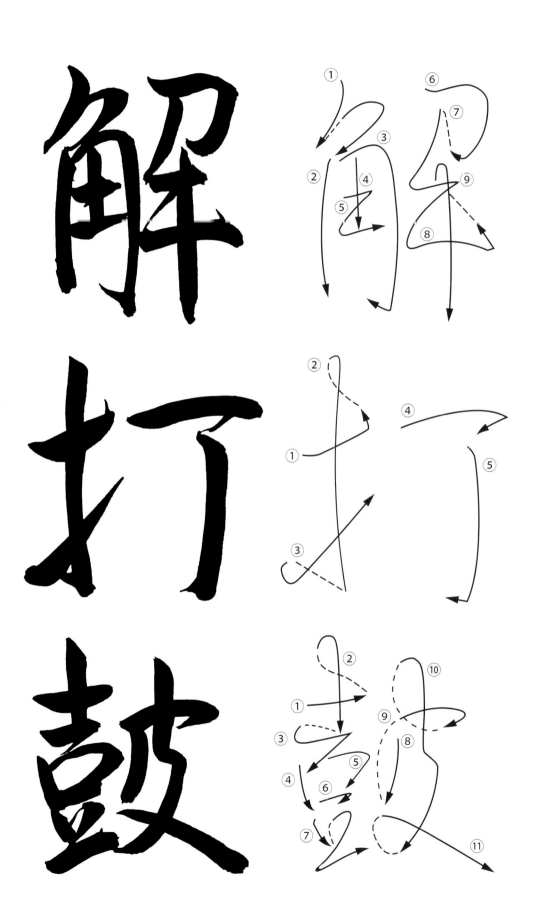

Kai Da Ko ("Release Beat Drum") in the Gyosho Style

After you have practiced the order of strokes in an ideogram and have memorized the order, then you can begin to make a personal adjustment. Refer to the work by Zakyu-An Senshō on page 72.

Mu Sho Jū
("No Place to Live")

This *zengo* comes from a section of one of the earliest of Buddhist writings in Japan, the *Kongō-kyo* (Diamond Sutra), and is considered the essence and most important part of the *Kongō-kyo*. This statement was the influence that moved Eno, the Sixth Patriarch, to enter the world of Zen.

應　無　所　住　而　生　其　心
o　mu　sho　jū　ni　sho　go　shin
　　no　place live

> *Live in a pure spirit.*
> *Pure spirit should not be placed in worldly passions.*
>
> *Pure spirit should not be placed in the five senses*
> *of mankind.*
> *Pure spirit is not attached to human desire.*
>
> *There is no permanence in one place or one thing,*
> *free your spirit as a moving cloud or running water.*
> *This does not mean to deny beauty,*
> *pleasure or the joy of life.*
> *Enjoy fully this unique gift of life.*
> *But do not cling to each thing or each incident.*

All Zen practitioners must come to this realization. This statement has been the guiding teaching for many famous swordsmasters, tea masters, and artists throughout the centuries.

Beauty is naturally recognized and appreciated. However, the very nature of this beauty often leads a person to desire and possess it. The wish to possess, leads to attachments which cause pain and sorrow because they cannot be fulfilled.

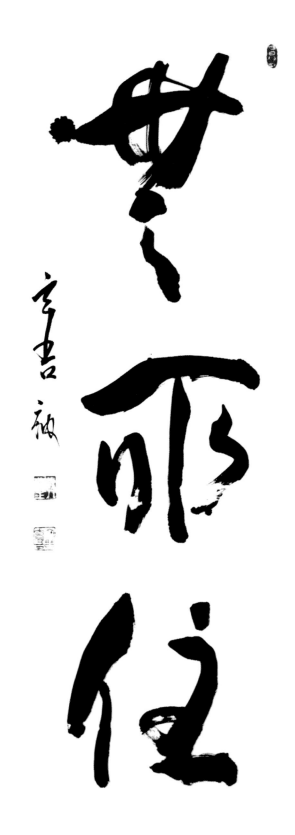

Mu Sho Jū "(No Place to Live") by Gengo Akiba Roshi of Kojin-An, Oakland, Calif., from *Kongō-kyo*

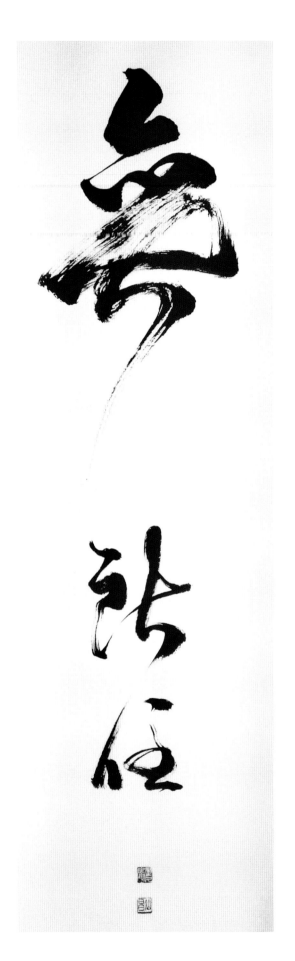

In his teachings Shakamuni Buddha said, "When one sees beauty, do not make it *live* in your heart. Be like a cloud or running water in a stream, simply appreciate beauty as beauty and do not grasp or hold it in your heart." In the case of this *bokuseki*, "live" means attachment and adherence. It is deep attachment that brings about delusions and indecision in a person. The teaching of the Bod hisattvas is that human nature mistakenly tries to hold on to attachments that cannot be maintained.

When the spring season arrives, the meadows may become a medley of colors, shapes and fragrances. The beauty and power of nature should be enjoyed. But however beautiful the flowers, in a few days their colors will fade and their petals will fall to the ground, once again to become a part of the soil. The destiny of life cannot be stopped by human power. In the statement *Ichi go ichi e* (*ichi*=one, *go*=life; *ichi*=one, *e*=moment), each moment of your life is a one-time experience. Make each moment as meaningful as possible because it is impossible to stop or cling to the passing time.

The *bokuseki* is written by Gengo Akiba Roshi in the *sosho* style. While he was preparing to make the first horizontal line of mu, a drop of ink fell on the left side of the paper. The artist has turned this "accident" to his advantage, skillfully balancing the drop in the top ideogram with the bold line at top left in the bottom ideogram ("live"). The total effect is successfully balanced. Cover the upper dot with your fingertip, and notice the total effect without this dot.

Compare it with the work by Zakyu-An Senshō. Writing styles differ between individuals, regardless of similarities or differences in cultural backgrounds. This work has a larger *mu* ("nothingness") in comparison to the ideograms for "place" and "live" below it. This difference in size serves to heighten the significance of *mu*.

Mu Sho Jū "(No Place to Live") by Zakyu-An Senshō

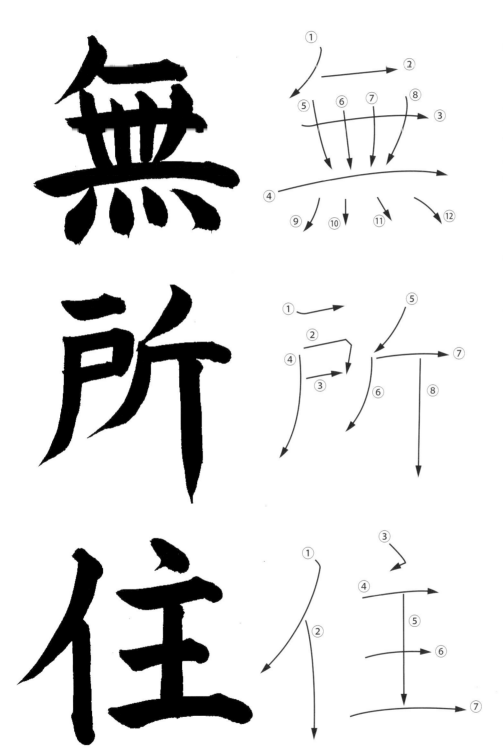

Mu Sho Jū ("No Place to Live") in the Kaisho Style

As always, it is important to follow the order of the strokes, and care must be given to make the strokes in *kaisho* style. To write in good *kaisho* style is very difficult.

While the classic style of writing in *kaisho* is rigid, with the strokes placed in a prescribed manner, *kaisho* can also be presented in a more relaxed manner. Sometimes, *kaisho* and *gyosho* are blended, and in such cases the emotional condition of the artist may be exposed.

When a work in *sho* is viewed as fine art, an important requirement is to understand the purpose of the writing and the historic background. In the classroom, I often compare the art of *sho* to a performance of music: both require technical skill *and* artistry. Music as it is written on the score should be practiced until it is properly mastered. Then when performing it before an audience, the artist will add to the memorized score his or her own sensitivity and emotion—and in the quality of the sound, the inner soul of the performer will be expressed through that music. On musical scores there is sometimes too a section marked "cadenza" where improvisations can be added; this spontaneous addition makes the performance a very personal one and raises it to a higher level in achievement.

And so it is with the visual art of *bokuseki*. Zen priests pour their energy into the ideograms to make the result a very personal conception.

Mu Sho Jū ("No Place to Live") in the Gyosho Style

The *qyosho*-style *mu* in the previous statement we looked at, *Mu Kan Sho*, consisted of two dots. In this sample, three dots are suggested in line 8, which is one continuous brush stroke. In the *gyosho* and *sosho* styles, the four dots of mu can be a suggestion of dots or can be one horizontal line. It is the artist's decision to make.

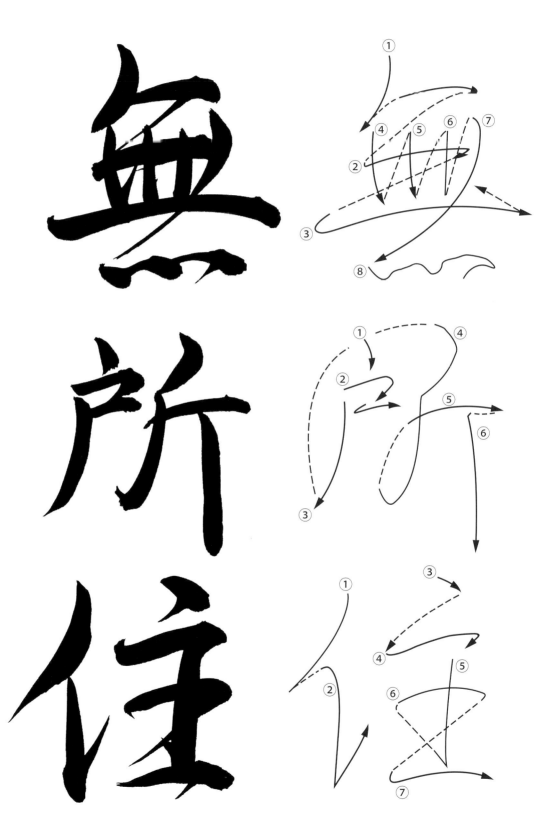

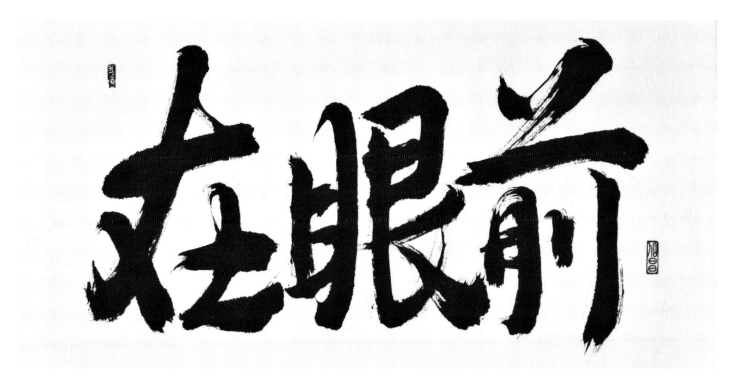

Zai Gan Zen ("Front of Your Eyes") by Zakyu-An Senshō

Zai Gan Zen (Me No Mae Ni Aru)
("Front of Your Eyes")

In teaching the basic core of Zen ideology, many a concrete example is used in an attempt to lead a wandering soul to the understanding of a concept. Among the teaching examples employed, a key point is that "the truth you seek is not far away or hidden but is right in front of your eyes." The person who is seeking the truth must first remove and wash away the traits of selfishness, confusion, and deep attachments. This process of purification is of the utmost importance in the path toward enlightenment.

Objects from nature, such as mountains, oceans, clouds and the moon, are frequently used to help convey this kind of profound message. For example, in the phrases "moon hidden by clouds" and "mountains hidden by clouds," the moon or mountains represent truth. Zengo like "As They Are" or "What You See in Front of Your Eyes" are also metaphors describing the truth. To attain this understanding via nature requires the clear eyes of the soul.

The example above by Zakyu-An Senshō is in *gyosho* style, using a contemporary horizontal format read from left to right. The placement of the seal is always very important in Asian artwork, and is determined by the composition and the available space. In this case two seals are used. The one on the far right is the calligrapher's name, while the smaller seal at top left reads "bright and clear." This seal is called *kambo* meaning "protective seal for the artist." In essence, it conveys that the space in between the seals is not to be disturbed in any way. (For instance, one may not cut the artwork in half to make two pieces from it!)

Zai Gan Zen ("Front of Your Eyes") in the Kaisho Style

Both the second ideogram *gan* (eye) and the third ideogram *zen* (*mae*=front of) have strong upright lines in their composition. You should therefore pay close attention to the spacing of these upright lines, so that it does not become repetitious.

As you write this statement always remain cognizant of the meaning. Zengo are open-ended and will lead to new insights.

The parenthetical statement noted on the previous page, "*Me no mae ni aru,*" is the way this zengo is spoken aloud in Japanese.

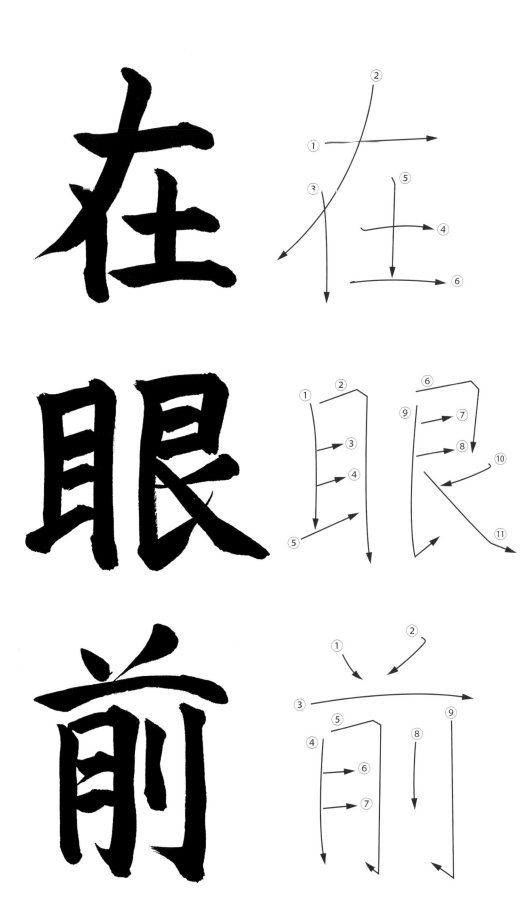

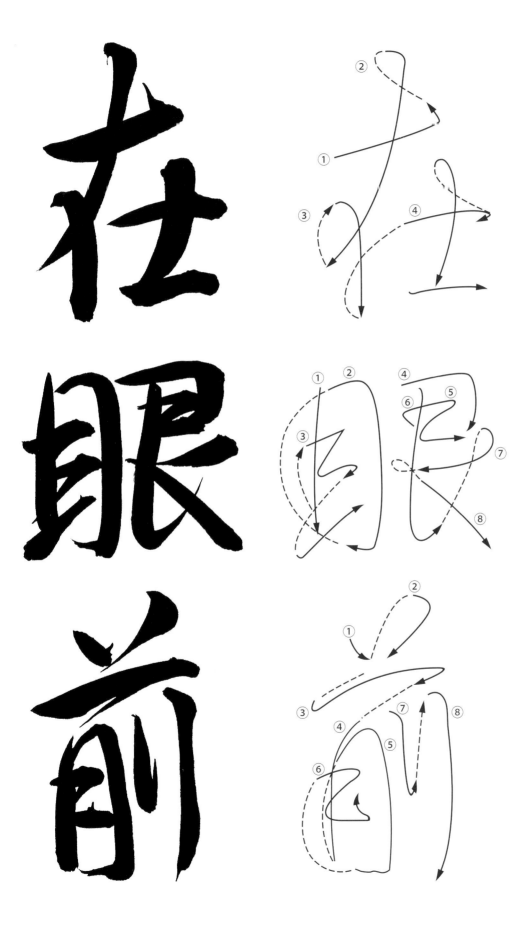

Zai Gan Zen ("Front of Your Eyes") in the Gyosho Style

This sample for writing the statement in *gyosho* is upright. But refer to the example by Zakyu-An Senshō (page 79): it too is in *gyosho,* but done in a horizontal format. The brush movement used when writing horizontally changes the relationship among the ideograms, and the spaces are thus much tighter.

FOUR IDEOGRAM ZENGO 四字篇

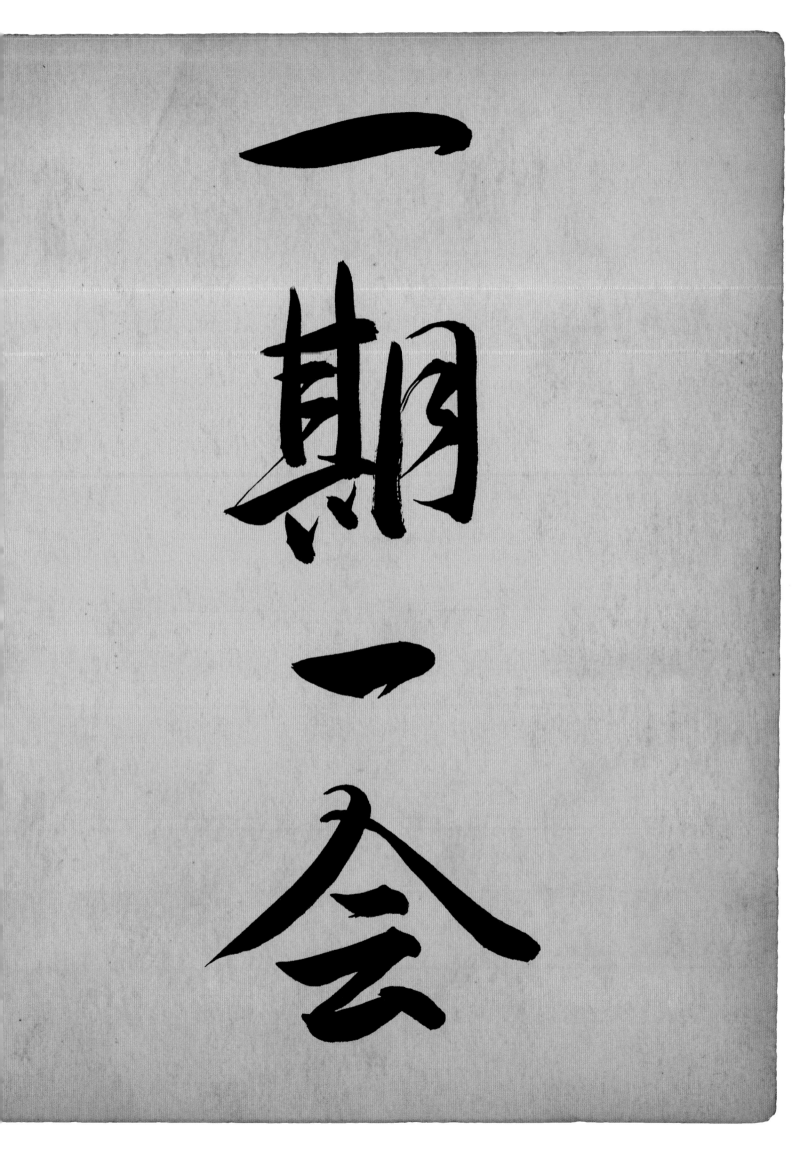
一期一会

Ichi Go Ichi E
("One Lifetime One Meeting")

This statement is one of the most popular sayings for display in the *tokonoma* (alcove) of a tea ceremony room. *Ichi go ichi e*—"One lifetime one meeting"—means that each moment is unique unto itself, never to be replicated. In the case of a tea ceremony, the faces may be the same, the tea room may be the same, but each gathering is a unique and fresh moment which can never be reproduced. Life is always in a state of flux; that fact combined with cyclical changes such as the seasons makes each experience unique. A tea ceremony host should carefully consider every detail in creating a serene and tranquil atmosphere to make the gathering a memorable event. But that event can never be recaptured. The *Ichi go ichi e* expression is often also used in conversation, signifying its importance in daily life as well as its universal relevance.

Unlike most *zengo*, this statement did not originate from Buddhist documents. Rather, it is attributed to Naosuke Ii (1815–60), *daimyo* (warlord) of Hikone Castle near Kyoto. As Tairo (Great Elder) of the Tokugawa shogunate, he held one of its highest administrative positions during those turbulent times focused on the controversy about whether Japan should open its doors to the West or not. (Unlike many of his countrymen, Ii felt that opening Japan's doors to the West was crucial for its survival, especially for the technology the West offered. For his beliefs he was assassinated in 1860 by warlords who opposed him.) Like many *daimyo* involved with cultural activities such as calligraphy, painting and the Noh drama, Ii Naosuke was also an enthusiastic and accomplished practitioner of the Japanese tea ceremony, and he left books and articles about it.

The *bokuseki* on the facing page, by Gitō Taigen Roshi, was written on a 10.5 x 9.5-inch (26.7 x 24 cm) *shikishi* board. *Shikishi* are constructed of sized or unsized paper mounted on very stiff cardboard, and trimmed with a narrow gold border. The advantage is that on completion the work, painting or calligraphy, can be immediately displayed and enjoyed, whereas if it is on regular handmade paper, the work must first be backed, stretched, and mounted as a scroll. The short and narrow (61 x 7 in. / 155 x 17.8 cm) hanging scroll on page 86, by Zakyu-An Senshō, is also suitable for a small tea room. Both of these *ichigyo mono* are written in the *gyosho* style.

Ichi Go Ichi E ("One Lifetime One Meeting") by Gitō Taigen Roshi of Ōbai-In: Daitoku-ji, Kyoto

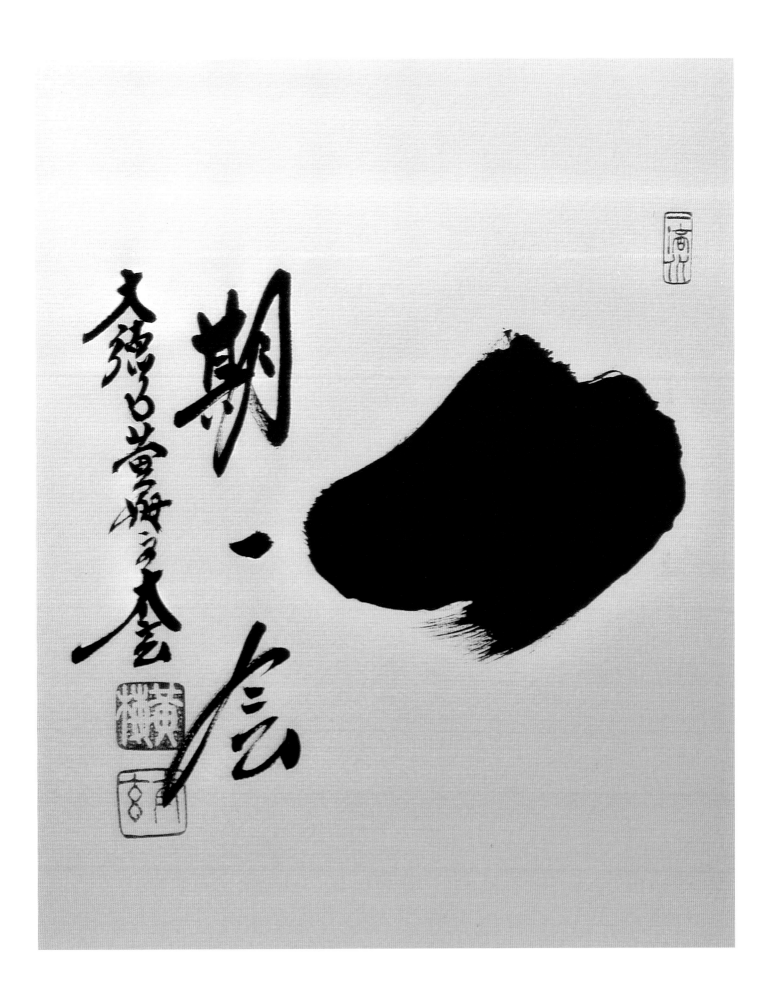

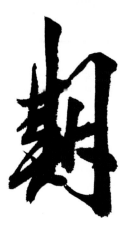
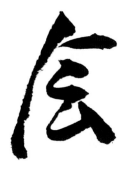

Ichi Go Ichi E ("One Lifetime One Meeting") in the Kaisho Style

A common practice in *shodo* is that if the same ideogram appears in the statement twice, one of them should be readjusted so there will be no redundancy. In the *kaisho* style you cannot change it much, but in *gyosho* there is much greater freedom. The work by Taigen Roshi (page 85) is a good example.

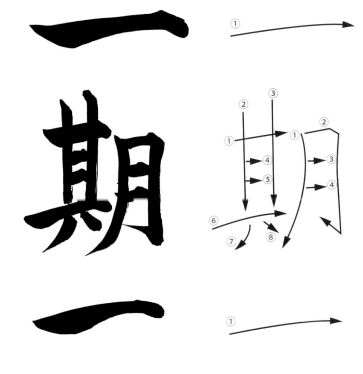
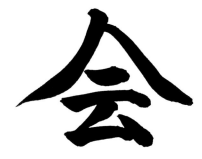
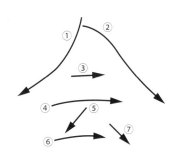

Ichi Go Ichi E ("One Lifetime One Meeting") by Zakyu-An Senshō

Ichi Go Ichi E ("One Lifetime One Meeting") in the Gyosho Style

As usual in the *gyosho* style, some strokes end with a wispy trail leading to the next stroke. Again, note how the two *"ichi"* characters vary.

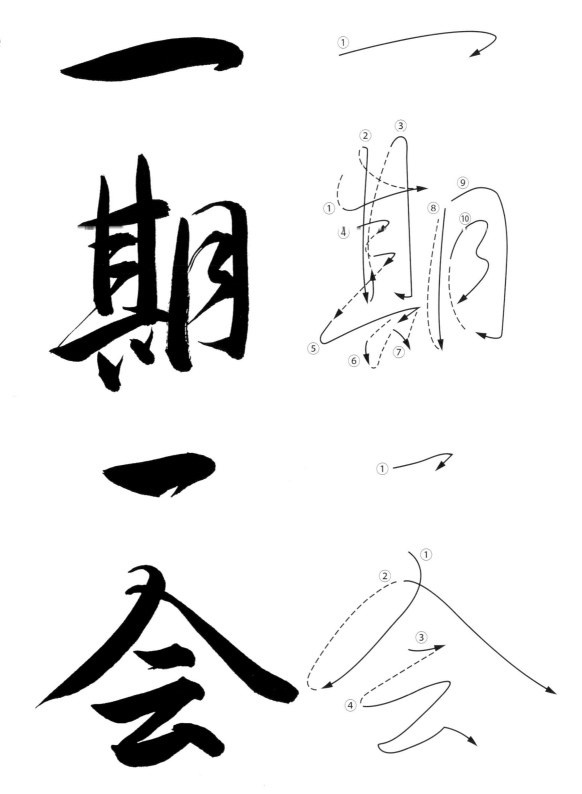

Wa Kei Sei Jaku
("Harmony Respect Purity Tranquility")

The four concepts in *Wa Kei Sei Jaku* (*wa*=harmony; *kei*=respect; *sei*=purity; *jaku*=tranquility) are not only at the base of Zen Buddhism, but also are the foundation of the philosophy of the tea ceremony. Both Zen and the tea ceremony emphasize a way of training the body and mind in awareness and spiritual insight. Thus, it is often said that Zen and tea are the same taste. Followers of Zen talk about the whole universe being experienced in the drinking of a bowl of tea.

These are principles that practitioners endeavor to integrate into their daily lives. The first two, *wa* (harmony) and *kei* (respect), connote that when respect is present, harmony should be the result. *Sei* or purity means that "dust" must be removed both mentally and physically in the world of tea or Zen. *Jaku* or tranquility indicates that mode where deep attachment and delusions do not exist.

The first great teacher of *chado* (*cha*=tea; *do*=way), often called the founder of the tea ceremony, was Juko Murata. He firmly emphasized the importance of these four ideograms' concepts. That emphasis led his disciple Sen no Rikyu to develop an awareness and sensitivity to rustic simplicity concepts which are known today as *wabi* and *sabi*. Breaking with tradition, Sen no Rikyu sought out common everyday folkware of Japan to replace the perfectly formed Chinese celadon tea bowls of the ceremony. And in place of imported Chinese paintings that had come to be expected in the tokonoma (alcove) display, he began to use *bokuseki*. The display of *bokuseki* in the tea room further deepened the presence of Zen in the tea ceremony. (Since the drinking of matcha, powdered green tea, was first brought to Japan by Zen monks, this was actually a reconnection to the roots of tea in Japan. However tea was brought to Japan for medicinal purposes in the sixth century.) Before Juko the tea gathering had been a grand social event. It was Juko Murata and Sen no Rikyu who focused on making the tea ceremony a spiritual experience, incorporating these four ideograms.

A *sho* artist will often look for a novel slant when he or she writes a well-known *zengo*. One way is to consider several styles of writing, and decide on a way to combine them appropriately. The artistry of the composition is the key. After practicing the standard styles of writing, a *shodo* artist's greatest source of creativity—the way of attaining wide range and depth of expression—is to move in one's own individual direction, and to find within oneself an individual way of expressing the universal concepts.

Madame Shūran Shirane (1912–1991) was a well-known *shodo* artist who specialized in *hiragana* (phonetic script). She left a legacy of many fine works. In this example, we can see examples of creative interpretation. The ideogram *wa* is presented in an unusual way. Normally the ideogram for "mouth" (口) appears on the right side of the character, but in this case it is on the left side. Second, notice the smooth transition between the brush strokes. There appears to be a blend of *gyosho* and *sosho* brush movements. Third, notice how Shirane has converted the three dots on the left side of the third ideogram *sei* ("purity") into one continuous line. This is a technique seen in *shodo* through the generations. For another example, see "Fresh Breeze Affects Serene Bamboo" on page 132.

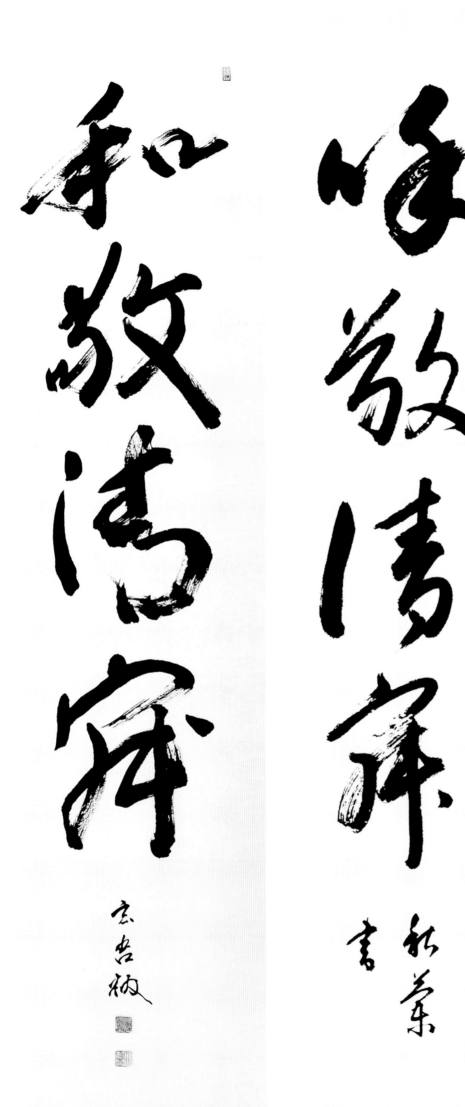

FAR LEFT *Wa Kei Sei Jaku* ("Harmony Respect Purity Tranquility") by Gengo Akiba Roshi of Kojin-An, Oakland, Calif.

LEFT *Wa Kei Sei Jaku* ("Harmony Respect Purity Tranquility") by Shūran Shirane, Tokyo

Wa Kei Sei Jaku ("Harmony Respect Purity Tranquility") in the Kaisho Style

Often, simpler ideograms are combined to make a single ideogram. In such cases, the left or right side's size may vary to create active empty space and a sense of balance, especially in relationship with the ideogram that follows. In the first ideogram, *wa* or harmony, the lefthand part is larger. However, in the third ideogram, *sei* or purity, the right side has the greater mass. The minute adjustments in size and space are very similar to composition in painting.

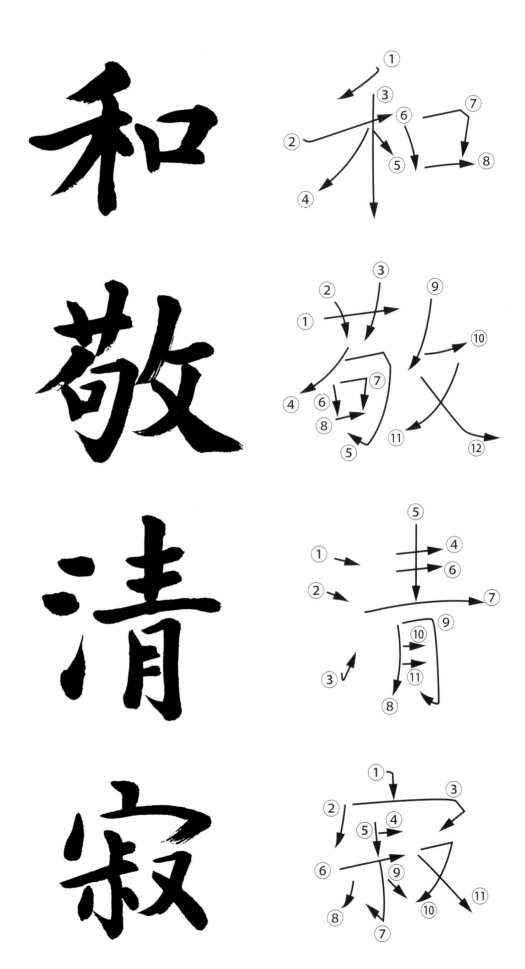

Wa Kei Sei Jaku ("Harmony Respect Purity Tranquility") in the Gyosho Style

It is said that *gyosho* style allows more freedom in artistic decisions; as an example, here the ideogram of wa is softer in *gyosho* style. Looking over Madame Shuran's work (page 89) you can see clearly how she switched the placement of the strokes 5, 6 and 7 in her work.

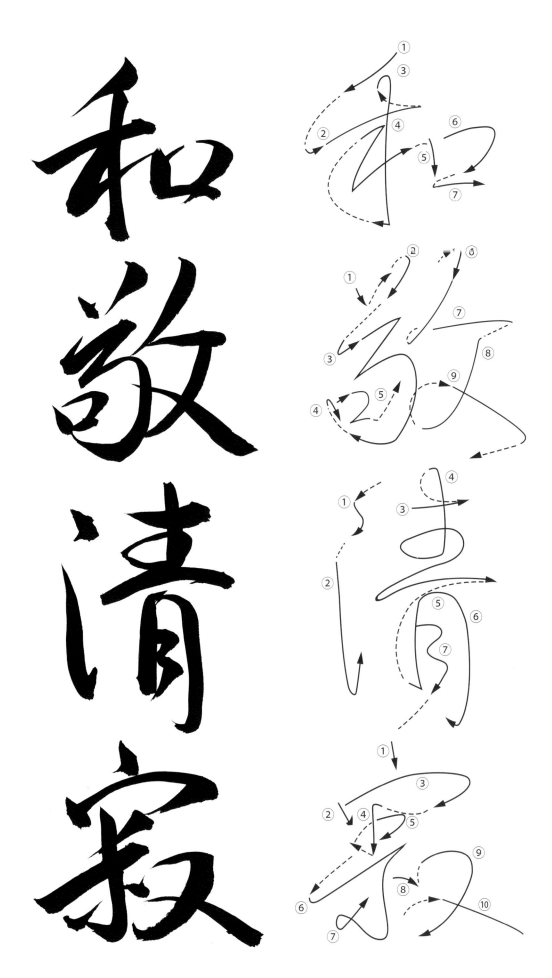

Za Ichi Sō Shichi (Ichi Ni Za Shite Shichi Ni Hashiru) ("Sit First Dash Seven")

Our contemporary world is filled with fast-paced technological changes which can often make life a confusion of activities and information. Faced with this superabundance, an individual needs to continually reorganize thoughts and activities when making decisions. How does one decide the direction and what actions to follow? What measures should be re-examined for a right or wrong course? This is a reality in our lifestyle today.

This *zengo* simply states: "Take a deep breath and calm your soul and senses; then make plan A and B. If this does not work, make plan C. Then take action." This is the translation for this zengo. "Sit first": first means that of all things existing in this world, there is one unchanging truth and this "one" is the source of all things. The universe begins from this one and returns to the one. In Buddhist teaching to return to the one is the self-cleansing of your soul. One is everything and everything is one. All living beings are born with bussho. Therefore, the purpose in life is to recognize your primal dignity and re-evaluate yourself. The general rule in Zen literature is that "this" takes the place of the pronoun "you." Therefore, first is a convenient way to point out that first is "you" as a part of this one which is the totality of the universe. "Sit first" means to focus back to this truth concerning the universe with all of the elements and return to this basic one, to bussho.

This statement often has been described as how a mentor in a Zen temple trains the student monks.

From ancient times to the present, from East or West, ones with great wisdom such as Shakamuni or Confucius have pointed out the nature of the ultimate "truth" through various methods. In his *Analects*, Confucius stated that "one is to spear through the truth." Bodhidharma brought Zen philosophy from India to China during a time when the teachings of Lao Tzu and Confucius were well established. The three philosophies were interwoven to create Chinese Zen. Because of this historical background in Chinese Zen, there are parallels in teaching with the philosophies of Taoism and Confucianism. This historical background is the reason that zengo are written in a Chinese context and most generally are read from the top to the bottom. Although the ideograms are written using Chinese grammar, most Japanese will understand the meaning, roughly speaking. However if this Zen statement is written in Japanese style grammar, it will be written as *Ichi ni za shite shichi ni hashiru*: "first you sit; then seven directions you will run."

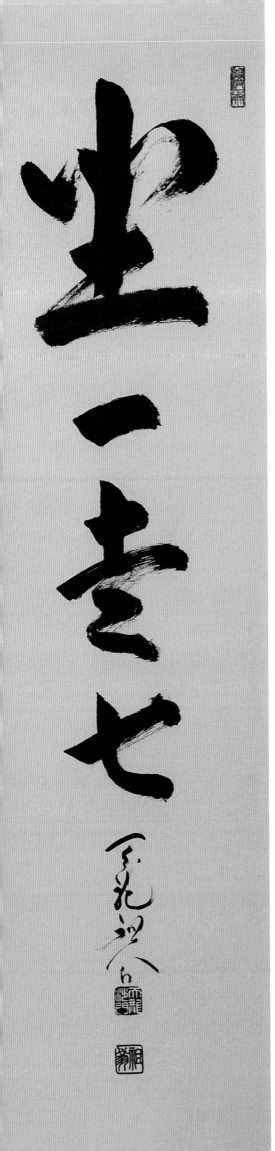

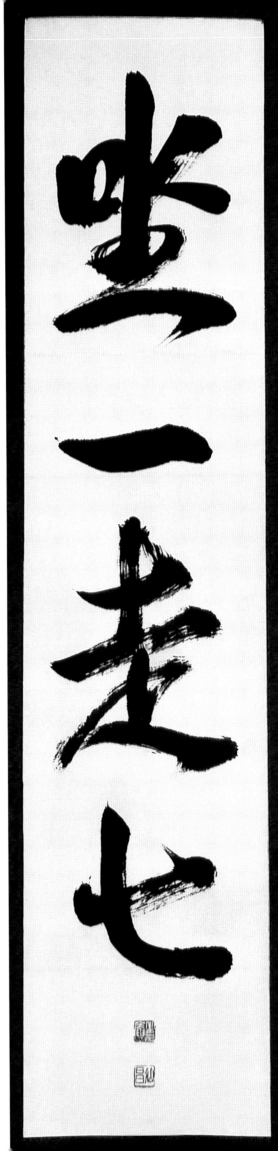

FAR LEFT *Za Ichi Sō Shichi* ("Sit First Dash Seven") by Seikō Hirata of Tenryu-ji, Kyoto

LEFT *Za Ichi Sō Shichi* ("Sit First Dash Seven") by Zakyu-An Senshō

Za Ichi Sō Shichi ("Sit First Dash Seven") in the Kaisho Style

Page 96 shows the many kinds of ideograms that have been used for *za* or "sit." In the first ideogram for *za* in this *kaisho* style example, to the left side is the ideogram for "mouth" and to the right side is "person." If the ideogram for "person" is written independently, after stroke 4 the next stroke would become extended and tapered to the right. However, in this case, "to sit in *zazen*" is of the utmost importance, so stroke 5 is not extended. In the third ideogram ("dash" or "run"), the same form is used in strokes 5 and 6, but these strokes are extended to give the feeling of motion.

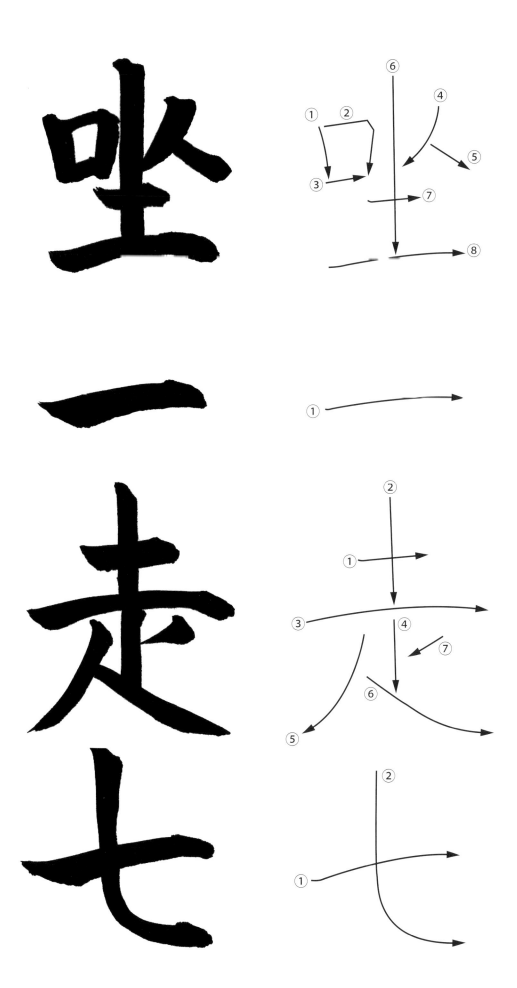

Za Ichi Sō Shichi ("Sit First Dash Seven") in the Gyosho Style

The first ideogram ("sit") has been simplified in the order of strokes, as has the third ideogram ("dash" or "run"). It is difficult to visualize the meaning in ideograms but that is the artistic challenge for the practitioner of *shodo*. The first ideogram should carry a feeling of stability for "sitting in *zazen*," and the third ideogram should carry a sense of speed or motion.

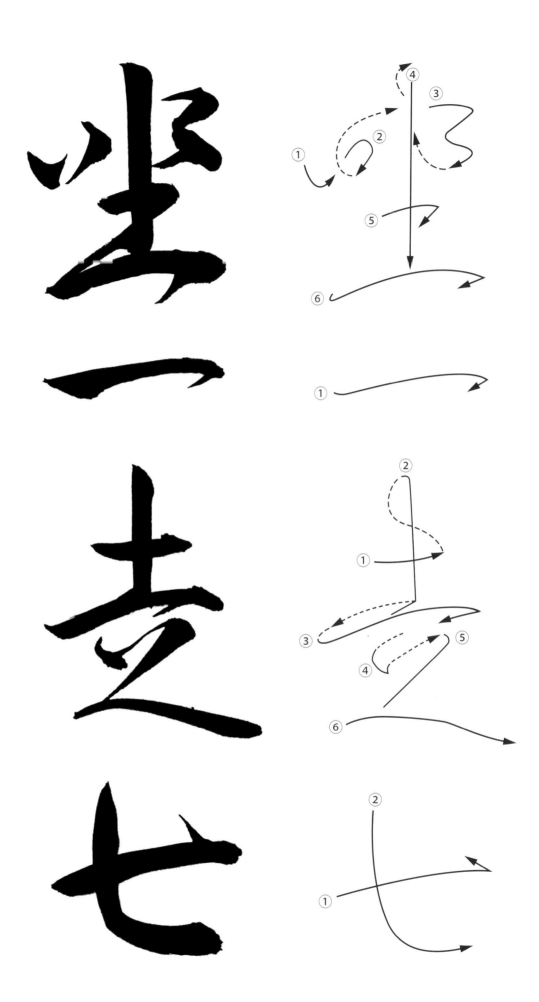

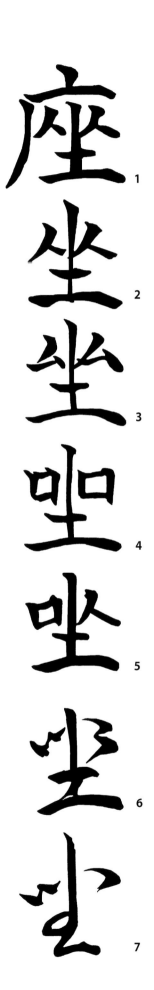

Various Styles of Writing *Za* ("Sit")

1. The top horizontal line and the left diagonal line indicate "roof." Originally this ideogram expressed the idea "In front of a shrine, one sits on the ground and accepts god's judgment." Today, however, the ideogram means "large building where many people can be seated," such as a theater.

2. Two people sitting on the dirt ground facing each other. The top ideograms, each of two strokes, mean "person." The two horizontal lines bisected by the upright line represent "ground."

3. and **4.** Instead of the ideogram for "person," this one has been used.

5. Here the ideograms for "mouth" and "person" have been used.

6. This is the *gyosho* style.

7. This is the *sosho* style.

Zui Ha Chiku Rō
("Ocean Waves After Surf")

The direct meaning of this *zengo* is that "without losing self-direction, you must have the ability to change and be flexible, according to the situation and time you face." Our society is very similar to one wave in the great ocean. It is constantly changing and under such conditions one must be able to be free to work and produce great deeds. This requires very tenacious and vital self trust based upon inner strength. Confront all the various incidents you face with flexibility. This requires great discipline. This *zengo* also refers to instruction: "methods in teaching must be adjusted with tolerance and adjusted according to the capabilities of the student." The understanding of this *zengo* is very important for any person who stands above or leads a group of people in an organization. There is the saying which states that "without solid and firm self-direction, all attachment and selfishness cannot be removed from one's self."

Shakamuni Buddha's teaching is: "If you have ten different disciples, you must use ten different methods to effectively teach each individual." Among the sculptures of the Kwanyin Bodhisattva you will often see one with many heads and arms. The meaning for this is that Kwanyin is symbolically offering many different answers and solace for each individual; offering guidance and compassion to each in an individual and compassionate way. These sculptures are called the 1,000 head and arm Boddhisattvas. The gifted or true teacher is one who grasps the capabilities of each person and teaches accordingly. Creative artists who understand the "true nature" of the material they are working with will be able to more successfully use their techniques in their craft.

Zui Ha Chiku Rō ("Ocean Waves After Surf") by Zakyu-An Senshō

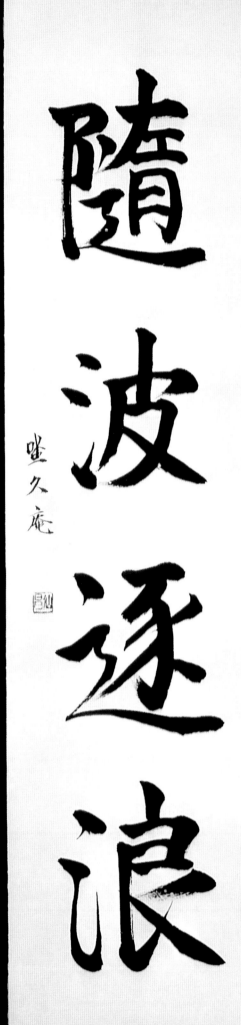

Zui Ha Chiku Rō ("Ocean Waves After Surf") in the Kaisho Style

The ideograms in this composition contain many wide-to-narrow-to-wide strokes. The last stroke in each of the ideograms ends in a taper. In order to avoid redundancy the tapers should be different. Notice that stroke 8 in the second ideogram and stroke 10 in the fourth ideogram end in a wave taper, but stroke 15 in the first ideogram and stroke 10 in the third end in a different kind of taper.

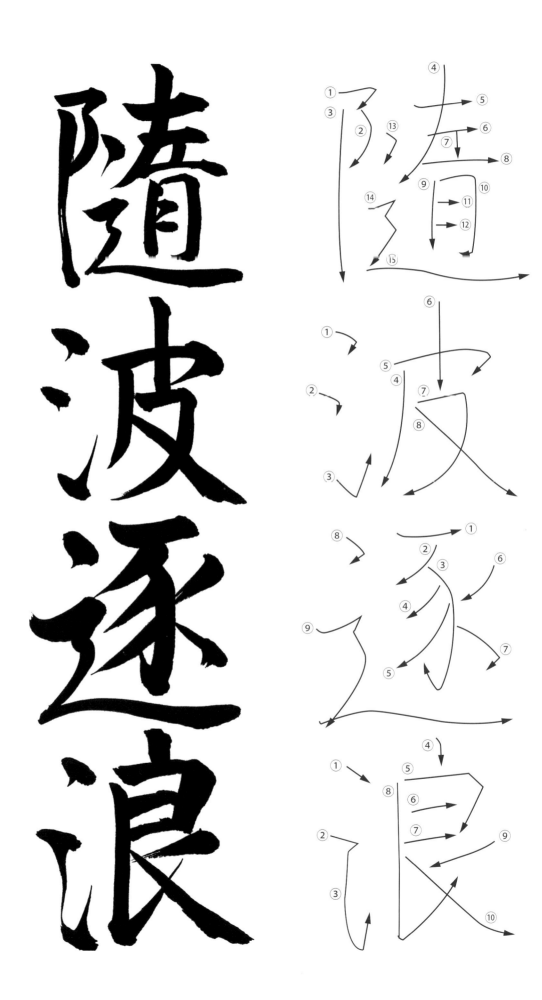

Zui Ha Chiku Rō ("Ocean Waves After Surf") in the Gyosho Style

In the *gyosho* style, the tapered strokes have been greatly readjusted. In the second ideogram, tapered stroke 6 ends without a line indicating the beginning of the next ideogram. In the first ideogram, stroke 8 clearly leads to the following ideogram. So it is not always necessary to have the last stroke of an ideogram lead to the next in *gyosho*. It is up to the *sho* practitioner.

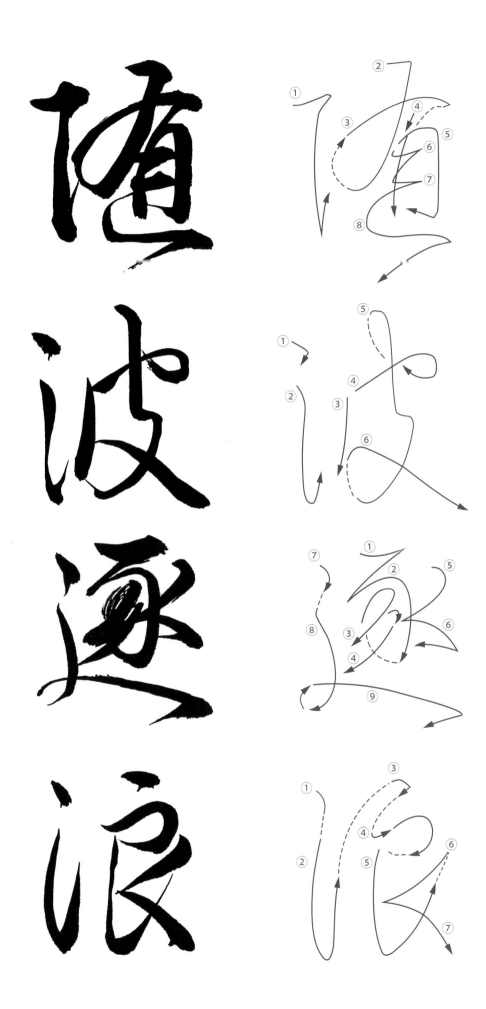

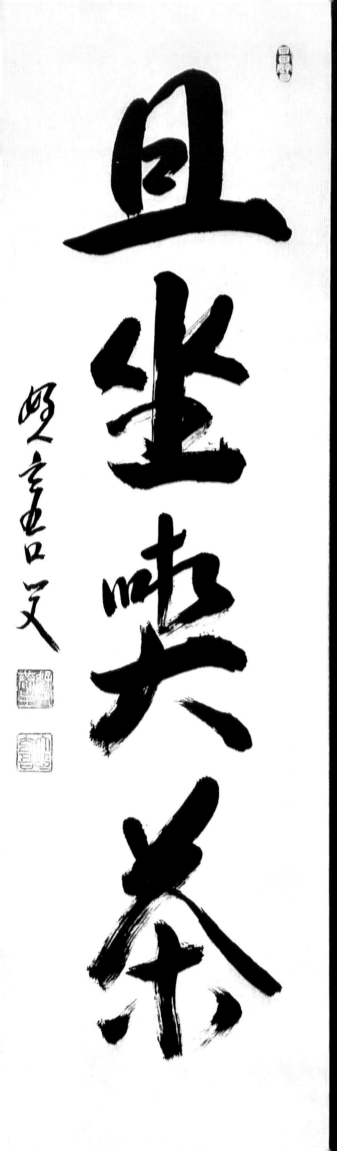

Sha Za Ki Ssa ("Have Seat Drink Tea")

The first two ideograms in this *zengo, sha* and *za*, mean "Sit awhile" or "Come and sit first." There is a variety of situations in which two persons will meet, however, in a student-teacher or counselor relationship, if a student is unsettled or irritated, to calm him down a teacher will say "sit awhile." *Sha Za Ki Ssa* defines the fundamental spirit of the tea ceremony by bringing tranquility to the atmosphere in saying "sit awhile and let's have tea." In a Zen temple, this atmosphere is of primary importance, especially when some admonishment is required.

A tea ceremony master's basic motto is: if in one's living quarters the rain does not leak, there is food to sustain life, fresh water is available and a fire is lit, then heat water and prepare tea. The first bowl of tea is an offering to Buddha and the second bowl is offered to the guest. This bowl of tea in addition to being a beverage also serves as a symbol for attaining a total understanding of the spirit of *wabi*. The spirit of *Wa Kei Sei Jaku* is shared in the single bowl of tea.

This *zengo* is often displayed in a tea ceremony room when powdered greet tea is being served. Is it any wonder that this *zengo* is used in a tea room?

Sha Za Ki Ssa* ("Have Seat Drink Tea") by Gengo Akiba Roshi of Kojin-An, Oakland, Calif., from the *Rinzairoku

Sha Za Ki Ssa ("Have Seat Drink Tea") in the Kaisho Style

In *kaisho*, the upright strokes 1 and 2 curve slightly toward the center, which gives a somewhat tight visual effect. Compare this ideogram with the more rounded effect in the work by Gengo Akiba Roshi (page 100). This tighter form is based upon the classic Chinese ideograms in *kaisho* style, but some Chinese might write it in more rounded form as the Japanese do. These are among the choices one can make in *shodo*. In this statement, notice that the ideogram for "sit" is not the one applying to sitting *zazen*, but to drinking tea: the upper part shows two persons. The artist chose to use this ideogram to enhance the meaning of the statement. This is one of the pleasures and challenges in *shodo*.

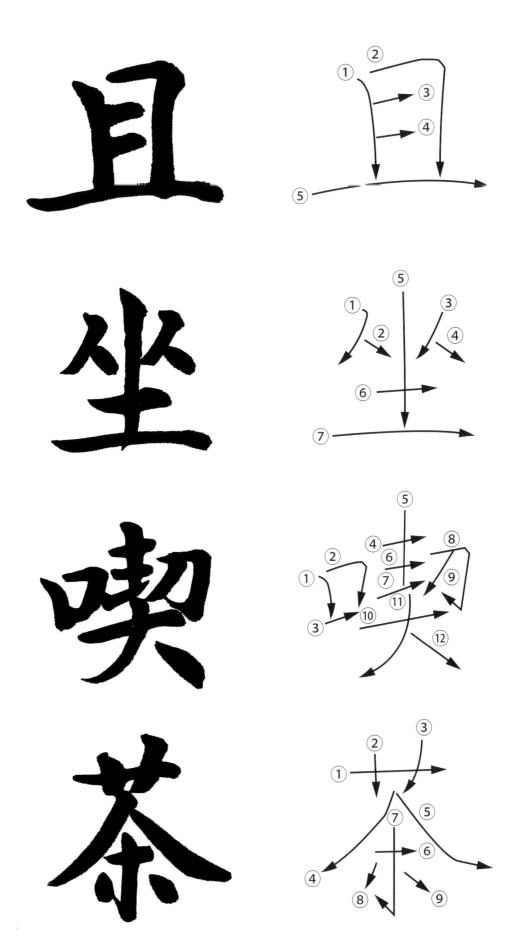

Sha Za Ki Ssa ("Have Seat Drink Tea") in the Gyosho Style

Notice the changes in simplification from *kaisho* to *gyosho* in each of the ideograms.

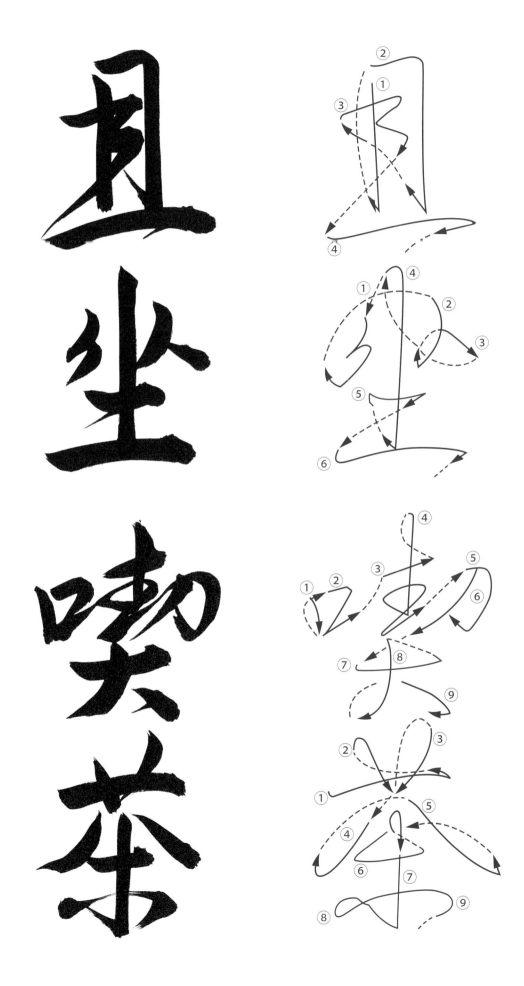

Zuisho Nushi To Naru
("Wherever, Become Your Own Master")

This *zengo* means that under all conditions, if you are awakened to the primary source in life, your self-direction and spiritual activities will be free. When you have removed illusions, reckless bigotry and ego, concerns in activities such as social etiquette and self direction will be wisely executed. Your judgment and decisions must be based upon wisdom from your personal experiences and teachings from wise elders; then you will be able to master your own actions and decisions. In Zen philosophy, the "true world" is daily living. Within this daily life, the sacred and common activities become "one" and we should face them with discipline.

The work at right is written in the *gyosho* style. Compare this *zui* with the *zui* in *Zui Ha Chiku Rō* on page 97 to see the differences between *kaisho* and *gyosho*.

Zuisho Nushi To Naru ("Wherever, Become Your Own Master") by Zakyu-An Senshō

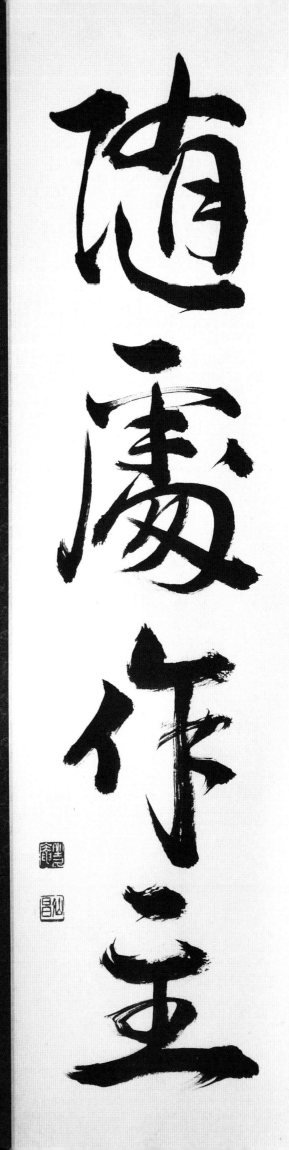

Zuisho Nushi To Naru ("Wherever, Become Your Own Master") in the Kaisho Style

The first ideogram is the same as that in a statement we focused on earlier, "Ocean Waves After Surf." The first and second ideograms require many strokes, but the third and fourth ideograms are much simpler and have fewer strokes. Therefore, in the first and second ideograms, make the strokes narrower and thinner to accommodate the strokes in the given space. The last ideogram has only 5 strokes, so use slightly thicker lines which will provide balance for the total statement.

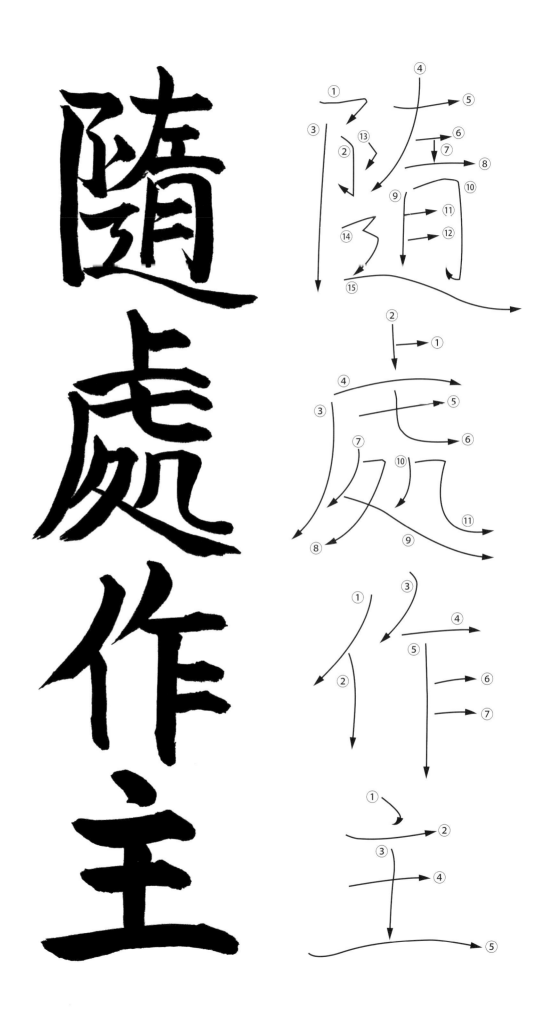

Zuisho Nushi To Naru ("Wherever, Become Your Own Master") in the Gyosho Style

In *gyosho*, the first ideogram has been greatly simplified and strokes 7 and 8 have been omitted. In the second ideogram, too, the strokes have been combined and simplified.

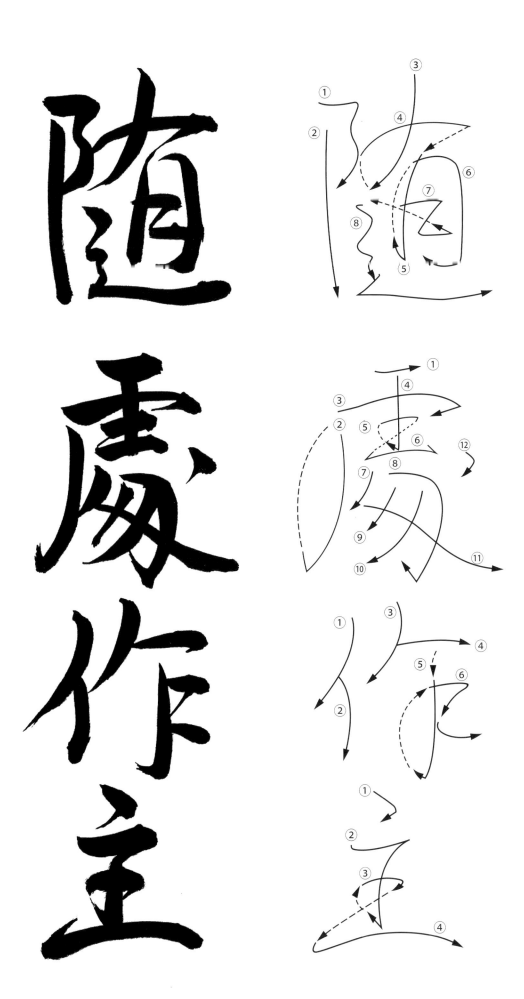

Dai Dō Mu Mon ("Great Path No Gate")

Zen is deeply rooted in the teachings and doctrines of Mahayana Buddhism and it gradually developed a rich textual tradition based on the interpretation of the Buddhist teachings and the recorded sayings of Zen masters—even though Zen tradition emphasizes that direct insight, expressed in daily life and not in words, is the path to the attainment of enlightenment. Sacred texts are thus regarded as no more than signposts pointing the way, "the finger pointing to the moon."

The teachings of Zen Buddhism include various sources of Mahayana thought, including, sermons, recorded sayings and teaching stories (enigmatic questions or contradictory statements) between Zen masters and their students that developed into various collections of *koan*. Among the main literary sources in Japan are Dogen's *Shobogenzo*, the authoritative text of the Soto sect (see page 173), which emphasizes zazen (seated meditation), and Wumen's *Mumonkan* ("The Gateless Gate"), a collection of 48 koan and commentaries compiled in the thirteenth century of rules on how to connect with the Buddha. Each koan illustrates an obstacle to insight and the path through the door or gate towards some essence of the spirit of Zen. The Confucian classics noted that the great path is the fundamental truth and surpasses unnecessary details. In life, any study in a school requires that one must pass

Dai Dō Mu Mon ("Great Path No Gate") from the Mumonkan by Gengo Akiba Roshi of Kojin-An, Oakland, Calif.

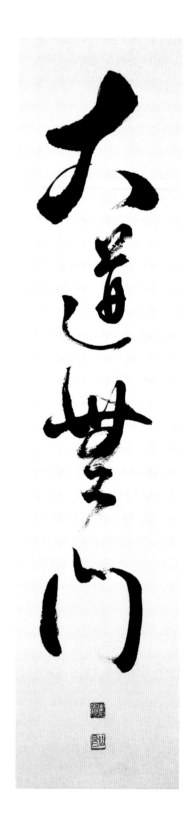

Dai Dō Mu Mon ("Great Path No Gate") from the Mumonkan by Zakyu-An Senshō

Dai Dō Mu Mon ("Great Path No Gate") in the Kaisho Style

In this four-ideogram statement, the first one ("great") is composed of only 3 strokes, so use wider lines to keep it in balance.

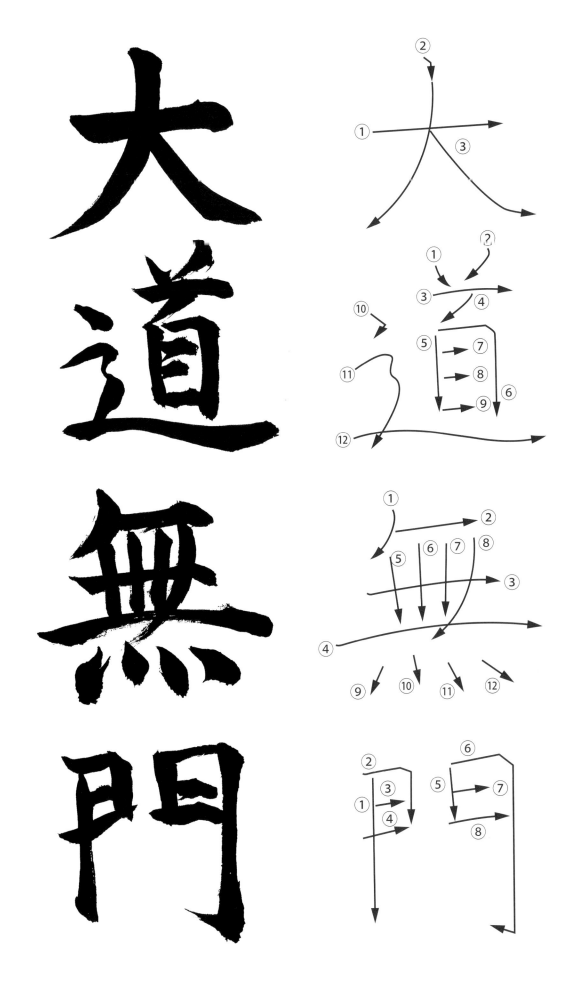

the gate. However, in the study of spirituality, attitude and readiness are required. The gate to the **truth** is open in every direction. The great tea master Sen no Rikyu's teaching was that "the wish to study that comes from the soul is the true teacher."

The two *ichigyo mono* on page 106, *Dai Dō Mu Mon*, derived from the *Mumonkan*, imply that in the path towards enlightenment, there is no gate. The "passport" is the *busshin* or Buddhist soul within you. Both works combine *gyosho* and *sosho* styles in the brush strokes.

Dai Dō Mu Mon ("Great Path No Gate") in the Gyosho Style

The third ideogram, *mu*, has been simplified and the four, three or two dots have been reduced to a line. These adjustments are all purely artistic decisions on how to create balance among the ideograms in the statement.

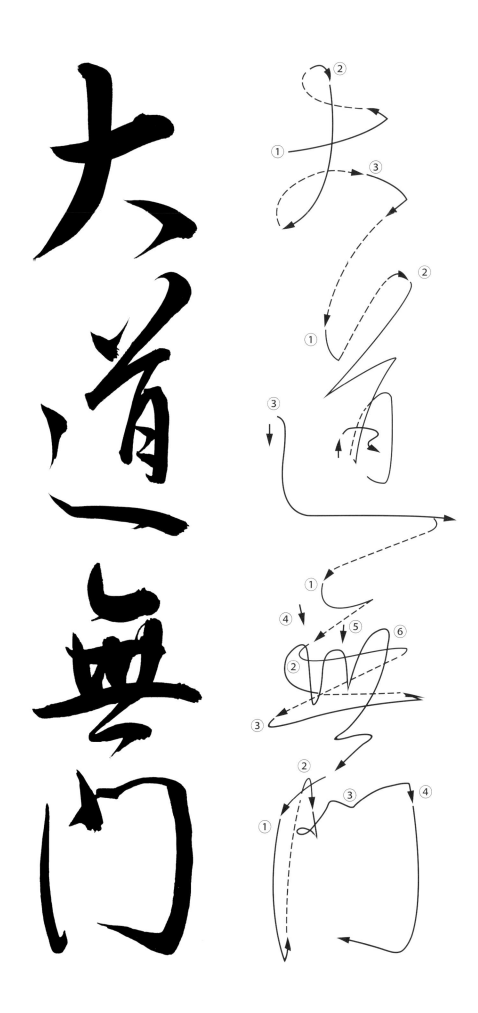

Shiru Ki Sore Kami (Ki O Shiru Wa Kami) ("Know Timing Is God")

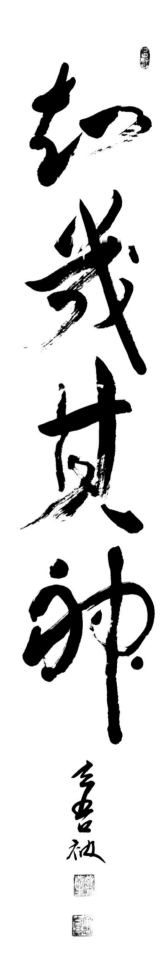

The term "god" means different things to different people, cultures and religions. In Japan, *kami*, the term used for god, is very general and en compasses many different concepts and phenomena. It is fundamentally identified with the sacred nature of the universe and it dwells in all things—natural phenomena like wind and thunder; natural objects like the sun, rivers, trees and rocks; some animals; guardian spirits of the land, occupations and skills; ancestral spirits; spirits of individuals who have accomplished meritorious service or achieved greatness, etc.

In the *zengo* above, to "Know Timing Is God," "timing" is best understood in the context of Japanese religious consciousness, which is imbued with the sense that we are a part of and are influenced by the natural world in our daily life. Our days are filled with the need to make decisions, many of which we may hesitate to make. However, there may be times when an opportunity must be seized, as it will lead to successful results. When an opportunity rises unexpectedly, it is clearly wise not to overlook the possibilities. Opportunities or chances occur all the time, yet how does one foresee these? To recognize and know "the moment" or "the time" is everything and depends upon heightened "awareness" as well as relevant knowledge and experience. This perception is what leads to "knowing the timing." This does not mean, however, that recognizing timing is tied to personal and selfish gains from the good will of others. In the world of Zen, with the guidance of a mentor, when one's spirit becomes uncluttered and with a clear-sighted view leads to *satori*, then with a self-generated power "recognizing the right" time should intuitively arise.

This zengo's wording, *Shiru Ki Sore Kami,* is actually modeled after the Chinese. In normal Japanese grammar, the phrase would be *Ki o shiru wa kami*. The first example of this statement, by Gengo Akiba Roshi, is written in a combination of *gyosho* and *sosho* styles. The second example (page 110) is in the *gyosho* style.

Shiru Ki Sore Kami ("Know Timing Is God") by Gengo Akiba Roshi of Kojin-An, Oakland, Calif., from Confucius

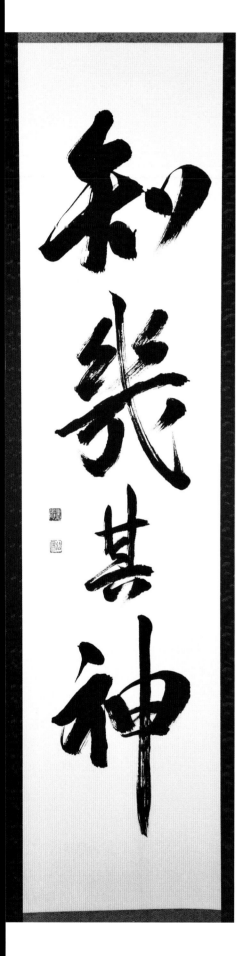

Shiru Ki Sore Kami ("Know Timing Is God") in the Kaisho Style

In the last ideogram, *kami*, the final stroke is usually tapered at the end. However, in this sample, stroke 9 stops with a stronger ending to give a more emphatic meaning to *kami*.

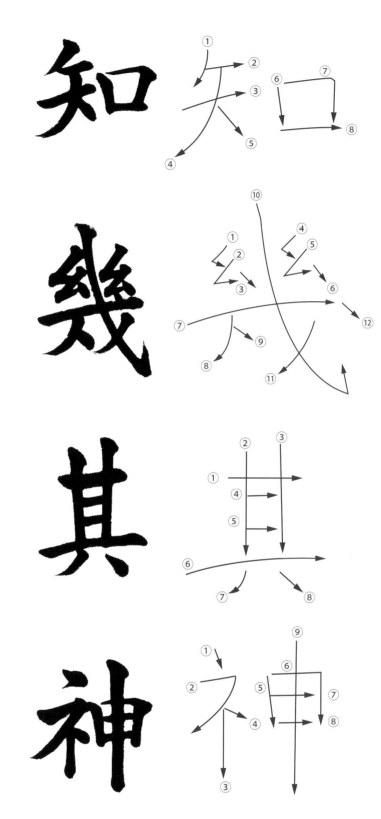

Shiru Ki Sore Kami ("Know Timing Is God") by Zakyu-An Senshō

Shiru Ki Sore Kami ("Know Timing Is God") in the Gyosho Style

In practice, one will learn the order and flow of the strokes. However, when composing the statement as a work of art, certain words such as *sore* ("is") may be made smaller in order that the meaning is given more emphasis and prominence. These are purely artistic decisions.

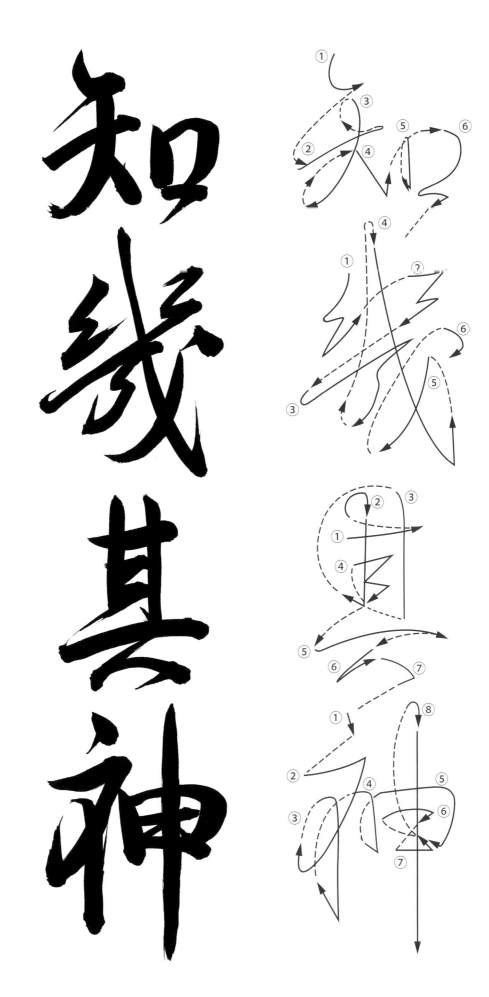

FIVE IDEOGRAM ZENGO 五字篇

獨坐大雄峰

Hon Rai Mu Ichi Butsu
("Originally [There Was] Not One Thing")

This is another *zengo* at the heart of Zen philosophy. Daiman Konin (601–74), the Fifth Buddhist Patriarch in the direct lineage of the Bodhi Dharma, in search of a successor posed the question: "What is the true core of Zen?" One of his disciples, the reputedly brilliant Jun Su, posted on the wall of the temple: "My body is a bodhi tree, my heart a shining mirror; discipline is constantly used to remove the dust and dirt to keep it shining and free." In other words, it is necessary to remove worldly desires and delusions to maintain the purity of *bussho* (Buddha-nature). After reading this statement, his fellow monks proclaimed him a suitable successor. The following day, next to Jun Su's statement, a new one appeared. "The body is not the bodhi tree; there is no stand or shining mirror; all things come from nothing; where can the dust alight?" That is, the purity of *bussho* is not substance; a shining mirror or heart does not exist. If there are no fixed substances, how can the dust alight? It was the work of an apprentice monk, Eno (Hui Neng, 638–713), whose statement is interpreted as "All things return to nothingness: cleanliness or filth must be surpassed." This explanation is one of the most basic of Buddha's teachings. Recognizing Eno's extraordinary insight and understanding, the Fifth Patriarch secretly presented him with the certificate of an enlightened monk and told him to leave the temple that evening, realizing that Eno's relationship with his colleagues would be compromised. Daikan Eno later became the Sixth and Last Patriarch. He stressed the importance of *furyu monji* (*fu*=not; *ryu*= standing; monji= literature), "not depending upon literature in seeking the truth." His message was that "Your heart is the Buddha. To be able to recognize this, you must have a pure mind."

Hon Rai Mu Ichi Butsu is also a very important *zengo* for those who practice *chado* (*cha*=tea; do=way of) and is why tea masters and Zen priests often say *Cha Zen Ichi Ni* or "Tea and Zen are the same taste." Drinking tea from a simple bowl, even one that has been mended, in an atmosphere of tranquility and simplicity, epitomizes the spirit of *chado*. In cold weather, the charcoal brazier is moved closer to the guests, and together with the bowl of tea, provides the necessary heat. This atmosphere of simplicity also suggests the true spirit of *wabi* and *sabi*. Some tea practitioners, however, are lured into collecting material objects, such as seasonal utensils, preparing splendid settings and offering lavish food. But excess is not a part of the "Zen spirit." In *chado*, the most important element is to share the warmth and compassion of the human spirit, the true meaning of *wabi–sabi*. Hence the statement "Originally come with not one thing" is greatly revered by tea practitioners.

LEFT **Hon Rai Mu Ichi Butsu ("Originally [There Was] Not One Thing") by Gengo Akiba Roshi of Kojin-An, Oakland, Calif.**

RIGHT **Hon Rai Mu Ichi Butsu ("Originally [There Was] Not One Thing") by Ariake-An Kōshō**

My *chado* teacher's mother, Ariake-An Kōshō, was an established tea practitioner and calligrapher who, along with her daughter, taught me many aspects of *chado*. She was about 70 years old when she wrote this *ichigyo mono*. When I moved to the United States in 1964, this was her gift to me. At that time, I was still not mature enough to understand the true meaning of the statement, but now I am impressed by her wisdom in selecting it for me. Her work is unpretentious but shows inner strength.

When she created the work, her brush was fully loaded with ink, so the first ideogram has a slight *nijimi* effect, resulting in a softer appearance. By the third ideogram, *mu*, the ink is running out, so a dry brush effect is achieved but she nevertheless moved on to completion employing her inner energy. The brush was reloaded for the fourth ideogram, and hence both wet and dry brush effects are created.

Hon Rai Mu Ichi Butsu ("Originally [There Was] Not One Thing") in the Kaisho Style

Any person who practices the art of calligraphy should begin with *kaisho* so that the formal order of strokes and composition are firmly fixed in mind. Then one can move on to *gyosho*. In this example, notice that the first and second ideograms are larger in comparison to the three following. Study this statement in *kaisho* and see how the overall effect is achieved.

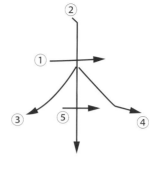

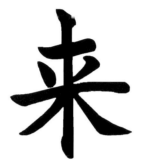
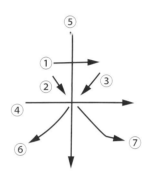

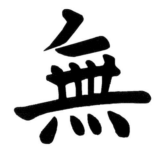
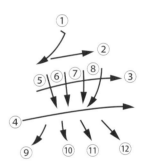

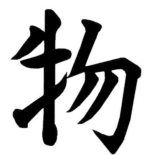
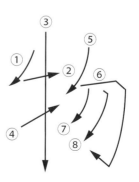

Hon Rai Mu Ichi Butsu ("Originally [There Was] Not One Thing") in the Gyosho Style

The order of strokes in the first ideogram has been greatly readjusted, compared to *kaisho*. Note and be aware of the difference. In many *ichigyo mono*, the ideogram of *mu* will appear many times. Historically, famous calligraphers have developed their own personalized manners of writing it.

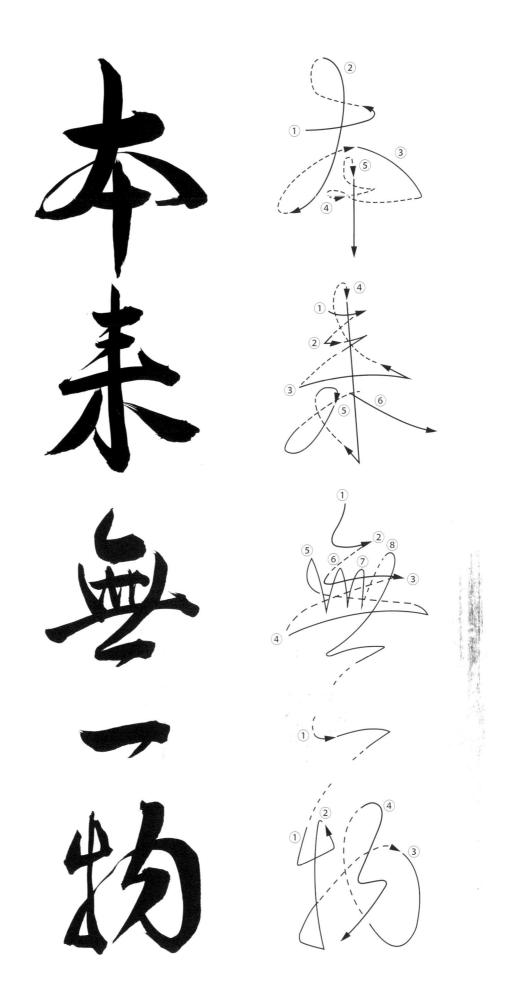

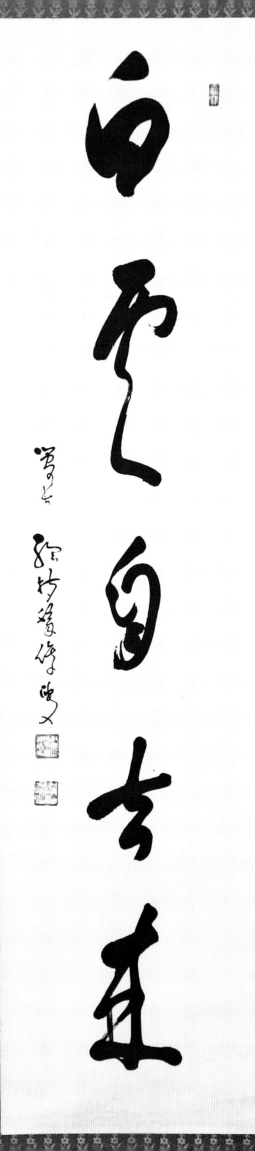

Haku Un Onozu Kara Kyo Rai Suru ("White Cloud Oneself Come and Go")

This *zengo*, read in Japanese, is one of a pair that form a complete statement. (The other half is "The Blue Mountain, Originally Does Not Move.") The two statements are used as an analogy between the eternal elements of the mountain and the ephemeral elements of the white cloud. However, in *zengo*, the focus is more on the statement about the white cloud. The white clouds move around an immobile blue mountain. The mountain is a metaphor for the person who comes into this world with *bussho*, or a Buddha nature for this eternal aspect. White clouds represent the ever-changing world desires and illusions which come and go while one is trying to focus on satori.

Both examples are written in the *sosho* style, but the work by Iwamoto Roshi uses a fluid brush movement with the use of ample ink. Shibayama Roshi uses a unique type of brush, possibly with bristles composed of horse hairs, which provide a special effect in

Haku Un Onozu Kara Kyo Rai Suru ("White Cloud Oneself Come and Go") by Katsutoshi Iwamoto Roshi of Soji-ji, Yokohama

each stroke. While the subject was white cloud, the Roshi used a dry textured line which is quite opposite from what is generally expected. The coarse lines may represent the subconscious elements that are suppressed.

Haku Un Onozu Kara Kyo Rai Suru ("White Cloud Oneself Come and Go") in the Kaisho Style

In the *kaisho* style, wider strokes are used for *haku un* (white) in the first ideogram. The second ideogram has more than double the strokes, so much thinner strokes are used in the composition of *un* or *kumo* ("cloud"). This is a good example to show whether thicker or thinner lines in the stroke should be used within an ideogram.

Haku Un Onozu Kara Kyo Rai Suru ("White Cloud Oneself Come and Go") by Zenkei Shibayama Roshi of Nanzen-ji, Kyoto

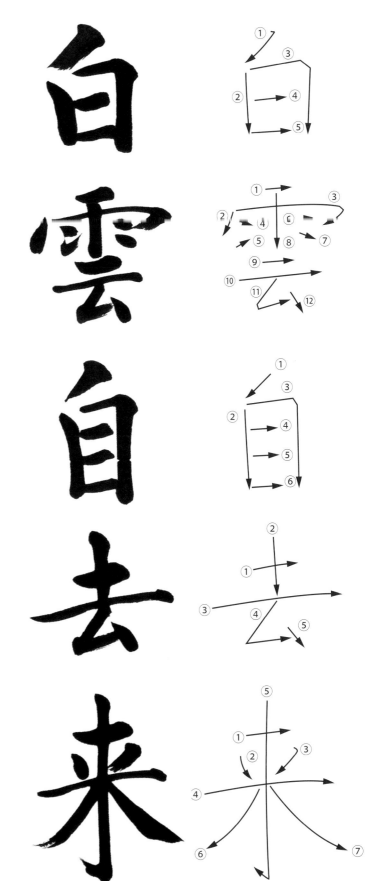

Haku Un Onozu Kara Kyo Rai Suru ("White Cloud Oneself Come and Go") in the Gyosho Style

In the *gyosho* style, especially in upright form, the contour of the ideograms may take on an hour-glass shape, with the first outer form being smaller, the second larger, then the next smaller and so forth.

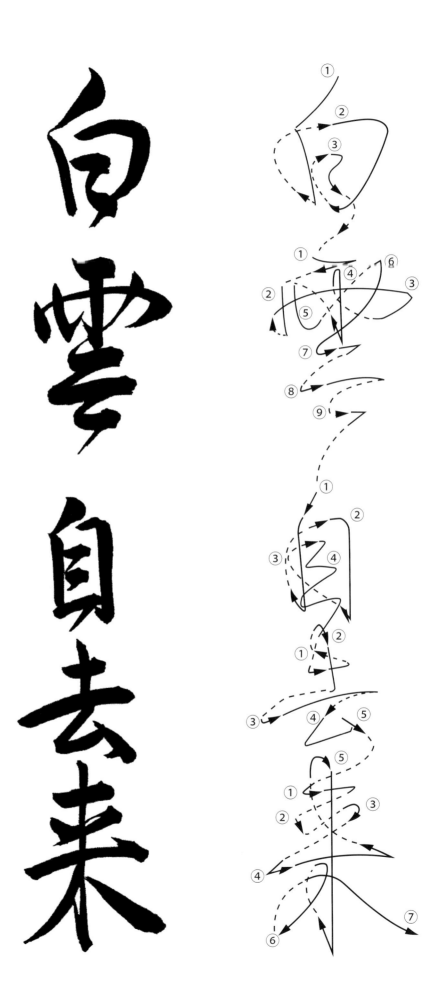

Doku Za Dai Yū Hō ("Alone Seated on the Great Summit")

Hyakujo (749–814) was the direct heir of Ma-tsu (Baso Doit-su, 709–88), one of the most famous Zen masters of all time. Hyakujo became best known for his establishment of the first truly Zen monasteries and his treatise on sudden enlightenment. He organized how life within a Zen temple should be carried out, including the arrangement of buildings, ceremonial aspects, rules and the strict and ascetic routines that are a part of a monk's daily activities. Today, it is accepted that the realization of the core values of Zen come through performing daily activities, what is known as the Hyakujo purification system. "If you have not produced one day, then you shall not eat that one day."

One day a young monk asked Haykujo Zenji, "What do you gain by practicing Buddhist teaching?" Hyakujo Zenji answered, "Alone seated on the great summit." In Buddhist cosmology, a sacred or mythical mountain, Shumisen (Mount Meru or Sumeru in popular Indian cosmology), was believed to stand at the center of the universe—Buddha's mythical home—surrounded by seas and continents. The power lies in the center of the mountain, with the sun and moon circling it at mid-point. When one metaphorically sits on the summit of such a mountain, it is as if he is master of the universe. Another symbolic reference is that one who resides in a remote area, far from the city but living self-sufficiently and practicing *zazen*, is as independent as a "star."

As Shakamuni stated soon after his birth, "Above and below, I am the only one" which means that there is only "one" in all the things in the universe.

Doku Za Dai Yū Hō ("Alone Seated on the Great Summit") by Shōdō Yoshida Roshi, Ken Chō-ji, Kita Kamakura

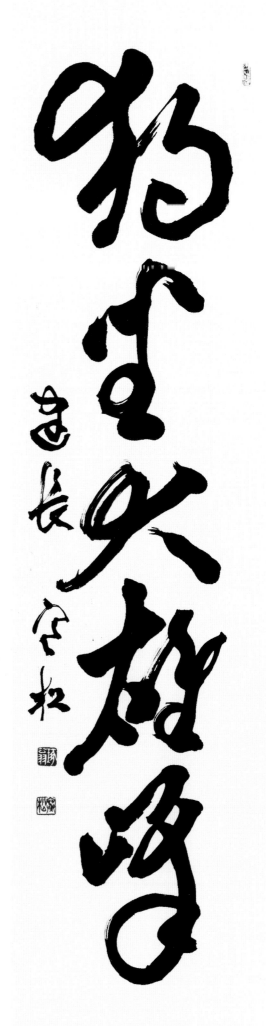

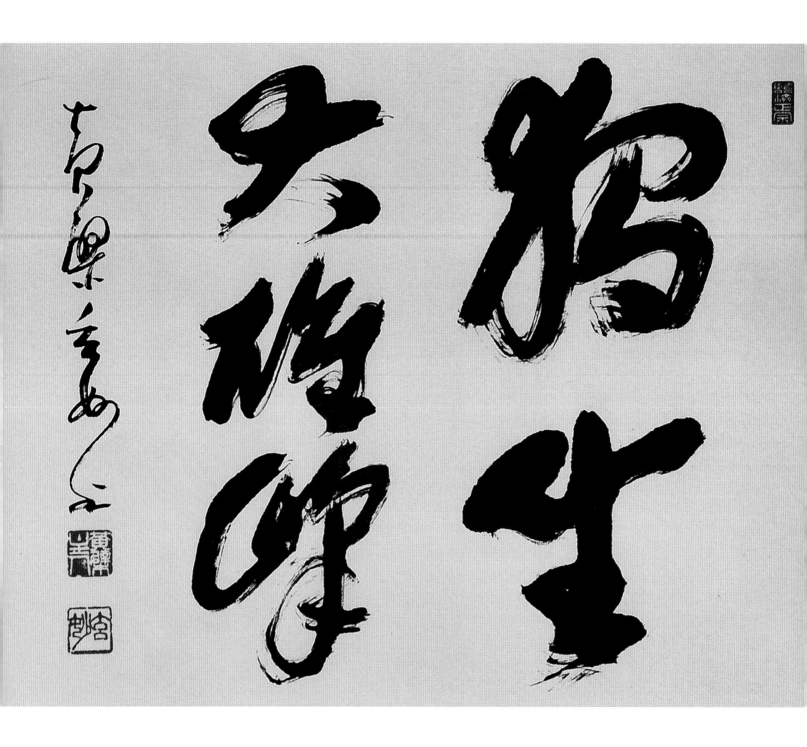

Doku Za Dai Yū Hō ("Alone
Seated on the Great Summit")
by Genmyō Murase Roshi of
ManPuku-ji Ōbaku Shu, Kyoto

Doku Za Dai Yū Hō ("Alone Seated on the Great Summit") in the Kaisho Style

As has been mentioned before, many Chinese ideograms are made up of two or three parts. So when considering the parts as a total composition, the brush movement from the left to the right side of the ideogram requires delicate adjustment in the thickness of the lines. For instance, in the first ideogram here, *doku* ("alone"), the left part is a simple unit of three strokes while the right side is composed of thirteen strokes. The common practice is to make the three strokes on the left larger than the strokes used on the right. This is the general practice in writing Chinese ideograms in *kaisho*.

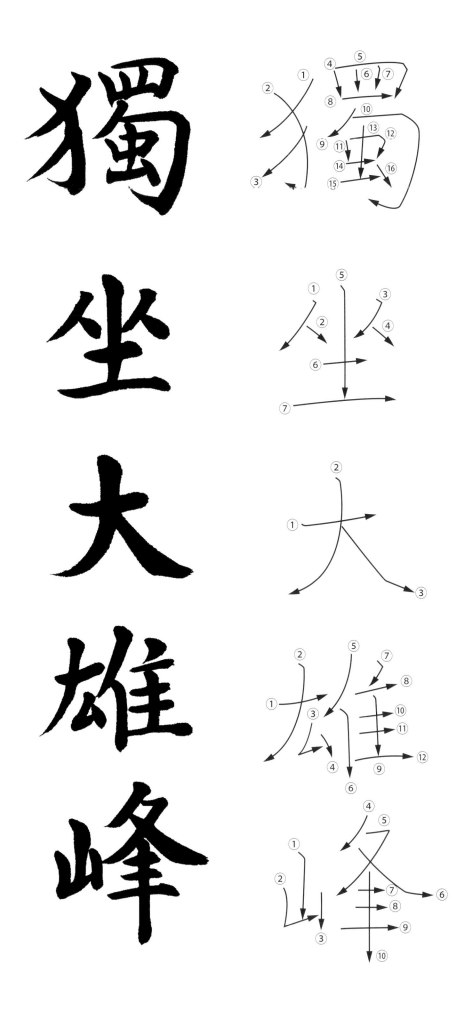

Doku Za Dai Yū Hō ("Alone Seated on the Great Summit") in the Gyosho Style

Compare and notice how the ideograms have been simplified in the *gyosho* style.

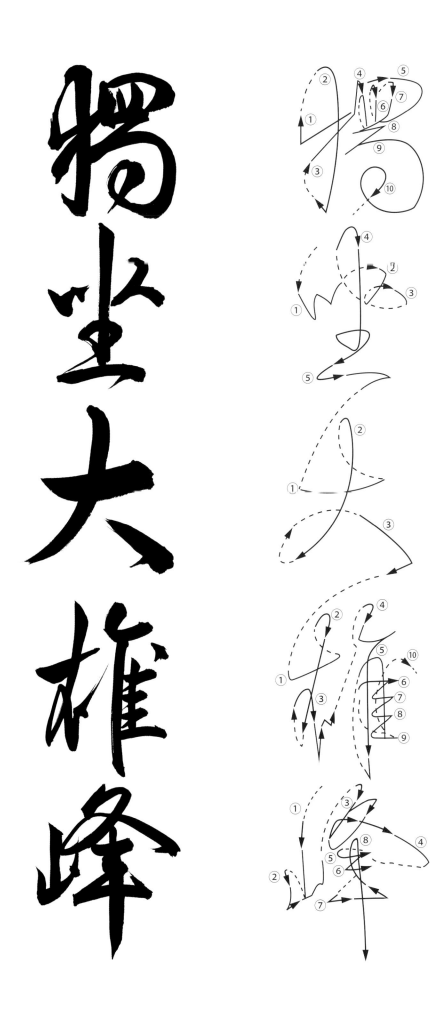

Nichi Nichi Kore Kō Jitsu ("Every Day Is a Good Day")

This *zengo*, taken from the *Hekiganroku* (Blue Cliff Records), a collection of case stories (*koan*) of Zen Buddhist masters originally compiled in China in 1125 during the Song dynasty and then expanded into its present form by Yuanwu Keqin (1063–1135), is one of the most universally acclaimed sayings, not only by Zen monks but also by tea masters, artists and other Zen practitioners.

Although Zen monks, for hundreds of years, have devoted their lives to being present in everything they do through concentration, tranquility and mindfulness, and to being dedicated and serving others, they cannot escape communication with regular society. Emotionally, they experience joy, anger, sadness and pleasure within a temple compound as well as human relationships. All of these are part of human existence. Often the monks experience difficulty with their special religious pursuits. Accepting the inevitability of a range of human emotions and realizing they must be incorporated in daily living leads to the dictum "Every day is a good day."

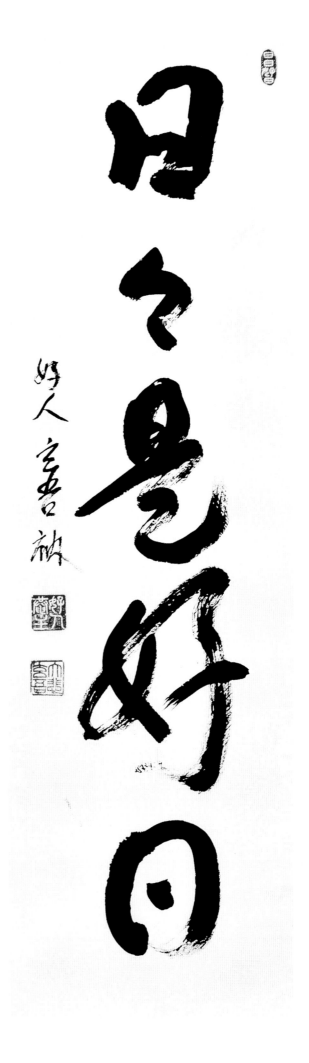

Nichi Nichi Kore Kō Jitsu ("Every Day Is a Good Day") by Gengo Akiba Roshi of Kojin-An, from the *Hekiganroku*

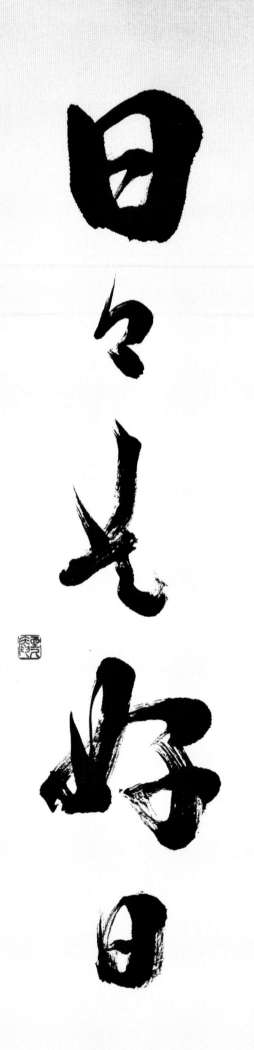

A trouble free world is not possible because of the very nature of the universe. When one is able to transcend or rise above these complexities, "Every day is a good day."

In the example by Zakyu-An Senshō, the third ideogram for *kore* is in an abbreviated *sosho* form and the ideogram for "day" is attenuated purely for artistic and compositional purposes. *Kaisho*, *gyosho* and *sosho* styles can be combined to both provide visual pleasure and to convey deeper meaning. The three different styles in writing *kore* or *ze* are discussed in Chapter 4.

Nichi Nichi Kore Kō Jitsu ("Every Day Is a Good Day") by Zakyu-An Senshō

Nichi Nichi Kore Kō Jitsu ("Every Day Is a Good Day") in the Kaisho Style

A statement of *ichigyo mono* may be short but the same ideogram may appear several times. For instance, in this statement, the ideogram for "day" appears three times. The common practice is to use a symbol which means "repeat"; you can see it in both the *kaisho* and the *gyosho* samples here. If the ideogram is to be used again, then its style will change. Notice the example in Gengo Akiba Roshi's art (page 125). This style harkens back to the days of the original pictogram.

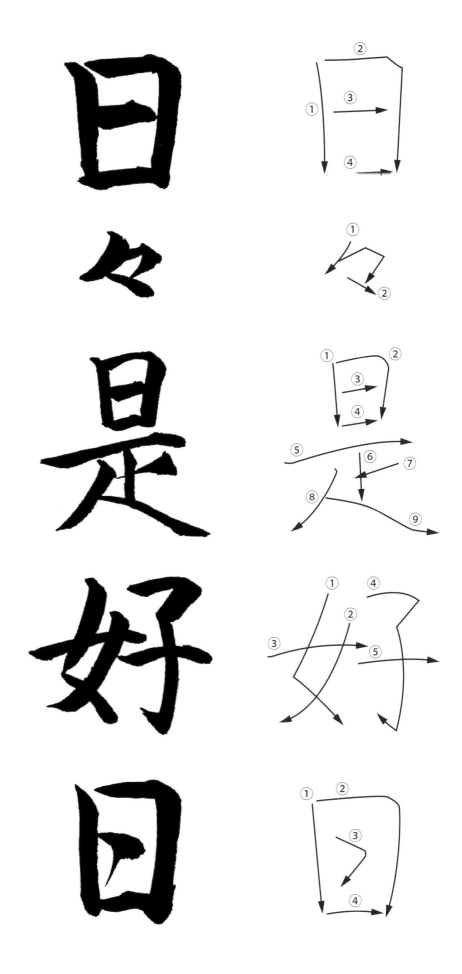

Nichi Nichi Kore Kō Jitsu ("Every Day Is a Good Day") in the Gyosho Style

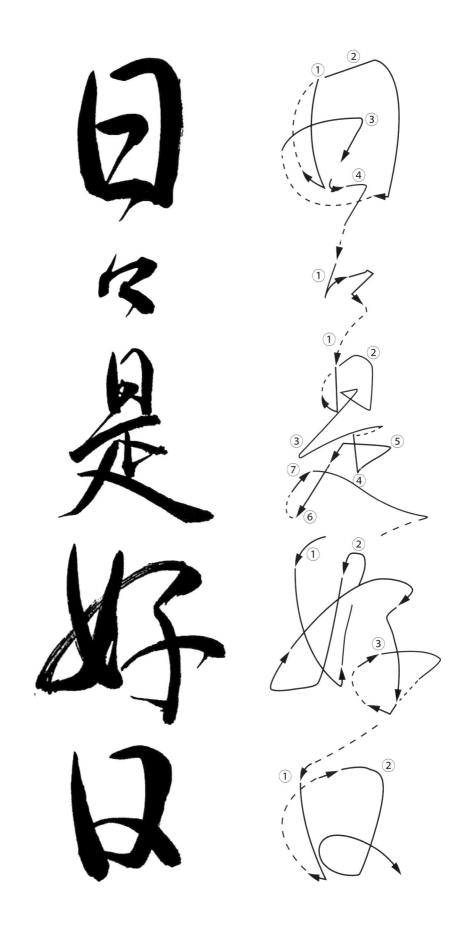

Hō Ken Ari Shu Ri ("Treasure Sword in My Hand")

Treasure sword is held by Dainichi Nyorai, the Great Sun Boddhisattva. Bodhisattvas are those wise and compassionate beings that appear in many forms and represent Shakamuni Buddha himself. This Boddhisattva, who holds a sword upright in the right hand to show his strength and unchanging enlightened status, carries a special message. Good or bad, love or hate, agony or joy; worldly attachments and delusions of the mind: all must be cut from the mind with this treasure sword. Because the spirit of *bussho* is within each of us, in order to protect this *bussho,* one must utilize this sacred sword. The meaning of this message is "use this sacred sword within us" when necessary to make the right decisions. This means to reach back to the *bussho* within and make it a living force to eliminate what is unnecessary. This allows greater freedom in the "decision making process" and at the same time this treasure sword can be used to "cut open the passage to enlightenment." Remove the unnecessary self-centeredness and use this sword to open the way to freedom. For the Zen teachers, who have great abilities and have used their experiences during training to develop a maturity with wisdom, intelligence and wit, it can be said that these qualities are their treasure sword.

During the Edo Period (1600s to the Meiji Restoration) samurai who practiced tea every day were not allowed to carry their short self-defense swords into the tea room. By the outside wall of the entrance to the tea house there was a special apparatus for hanging swords. With swords hanging on the outside wall of a tea house, this statement may seem to be out of place. Yet the samurai influence was strong in *chado* and during the process of preparing a bowl of tea, the host holds the dipper and *chashaku* (tea scoop) in a similar manner as holding a sword.

Hō Ken Ari Shu Ri ("Treasure Sword in My Hand") by Zakyu-An Senshō

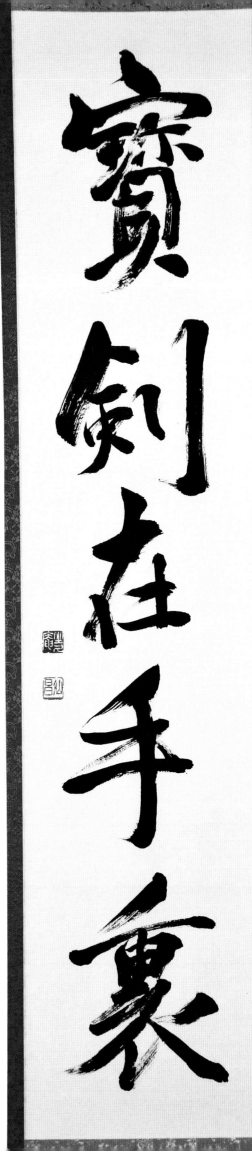

Hō Ken Ari Shu Ri ("Treasure Sword in My Hand") in the Kaisho Style

In artistic writing, the ideogram for "treasure," at the bottom, should be rendered in the classic *kaisho* style. In contemporary writing, the simplified version of "treasure," at bottom right, is sometimes used.

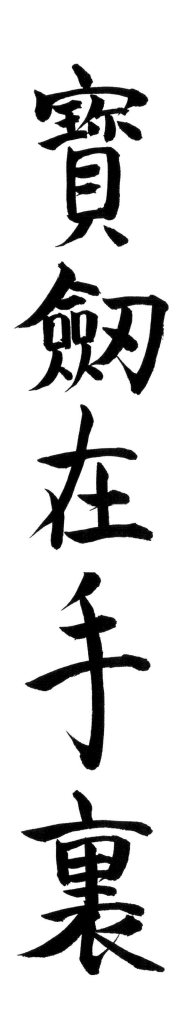

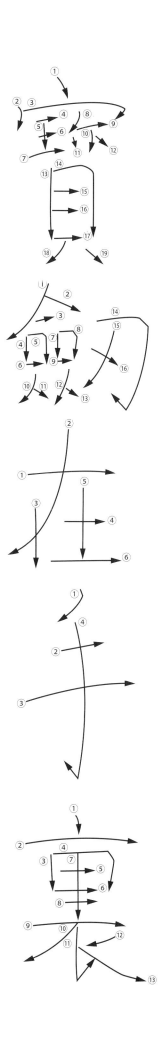

Hō Ken Ari Shu Ri ("Treasure Sword in My Hand") in the Gyosho Style

Many Chinese ideograms have been simplified and the number of strokes has become minimal for daily use. But in the art of calligraphy, in many cases the original or "old fashioned" form of the character is used. This use is of course purely a personal choice. Some shodo practitioners maintain that ideograms that contain many strokes are easier to compose than those containing only a few strokes. However, in this case a simplified version has been used. Here, for example, the third and fourth ideograms are much more difficult to compose for an overall balance of ideograms in the statement.

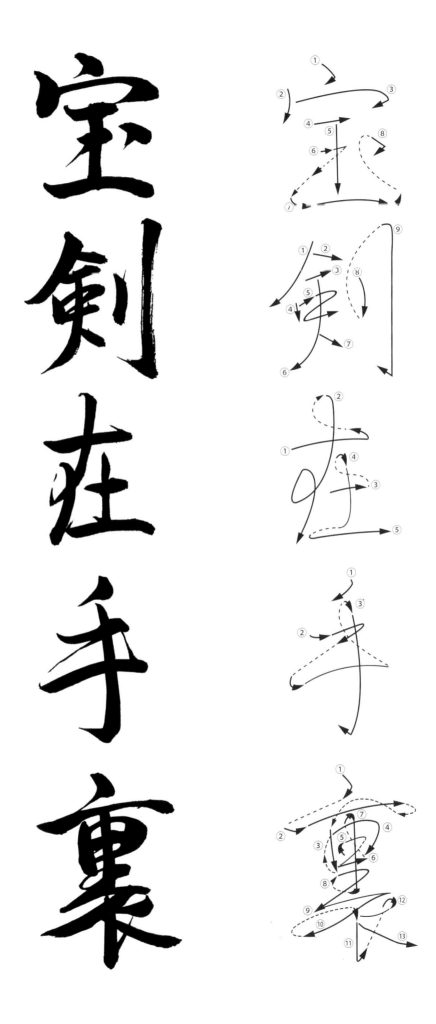

Sei Fū Shū Chiku O Ugokasu ("Fresh Breeze Affects Serene Bamboo")

The famous Zen priest Zenji Takuan (1573–1645) commented that *The Six Hundred Volumes of Hanya Sutras* presents hundreds of thousands of religious messages through their teaching methods which speak of *nothingness* and *emptiness*. These millions of words or teachings are equivalent to "bamboo leaves in a forest." Countless hours of guidance with Zen masters, koans and meditation may take place but the moment of enlightenment will actually come at an unexpected moment, just as a falling bamboo leaf in a forest. Takuan was also known for his role as the teacher in Zen philosophy for the famous swordsman, Miyamoto Musashi, who was so completely immersed in his understanding of Zen that he was able to use the spirit of *emptiness* or *nothingness* to win countless duels and he never lost. Musashi's ability to be in a state of emptiness or *mushin* allowed him to sense every move of his opponent which made him invincible. His actions were as spontaneously natural as a falling leaf of bamboo. Musashi is the author of the *Book fo Five Rings*, the essence of his strategies in the martial arts.

Takuan Zenji, born at the beginning of the Edo period, is known for his *tanka*, his *haiku* and the tea ceremony. Among his many writings, his book *The Unfettered Mind* has been translated into English (see Appendix). His *bokuseki*, which have not been presented in this book because they are in private collections, have been highly praised by generations of tea practitioners.

Sei Fū Shū Chiku O Ugokasu ("Fresh Breeze Affects Serene Bamboo") by Chisui Muroga, Oakland, Calif., from *Hekiganroku*

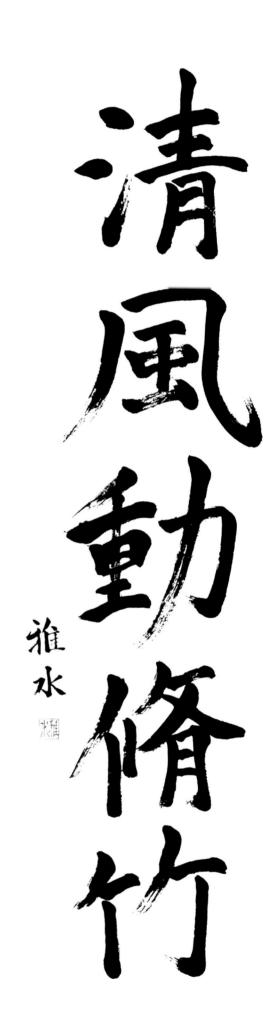

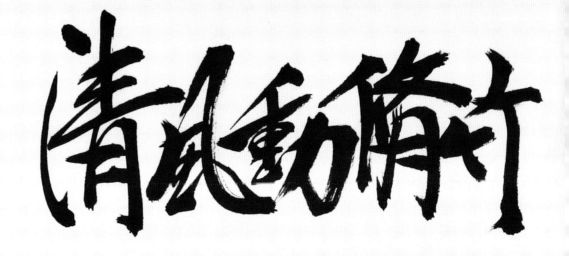

LEFT: This *ichigyo mono* was created by Madame Muroga Chisui, who was a teacher in *sho* for many years at the Japan House, located on the campus of the University of Illinois, Urbana-Champaign. In contrast to the professional *sho* practitioners who seek uniqueness in their work with the goal of displaying it in large exhibitions of *shodo,* an unassuming honesty and modesty permeates her work, reflecting her personality.

Sei Fū Shū Chiku O Ugokasu ("Fresh Breeze Affects Serene Bamboo") by Zakyu-An Senshō, from *Hekiganroku*

Apart from the philosophical Zen interpretation of this *zengo*—"nothingness" and "emptiness"—on another level the *zengo* evokes the unique sound of a cool, refreshing wind rustling a stand of bamboo. This makes it a popular *ichigyo mono* for display in a tea room, more so if the leaves of a bamboo cast shadows on the room's *shoji* screens. The *zengo* can, in fact, be equated to a *sumie* ink painting of bamboo, encouraging the senses "to enjoy the rustling sound of bamboo with one's eyes."

The horizontal composition is written from left to right. The creator has compacted all five ideograms to fit the narrow confines of the paper, which has dictated a different approach and technique. A single bamboo leaf falling in the large space beneath the ideograms perhaps suggests a bamboo grove and adds to the effect of a combination *zengo*/*sumi-e*. The red seal in the center bottom indicates that the central area is active empty space.

Sei Fū Shū Chiku O Ugokasu ("Fresh Breeze Affects Serene Bamboo") in the Kaisho Style

The ideograms in this statement utilize many straight strokes and some dots. However, in the second ideogram, stroke 2 has a dynamic curvature which must be incorporated in the overall composition. Also take note of the greater width in the strokes for the last ideogram, *take* ("bamboo").

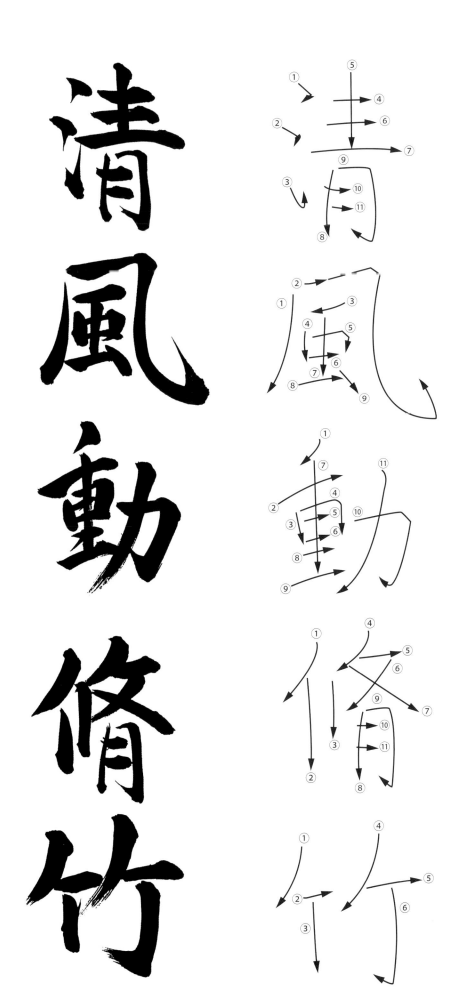

Sei Fū Shū Chiku O Ugokasu ("Fresh Breeze Affects Serene Bamboo") in the Gyosho Style

In the *gyosho* style of writing, notice the consolidation of some strokes as the brush takes on a flowing movement. In the example by Zukyu-An Senshu (page 133), because the writing is horizontal, the ideograms do not have a connecting line. However, when writing in upright form as here, the continuous movement of the brush strokes can be appreciated.

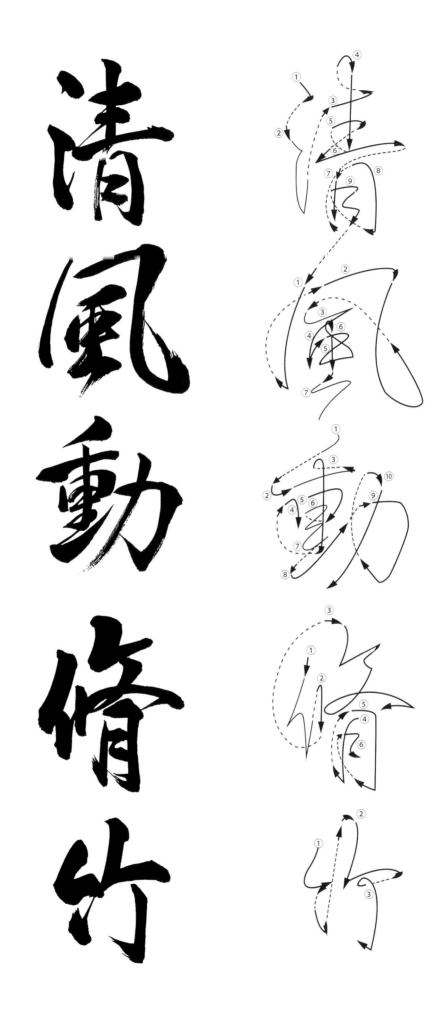

Gei Dō Kore Butsu Dō ("The Way of Art Is the Way of the Buddha")

All activities, including such creative work as writing poetry, painting, ceramics, performing on stage or on musical instruments, or the mundane daily necessities of cooking, washing, or cleaning can be carried out in the spirit of "The way of art is the Way of the Buddha." When a person is totally focused with body and soul on that activity, then even mundane duties are a path to the *bussho* within. This "way of art" must include the total involvement of body and soul carried out with great economy and perfection. This is a path to purifying the soul. In Zen temples, the monks carry out these temporal and secular activities as a form of meditation and call it *samu* (*sa*=make; *mu*=job created for the purpose of meditation).

In the fine and performing arts, the highest refinement in mastering techniques must first be acquired, then combined with personal emotional and philosophical elements to become a part of one's "blood and muscle" so that the expression can come easily without concern for the craft. For this creative passage, an individual must first take all the techniques and knowledge, and digest, ferment and completely incorporate them within body and soul. Then these elements must be subtracted from one's "consciousness" and the artist must return to the original state. Those who are successful in this process will produce excellent work and this is the mark of a truly great artist. The process is especially true in *shodo* and *sumie*. Once black ink is on the white paper it cannot be erased. So, before the brush is picked up, many preparation sketches must be developed in your mind: sometimes using the arm without the brush to go through the required movement so that the physical motion becomes familiar. The final result must be seen "in the eye of your soul" and is called *shingan* (*shin*=heart; *gan*=eye). When the final work is genuine and completed satisfactorily, this method is equal to the "Great Passage, no Gate."

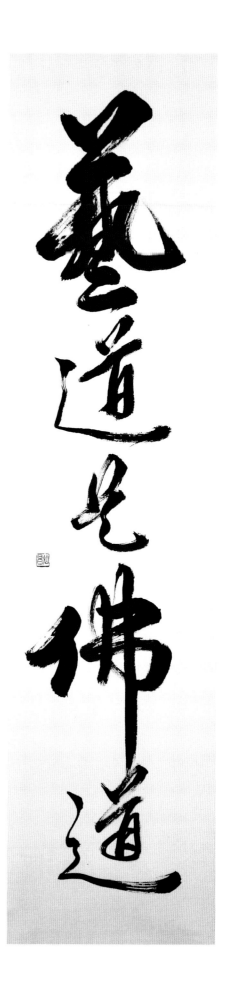

Gei Dō Kore Butsu Dō ("The Way of Art Is the Way of the Buddha") by Zakyu-An Senshō

Gei Dō Kore Butsu Dō ("The Way of Art Is the Way of the Buddha") in the Kaisho Style

When writing this statement it is important to keep the ideograms in proportion to the others. This is a challenge because of the wide differences in the numbers of strokes. The older form of the ideogram *gei* ("art") is very complex, with a total of 19 strokes. Therefore the strokes for its many parts are smaller. Study the ideogram: it will take practice to fit all of the strokes into the given space. The last ideogram is the simplified version of the ideogram for *way* (but in *gyosho* style the complex form is used; see the next example).

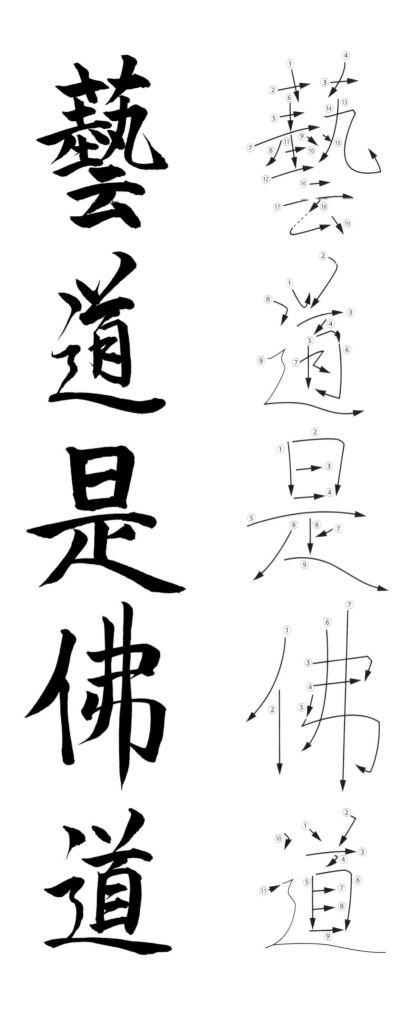

Gei Dō Kore Butsu Dō ("The Way of Art Is the Way of the Buddha") in the Gyosho Style

Study carefully how the writing of *gei* has been simplified here. Again, notice the flow as you move from one numbered stroke to the next.

The below ideogram, *dō* (*way* or *road*), shows the contemporary simplification found in normal use.

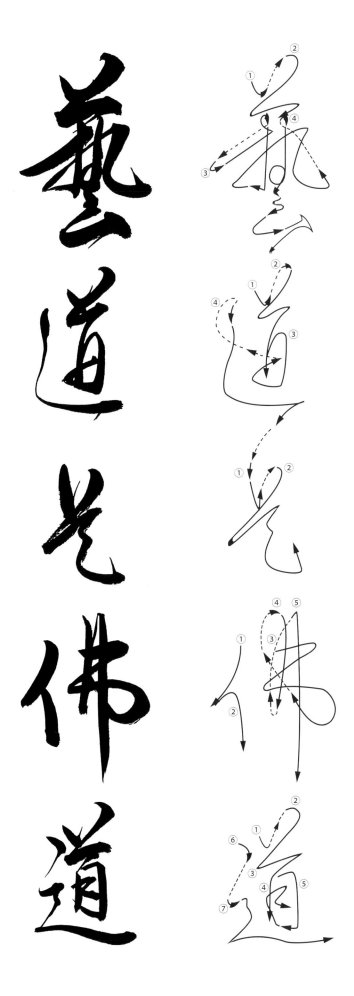

Kumo Sari Seizan Arawareru ("Cloud Passes Blue Mountain Appears")

Skies are covered with clouds and as they drift away, the beautiful blue mountain appears before your eyes. Clouds are used symbolically in many Zen statements; in most cases they are symbolic for indecisiveness, illusions or delusions concerning worldly desires. Clouds, of course, are daily occurrences for us, and elicit common phrases like "today is a sunny day" or "storm clouds are in the sky." Through such common subjects, the Zen world strives to guide us to the world of enlightenment. The metaphor is that one cannot understand or digest the meaning of "the truth" because it has been covered by clouds in our spirit. Teachers in Zen intuitively sense that the individual needs and causes of distress require individual answers, methods or passages, so there are a hundred different approaches for a hundred individual wandering souls.

The usual interpretation here might be that dark clouds have been swept away from your spirit. Yet the very next moment, unexpected calamities from natural or human causes may upset any tranquil spirit. Many a priest facing such disasters will be shaken and it takes utmost discipline not to lose the "spirit of *bussho.*" However, the blue mountain exists "right before your eyes," morning, noon or night whether it is a clear or a cloudy day. It is always there.

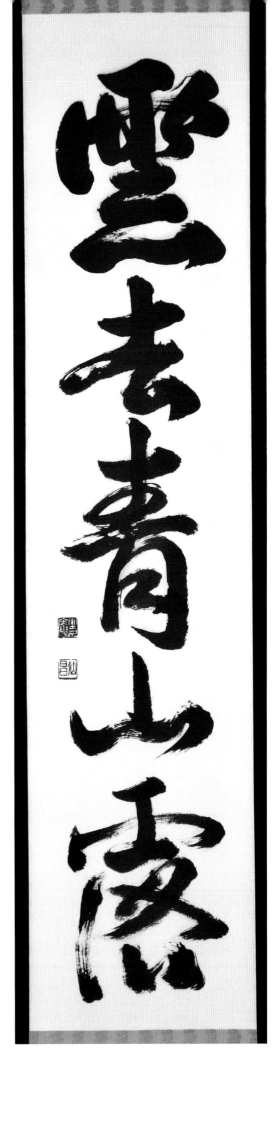

***Kumo Sari Seizan Arawareru* ("Cloud Passes Blue Mountain Appears") by Zakyu-An Senshō**

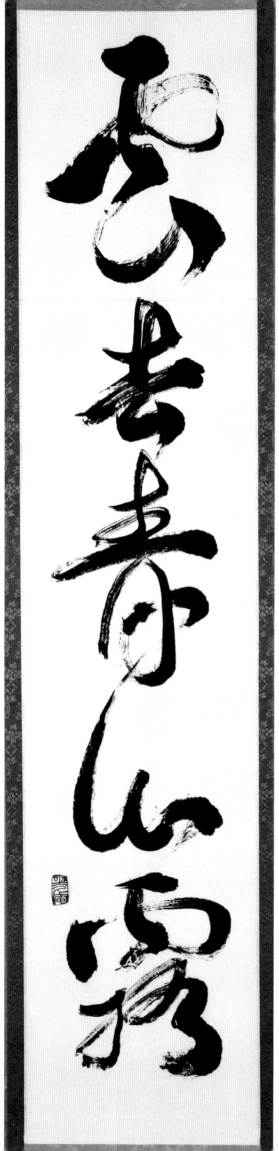

Kumo Sari Seizan Arawareru ("Cloud Passes Blue Mountain Appears") by Zakyu-An Senshō

This example, written by the same calligrapher, blends the _gyosho_ and _sosho_ styles. In the topmost ideogram ("cloud"), the freshly applied ink on the brush creates a rounded _nijimi_ effect in the first short horizontal stroke. The second stroke—the diagonal on the left—begins with ample ink but as the brush moves upward and to the right, the ink begins to run out and the brush is slightly lifted to create a three-dimensional dry brush effect in the circular motion. In the fourth ideogram ("mountain"), the fact that the first stroke overlaps the bottom of the previous ideogram ("blue") is evidence that the ideogram of "mountain" is written in the _sosho_ style.

Kumo Sari Seizan Arawareru ("Cloud Passes Blue Mountain Appears") in the Kaisho Style

The last ideogram is very complex and is made up of 21 strokes. The fourth ideogram is composed of 3 strokes. Therefore, it is important the the two are structurally in balance. All of the ideograms in *kaisho* should carry structural mass regardless of the number of strokes. This is the challenge.

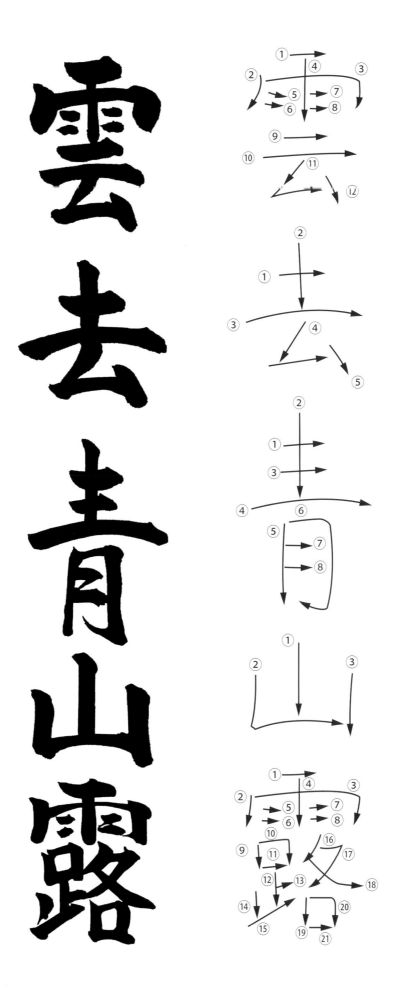

Kumo Sari Seizan Arawareru ("Cloud Passes Blue Mountain Appears") in the Gyosho Style

Notice again how in *gyosho*, strokes have been simplified in each ideogram; however, you follow the same path as in *kaisho*. Also note how the wispy ends lead to the next step in the ideogram or in the following ideogram.

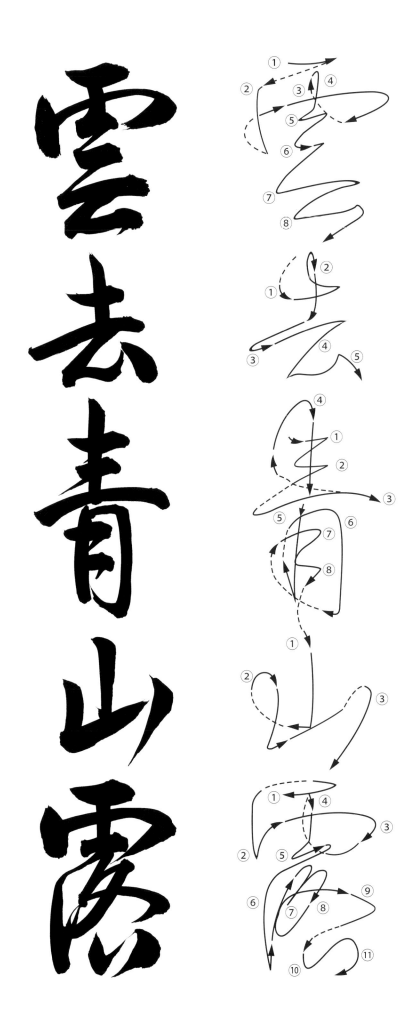

Bu Ji Kore Ki Nin ("Without Stratagem Is Noble Person")

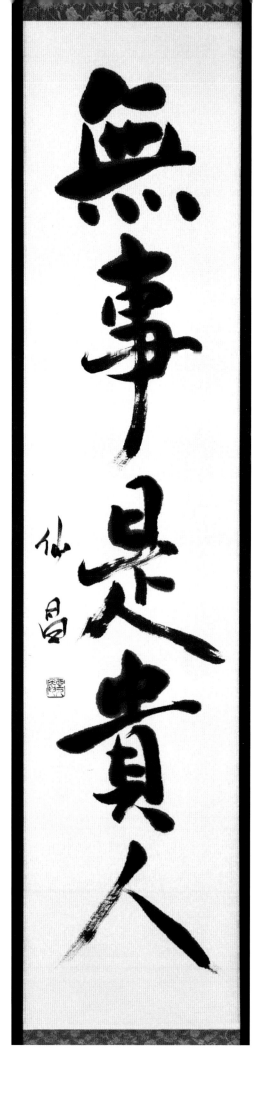

The instruction of Rinzai, the founder of the Rinzai sect of Zen, was that one should not look outside of oneself for answers and actions and develop various schemes, arrangements and planning, but look within and then you are *bu ji* which means that you are natural. Maintain your spirit in peace, flowing with the laws of nature, but be thorough and people will recognize that such a person is "noble." In the original state when born, one has *bussho*, therefore searching outside will not help. There is no other passage and the unenlightened eventually end up in quest of so many different directions, they lose their souls. When the scheming, planning and arranging end and one simply follows the laws of nature, that person is in the category of *bu ji* and the Buddha within will appear. Then such a person is a noble person. However difficult the situation may be, not staying in one static position and accepting a natural flow gives a person an intangible element which will glow. When a person comes to a realization of this truth, it can be said that he has stepped into the world of enlightenment. So this statement does not mean "Do nothing; take a nap all day long." It is the unnatural manipulation of events that causes problems.

The first *zengo* here is written in a "casual" *kaisho* style whereas the second example is written in a combination of *sosho* and *gyosho* styles, using a long *sosho* type of brush. Long bristles hold an abundance of ink. The first few strokes thus produce a *nijimi* (blurred) effect, with a softer, more rounded appearance.

Bu Ji Kore Ki Nin ("Without Stratagem Is Noble Person") by Zakyu-An Senshō, from *Rinzairoku*

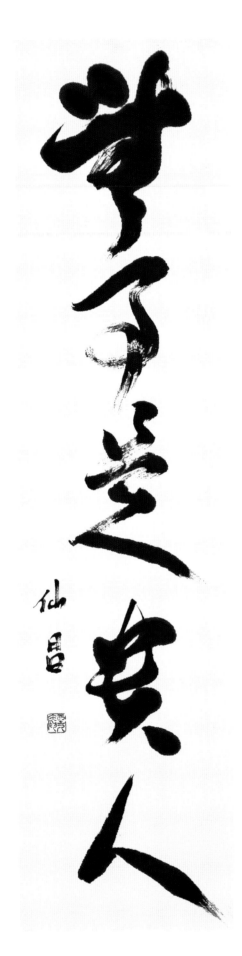

Bu Ji Kore Ki Nin ("Without Stratagem Is Noble Person") by Zakyu-An Senshō

Bu Ji Kore Ki Nin ("Without Stratagem Is Noble Person") in the Kaisho Style

The *kaisho* style's characteristic balance and structure are especially clear in this *ichigyo mono*.

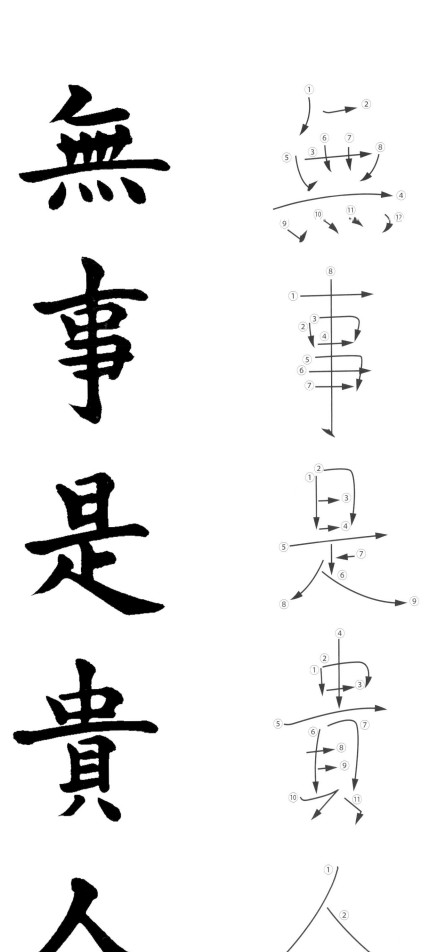

Bu Ji Kore Ki Nin ("Without Stratagem Is Noble Person") in the Casual Kaisho Style

Casual *kaisho* style's fluid brush strokes make it ideal for individual expression.

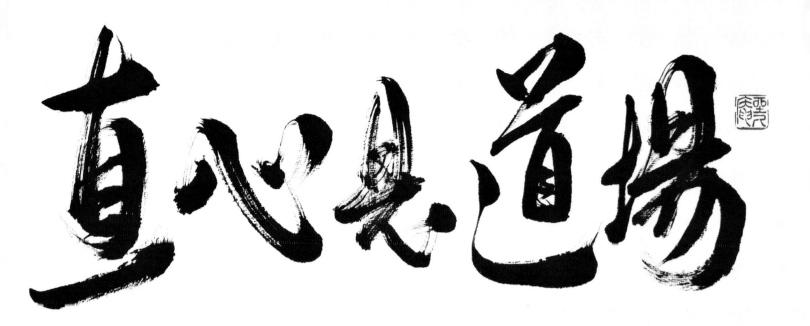

Jiki Shin Kore Dōjō
("Willing Heart Is the Dojo")

This statement, recorded in the *Book of Yuima,* is attributed to Yuima Koji (in Sanskrit: Vimalakirti), who was thought to be an enlightened teacher during the earliest stages of development for Buddhist teaching. One day on his way back to the city, Yuima unexpectedly met a fellow monk on the street who asked, "From whence do you return?" Yuima answered, "I'm returning from the dojo where I attained satori." The fellow monk then asked, "Where is there such a dojo where one can attain satori? In the city there is so much noise and activity that I wish to escape to the dojo from whence you came." Yuima's answer was, *Jiki shin kore dōjō* or "The willing heart is the dojo."

The atmosphere of our contemporary lifestyle surrounds us with a multitude of tools and equipment, an unprecedented variety of conveniences. Yet the complaint is often that it is difficult to find a place where one can study or acquire competence in some discipline. All that a person needs is "a sincere willingness to study." If one truly wishes to study, one can do so under any circumstance. Yuima Koji stated that only the "dojo within" was needed to develop even such traits as compassion, wisdom and spiritual training, to name a few, and that a special setting and methods were not necessary.

This *ichighyo mono* is a *gyosho*-style horizontal composition.

**Jiki Shin Kore Dōjō ("Willing
Heart Is the Dojo") by
Zakyu-An Senshō**

Jiki Shin Kore Dōjō ("Willing Heart Is the Dojo") in the Kaisho Style

In the *kaisho* style, brush movements follow the exact order of strokes in the traditional or classic manner. Yet a person who writes ideograms will eventually reveal personality through their choices in brush movement and composition. For instance, the first ideogram here contains the character for "eye" in its center. The formation of this element could be very structured, or could be more relaxed with the line curving slightly inward. These are personal choices, and so are good aspects to notice if you wish to better understand the differences that create individual styles in *shodo*.

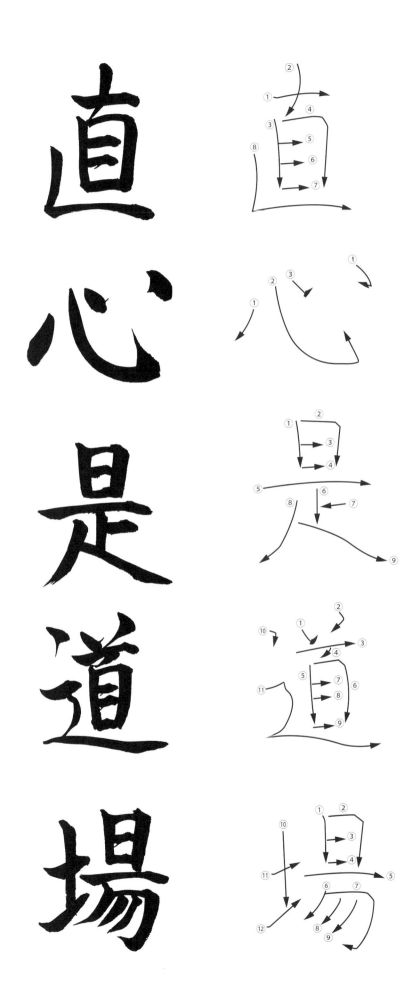

Jiki Shin Kore Dōjō ("Willing Heart Is the Dojo") in the Gyosho Style

Carefully study the transition and flow of each stroke within the ideogram. Notice how the last line of the final ideogram ends, to avoid redundancy.

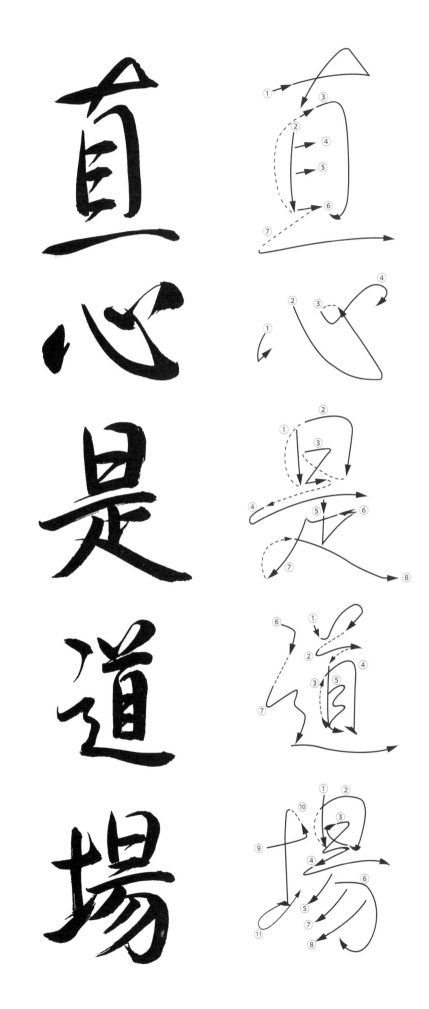

Mizu Itaru Kiyoshi Nashi Sakana
("Water Reaches Purity No Fish")

A world without faults is an idealized world. The reality of life is that day after day, a multitude of varied events and activities happen one after another, forming like a cloud or mist that envelops us within it. From this arises desires which are very difficult to suppress or eliminate. In Buddhist teaching, such human desires arise from five different sources: the eyes, ears, nose, tongue and body. Consider that these five sources extend to the pleasures of food, beverages, sleep, sexual activity and on to wealth and fame. Interweave these with the emotions of love, hate, jealousy, sadness and joy, and life can become a turmoil.

Even the Zen monks who practice asceticism within a temple compound and have reached enlightenment must still face certain realities of life, such needing sleep and food at intervals in order to sustain life.

When a stream has been purified by human intervention or natural causes, "fish cannot live." This *zengo* points out a simple fact of life. In its literal sense it can be read as "water that is too pure cannot sustain fish." It points out a simple fact of life. The *zengo* in Chapter 4, *Sen Shin* ("Purify the Heart"), stressed that the heart and soul must be purified with intelligence and wisdom. These two zengo are analogous in that the impurities in water or the five desires must be controlled with wisdom and intelligence.

The first *ichigyo mono* here is an upright rendition by Setsuei Ota. The second example, by Zakyu-An Senshō, is written from right to left. Water, required for all living things, is the source of life. Here, then, the ideogram for "water" has been enlarged to emphasize this importance. With "Water" as the main focus, the "Reaches Purity, No Fish" portion is written in a mixture of *gyosho* and *sosho* styles.

Mizu Itaru Kiyoshi Nashi Sakana ("Water Reaches Purity No Fish") by Setsuei Ōta, Saitama-ken

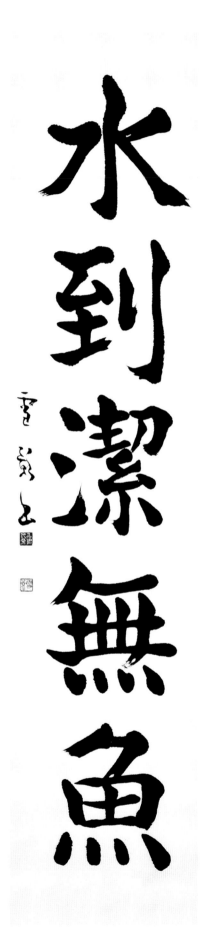

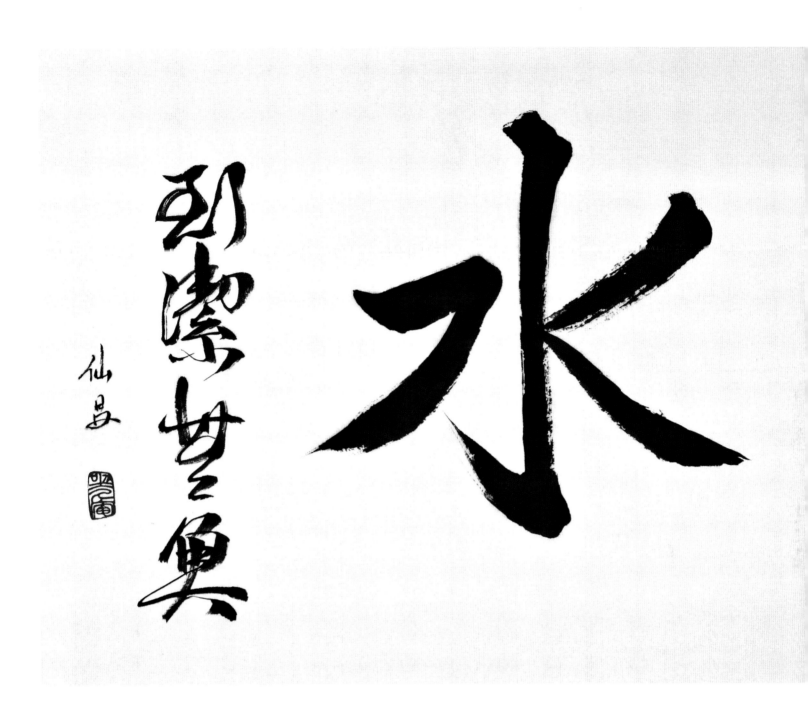

Mizu Itaru Kiyoshi Nashi Sakana ("Water Reaches Purity No Fish") by Zakyu-An Senshō

Mizu Itaru Kiyoshi Nashi Sakana ("Water Reaches Purity No Fish") in the Kaisho Style

Setsuei Ota's work, done in the *kaisho* style, serves as a good study example.

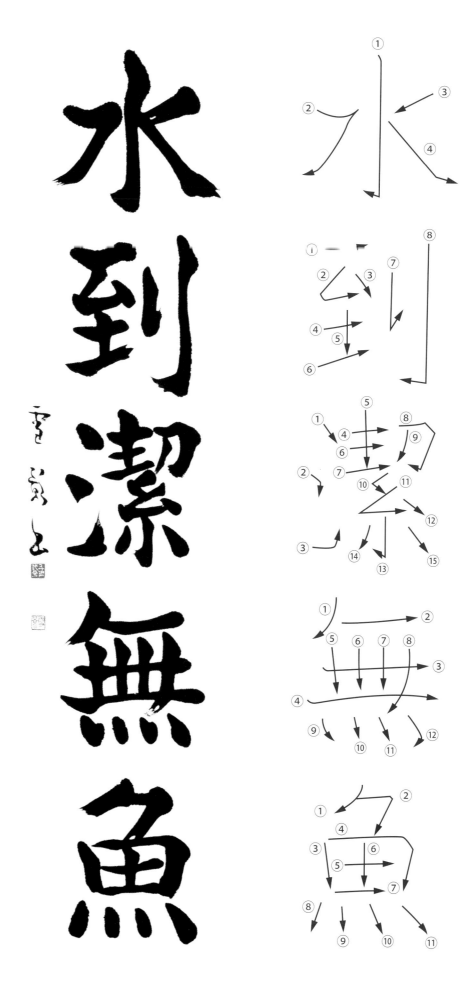

Mizu Itaru Kiyoshi Nashi Sakana ("Water Reaches Purity No Fish") in the Gyosho Style

The ideogram for "water" is composed of six strokes, and the basic form for each stroke is clear and obvious.

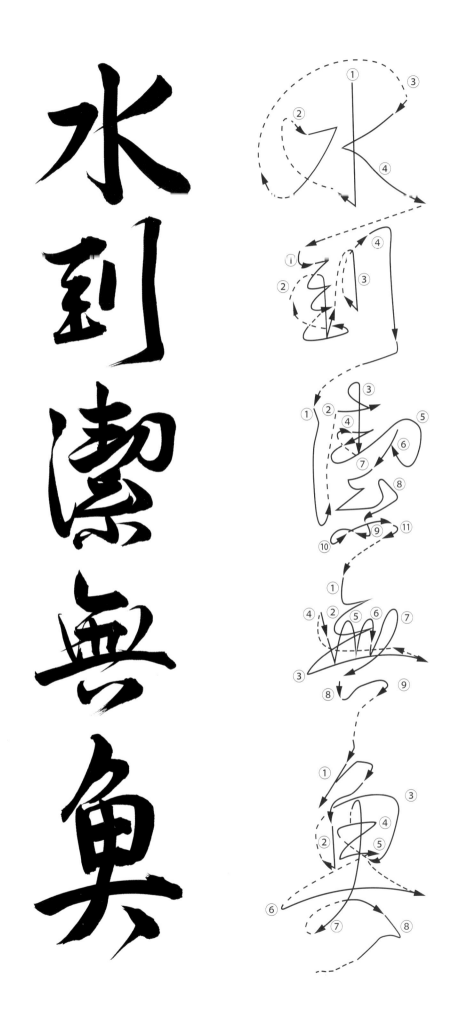

SEVEN & EIGHT IDEOGRAM ZENGO

七字篇 八字篇

向裏向外逢著便殺

Ha Kkaku No Ma Ban Kū Ri O Hashiru ("Octagonal Grinding Disk Cuts Through the Universe")

An eight-sided grinding disk is the large millstone which is turned by an ox or donkey. The idea that such an object was flying and cutting through the universe was something beyond common sense during the latter portion of the Kamakura period (1185–1333). There were intense debates on which form of Buddhism was superior: the established forms of Mahayana Buddhism or the newly imported Zen Buddhism. Scholars of the established Buddhist doctrine, with the intent to "crush" the newly arrived Zen Buddhism, debated Myocho Shuho who represented the Zen Buddhism side. (Later the Imperial Court honored Shuho by awarding him the highest title of Daito, Kokushi.) The scholars, after many debates, questioned Shuho:"Zen discourses intimate *kyo gai betsu den* [*kyo*=teaching; *gai*=outside; *betsu*=separate; *den*=communication]. What is the meaning of that phrase?" Shuho's instant answer was "Octagonal grinding disk cuts through the universe." The meaning of this phrase is that regardless of how well one intellectually understands the doctrine or dogma, without actual experience the understanding remains only on the surface. Deep attachments, delusions, intellectual understanding of good or evil; stubborn self-centered ideas and teaching through sutras: they who assume they are

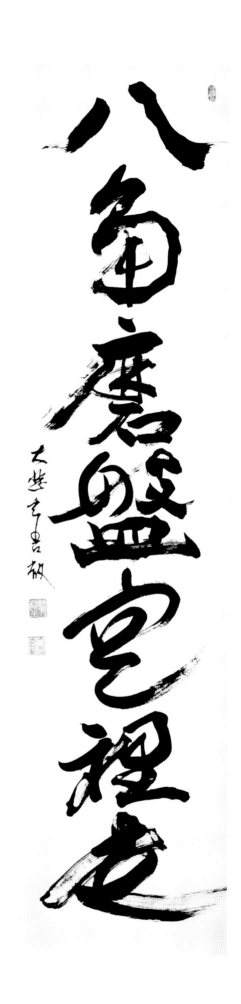

Ha Kkaku No Ma Ban Kū Ri O Hashiru ("Octagonal Grinding Disk Cuts Through the Universe") by Gengo Akiba Roshi of Kojin-An, Oakland, Calif.

erudite scholars can be smashed into pieces but spiritual activity is totally free. Thus this statement ended the discourse and debates between the established Buddhist sects, and Zen Buddhism consequently gained a foothold in Kyoto.

The sagacity of this *ichigyo mono* made Zen Buddhism acceptable to other Buddhist scholars, and Daito, Kokushi since then has become greatly respected. The goal in Zen is to search for the truth with complete disregard for scholarly dialogue or one's station in life.

In the work at left by Gengo Akiba Roshi, the subtitle is "Furyu Monji." This means "not depending upon literature," and is one of the phrases in traditional Chinese ideograms that explain the characteristic nature of Zen Buddhism. Other such phrases are *Kyo gai betsu den* meaning "extracurricular or outside the teaching of sutras"; *Jiki shi jin shin* meaning "directly reaching to the heart and soul of that person"; and *Ken sho sei butsu,* meaning "rediscover the existing Buddha nature within oneself." One must surpass or go beyond doctrine and the language from the teacher, and directly connect with the spirit within. The student must take the mentor's teaching and then internalize and digest it. Then it becomes an intrinsic part of heart and soul and allows each individual to grasp the core of Buddhist teaching in order to open the passage to satori. A simple way of saying this is to point your finger to your heart and it is the Buddha.

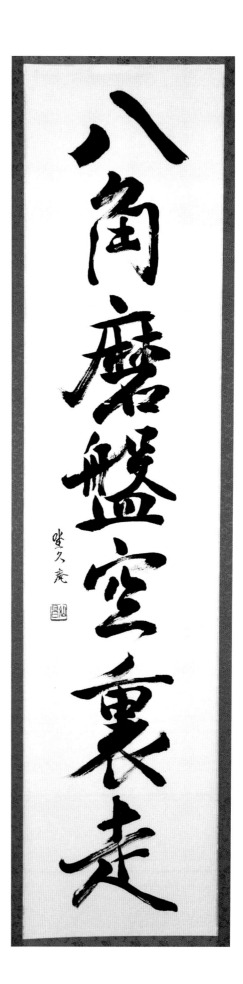

***Ha Kkaku No Ma Ban Kū Ri O Hashiru* ("Octagonal Grinding Disk Cuts Through the Universe") by Zakyu-An Senshō**

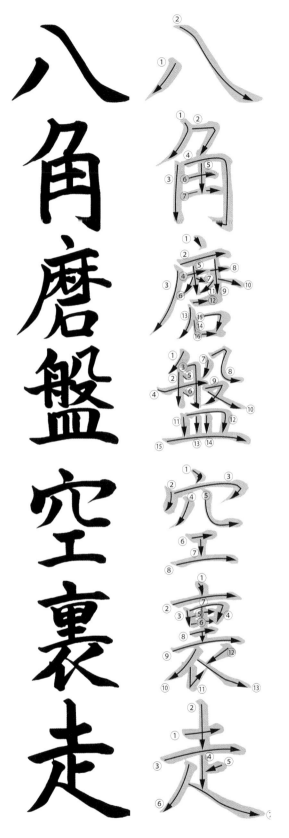

LEFT *Ha Kkaku No Ma Ban Kū Ri O Hashiru* **("Octagonal Grinding Disk Cuts Through the Universe") in the Kaisho Style**

The first ideogram is the number "8" and is composed of only two strokes. The following ideograms are much more complex, so the size, width, strength and spacing of the two strokes in the first ideogram of "8" are the key for success in writing this statement.

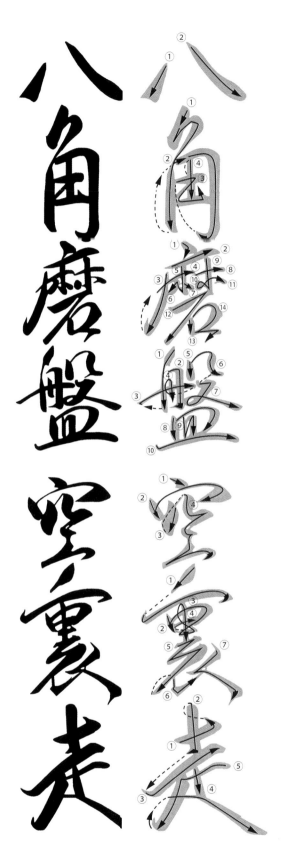

RIGHT *Ha Kkaku No Ma Ban Kū Ri O Hashiru* **("Octagonal Grinding Disk Cuts Through the Universe") in the Gyosho Style**

In *gyosho* style, the ideograms basically follow the *kaisho* order of strokes. But this is a powerful statement, thus requires greater energy in writing each ideogram.

Uchi Ni Mukai Soto Ni Mukai Au Mono O Subete Korosu ("Face In Face Out Meet Person Kill All")

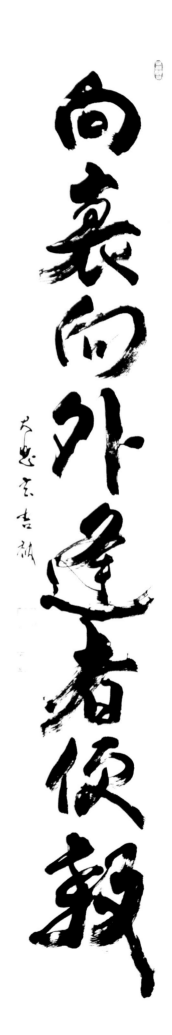

At first glance, this well-known eight-ideogram *zengo* appears to carry a fearsome message. It is one phrase taken from an eight-line statement and is the only one that is used in *ichigyo mono*: "When you meet Buddha, kill him; when you meet the founder of the Zen dharma, kill him; when you meet the teacher, kill him; when you meet father and mother, kill them; when you meet brother and sister, kill them; then you will be released from any imprint and you become totally free."

The message being conveyed is "How to be released from the binding influences that others provide which hinder self-realization." In the search for release from undesirable influences, Zen monks use the harsh metaphor "to kill," meaning "to eliminate." Look around and consider the daily constant and unquestioned influences which surround us. These influences may be subtle but affect us as they are incorporated into our being as we blindly move on. In Japanese society, obedience has been a highly praised and deeply ingrained trait. However, there are occasions when one must speak out if the decisions have far-reaching consequences. When faced with such situations, consider this *ichigyo mono*.

The second work shown here (page 160) was created by Shinpei Sakakura (1934–2004), a well-known artist of both prints and paintings. He spent his childhood and teens in a Zen temple and intended to become a Zen priest. As he matured, he realized that his talents lay in the visual arts and he became a contemporary abstract artist and lived in Paris for many years. In his later years, he returned to Japan where his work was widely praised by both professionals and the public. He became known for his unique style in *sho*. His *ichigyo mono* also resonates with the message "Remove all of your outer garments to become pure," in other words, remove all of your influences.

Uchi Ni Mukai Soto Ni Mukai Au Mono O Subete Korosu ("Face In Face Out Meet Person Kill All") by Gengo Akiba Roshi of Kojin-An, Oakland, Calif., from the *Rinzairoku*

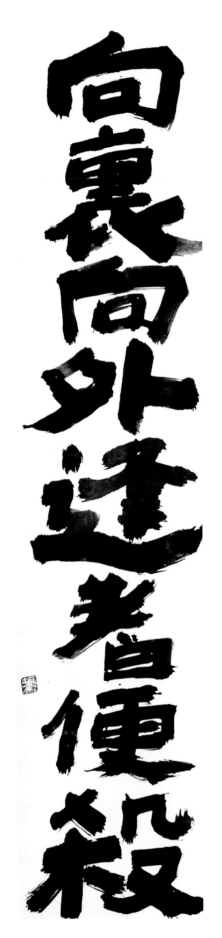

*Uchi Ni Mukai Soto
Ni Mukai Au Mono O
Subete Korosu
("Face In Face Out
Meet Person Kill
All") by Shinpei
Sakakura, Paris*

In the Kaisho Style

Note that in *kaisho*, if the same ideogram appears twice in a given statement, the second should be a copy of the first. In this example, the first and third ideograms match.

Compare this to the orthodox *kaisho* style shown at right.

向裏向外逢著便殺

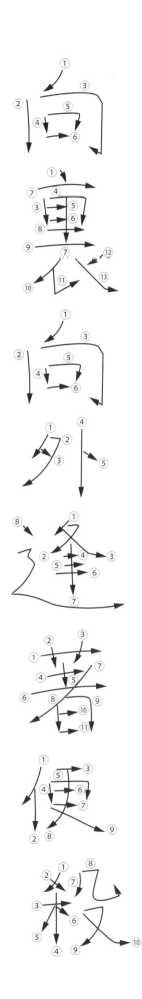

To develop the technical skills for writing *kaisho* in the orthodox way, often the "copy book" style of learning is used. It is common to copy the Heart Sutra (*Hanya Shingyo*) in memory of a family member or a close friend. Usually several steps are required. The first copy is made in dark ink and is usually a replica of a work by a famous priest or by someone recognized by the Japanese government as a National Treasure. The second step is to write a copy of the Heart Sutra in light gray ink. Next, a thinner paper with lines is placed on it and written upon.

Both this and the work by Shinpei Sakakura are written in *kaisho*. However, in the Sakakura statement his personality is clearly evident. When writing many ideograms in upright style, each must fit a given space, as if in a grid.

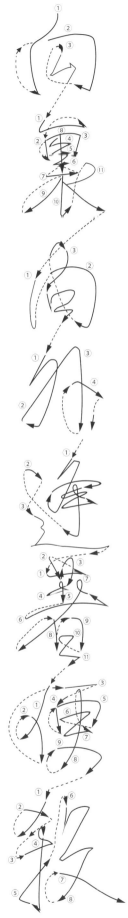

STUDENTS OF SHODO

玄回首

Japan House, University of Illinois, Urbana-Champaign Campus

Jiki Shin Kore Dōjō
直心是道場
("Willing Heart Is the Dojo")

Since ancient times the term *"Fu ryu monji"* has been used as an admonishment for a trainee in Zen. (*Fu*=not; *ryu*=standing; *monji*=literature or the essays written by the previous enlightened monks.) Writings and essays did not take precedence over *zenki* (*zen*=Zen; *ki*=opportunity) and in the process of constantly pursuing an answer to a koan (an enigmatic Zen conundrum) the sudden moment of the breaking point of "realization" comes at unexpected times, often during common daily activities.

Whether such deep and significant meanings can be found in the practice of writing *ichigyo mono* in shodo is subject to question. Certainly, this is not universal for all practitioners of shodo. However, in writing Zen statements and exercising the attempt to understand the meaning, spiritual energy is expended and vital forces will allow an individual to create a work that goes beyond the craft of the brush. Professional shodo practitioners follow a daily schedule of writing ideograms with an artistic visual sense sharpened to the highest degree. Their skill in brush technique is of course significant, even though this may not be immediately evident to all viewers. (For example, if a casual viewer, at first glance, feels that there is leftover space, careful examination will show that this is actually active empty space.) The refined beauty on all levels that the professional shodo artist pursues, when combined with spirituality, will create works which have impact upon the viewer. The work of these individuals borders on abstract art.

Once a week, participants who come from a variety of backgrounds practice shodo in my studio. Among them are many who have had *zazen* experience in the past, or are currently practic-

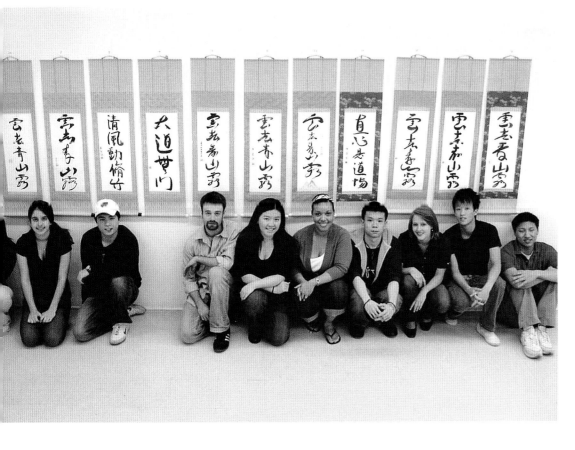

Northwestern University, Evanston, Illinois

Sei Fū Chiku O Ugokasu
清風動脩竹
("Fresh Breeze Affects Serene Bamboo")

Kumo Sari Seizan Arawareru
雲去青山露
("Cloud Passes Blue Mountain Appears")

Dai Dō Mu Mon
大道無門
("Great Path No Gate")

ing *zazen* with Zen monks. The examples shown in this chapter are by students of *sho*, mainly Americans, who have taken my classes. They come from all walks of life, ranging from former art teachers to university students, from fine woodworkers to medical doctors. The thing they share in common is their choice to begin something new: their decision to study *sho*.

These practitioners cannot compete with the professional shodo artist in terms of skill level of brush use. Therefore, when examining their *ichigyo mono*, the background and character of the creator must be taken into consideration. The respect and honor given to their work is due to the fact that all aspects of personality and character are embedded in the brush strokes, and the viewer must retain an openness in understanding.

As discussed in Chapter 1, nearly a century ago, the world of professional shodo artists in Japan initiated a new direction: they began to reach beyond the orthodox method of writing that had been established for many centuries. This trend was to seek a more "T-shirt and blue jean," or very casual, style of writing, and yet the work must maintain artistic strength in every aspect, within that casualness. It is obvious that the work by the workshop participants and university students in this chapter should not be compared with the work—whether it's orthodox or unorthodox in style—of Zen monks or professional shodo artists. However, each of the students' examples carries its own life and beauty to appreciate.

Their work is here to inspire you, the reader, to pick up a brush without embarrassment and to enjoy the creative process. As you develop technical skills for writing a *zengo*, it may lead you to a new spiritual understanding for your own passage.

Mu 無 ("Nothingness")

Kevin Drake, California "The ink drop did it!"

Yu 夢 ("Dream")

Michael Carroll, California The art does not come from just letting go but from first laboriously learning the craft step by step, then letting go.

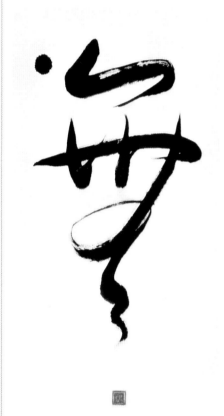

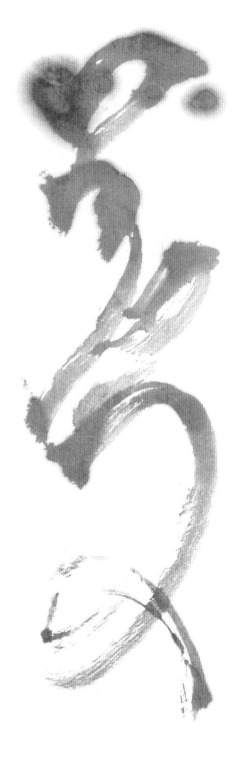

Nyoze 如是 ("As It Is")

Elizabeth Goreth Baker, Lilydale, Minnesota I was encouraged by my *sensei* to practice calligraphy and focus on developing the disciplined brushwork that is required. On this journey, I discovered my creative potential. My experience is that the very act of calligraphy is an exercise in self-development and has the power to calm the mind and the spirit.

Hon Rai Mu Ichi Butsu 本來無一物 ("Originally Not One Thing")

Kerry Marshall, California Studying and practicing *sho* has taught me to pay attention, quiet my mind and let the brush express the spirit and energy of the kanji to be written. Although I do not speak or understand Japanese, I try to keep in mind what each kanji is expressing as I begin my work. *Sho* is a pattern language to me, a meditative dance.

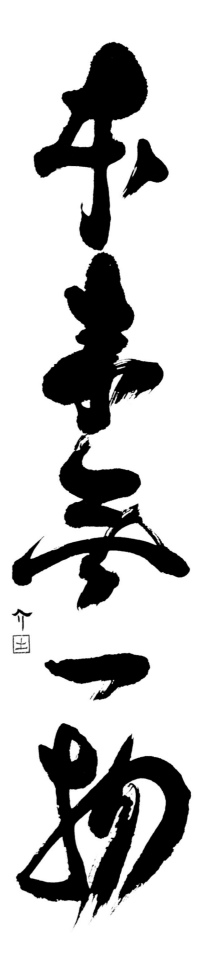

Zai Gan Zen 在目前 ("Front of Your Eyes")

Rev. Robert Taikan Yanasak, California
Working with the characters of the Zen statement proved to be very difficult for me. I've been a practitioner of Zen Buddhism for 45 years so Zen as such is not new to me but Japanese calligraphy is, and working with this statement proved to be exhausting. Learning to work with the brush in a way that allowed the brush to realize its own nature while surrendering to what, in fact, was right in front of my eyes was a battle between my ego and its wanting me to be the best in contrast to the painful display of a brush that refused to surrender to anything less than a movement or stroke born of a mind free of expression. Over and over I practiced, both the execution of the characters but, equally, surrendering my life to what was right in front of my eyes. That surrendering proved to be much more difficult than the brush. I had to let go of my desire to do well and simply surrender to who I was at that very moment. The vulnerability needed required a deep surrender to the process itself and not looking beyond that. My mind in its relentless persistence wanted so much to be in control and have everything to say about the results. Repeatedly, I tried to surrender my life, my whole body, over to what was right before my eyes. That exercise was, and is, a bittersweet exercise at all levels that slowly brings me home. I continue to have a relationship with my brush that encourages me to surrender to my life, as it is, right now. In casual observance, one would think I was doing calligraphy and they would be right … and most definitely wrong.

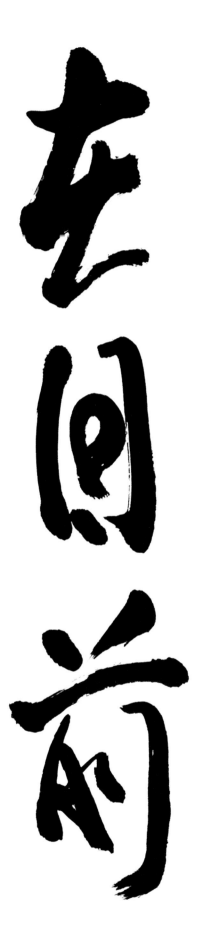

Za Ichi Sō Shichi 坐一走七 ("Sit First Dash Seven")

Laurie Sargent, California
Calligraphy excites me. To me it is a dance with a type of choreography that allows me to be expressive but within limits. In learning the choreography of any dance, it is helpful to work under the discerning eye of a master and to execute many repetitions, and so it is with calligraphy. When the characters or ideograms finally feel "right," it is exhilarating.

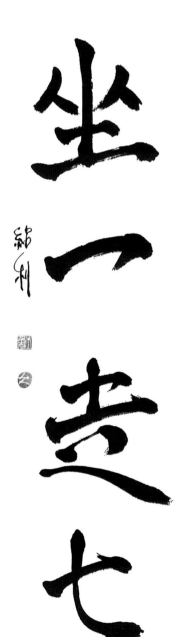

Zui Ha Chiku Rō 随波逐浪 ("Ocean Waves After Surf")

Francie Dittrich, Michigan
I try to capture the essence of the meaning of the ideogram in its execution. To lose one's self in the moment of painting the ideogram gives me great joy. Patience...persistence...practice...a line...one life!

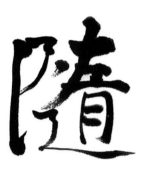
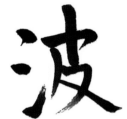
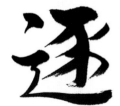
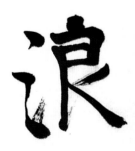

Zui Ha Chiku Rō 随波逐浪 ("Ocean Waves After Surf")

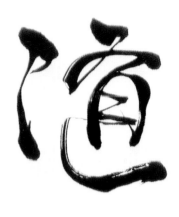

Marilyn Katzel, California
I am grateful for this unique experience to practice calligraphy together with the tea ceremony to realize this expression of true beauty. The art of calligraphy using a Zen statement is a beautiful way to reveal the wisdom of our true nature.

Doku Zai Dai Yu Ho ("To Sit Alone on the Summit of the Great Mountain")

To sit alone I become aware of the breath
To sit like a mountain engages my effort
to become focused and grounded in the
moment.
Alone we sit on the Summit reveals still-
ness and spaciousness to trust ourselves
and feel compassion for all beings.

There is energy connecting the Zen statement to my mind, to the brush in hand, to the ink on paper, awakening our wisdom. From my background in art studies and from years of yoga practice, I find much joy and excitement through the art of calligraphy.

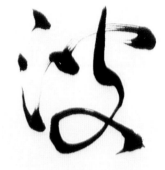
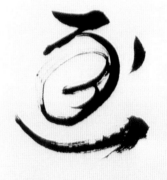
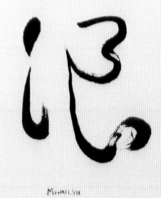

Sha Za Ki Ssa 且坐喫茶 ("Have Seat Drink Tea")

James Herron Katzel, MD, California After one month of writing the same statement using different sized brushes and various styles of calligraphy, I started to understand a small part of why *Doku Za Dai Yu Ho* ("Alone Seated on the Great Summit") is an admired Zen statement by practitioners of the tea ceremony. By reading and meditating with this great statement, I began to feel the embodiment of generosity. Sitting alone, you develop and display that uniqueness, and from the strength of that great summit you produce great works of humanity or of art. To do that requires staying centered and present. Just an instant in that present is beautiful, luxurious and enjoyable. And later it might be recalled, for even a brief moment in this short life, by the generosity of sharing tea.

Albert Camus wrote, "Real generosity toward the future lies in giving all to the present." For me, this is the living connection being created on that great mountain summit, that between the unique individual and all of humanity. Producing great and unique works by giving everything to the present is what links all of us to the generosity of those before, as well as to those to come. Thus, the generosity of our great teacher gives art and beauty for today, but also toward the future.

Dai Dō Mu Mon 大道無門 ("Great Path No Gate")

Grace Campbell, Seattle, WA It is always thrilling for me to see the calligraphy emerge as the brush and the order of the strokes do their dance across the paper. The black lines that have been thoughtfully practiced come together to create such beautiful forms, letters, words, statements, beauty... ART!

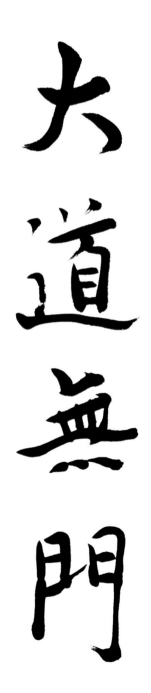

Doku Za Dao Yū Hō
独座大雄峰
("Alone Seated on the Great Summit")

Shizuko McConathy, California Over the last fifteen years, this class has given me the joy of learning something important. Concentration, focus, balance, trying new artistic ways—dark and light, very wet and dry, large and small—are all part of the experience. I look forward to Monday mornings, and sweets at 10:30 with thick *maccha*.

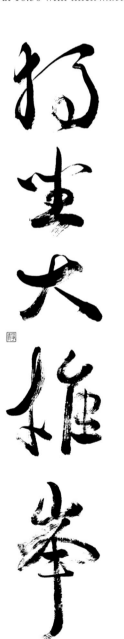

Sei Fū Shū Chiku O Ugokasu
清風動脩竹
("Fresh Breeze Affects Serene Bamboo")

Judy Parker, California For me, this statement evokes the peace and tranquility of feeling the breeze, maybe with a few drops of refreshing rain, and the strength of the bamboo that bows before the rain yet retains its strength. When I practice calligraphy, I feel both serenity and strength. It is a refreshing path to inner peace and knowledge.

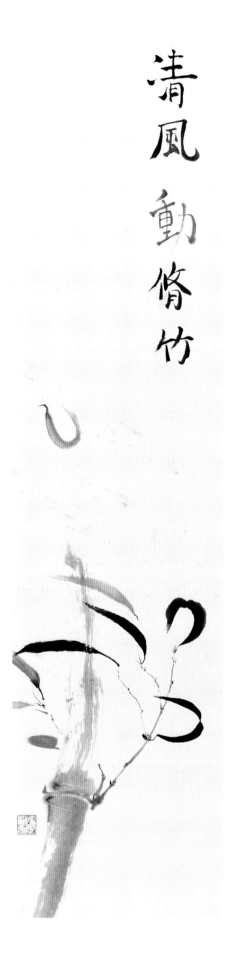

Appendix

The Original Sources of Zengo

Shinjin Mei
信心銘

Shinjin Mei, a 584-word poem commonly interpreted as "Faith in Mind" and traditionally attributed to the Third Chinese Clan (Zen) Patriarch Kanchi Sosan三祖僧璨 (d. 606), is one of the earliest expressions of the Buddhist practice of mind training. It is considered one of the four most important introductory essays on Zen, the others being *Shodo-Ka* 証道歌 ("Song of Attaining the Path [of Enlightenment]"), a 247-line poem by the Sixth Patriarch Eno, who crystallized Buddhist teaching methods; the *Ten Bulls* or *Ten Ox Herding Pictures* 十牛図, a series of poems, short pieces of prose and accompanying pictures intended to illustrate a Buddhist practitioner's progression towards enlightenment through the relationship of an ox and a cowherd; and *Fukan Zazen Gi* 坐禅義 ("Principles of Zazen"), an instruction manual by the Japanese Buddhist teacher Eihei Dogen concerning the concepts underlying *zazen* (sitting meditation). Among the four essays, *Shinjin Mei* is recognized for its fine literary form, which has condensed the core of Zen philosophy in fewer than 600 words. Zen monks still use it as a reference. Sosan, who had received direct training from the Bodhi Dharma, was able to convey a clear message to generations

who followed. In summary, the message contained in *Shinjin Mei* is "The preeminent or highest point of enlightenment is not difficult to obtain so one should stop searching for a myriad of different passages. Many Zen monks think that truth and enlightenment are far away. They try so hard by manipulating their minds yet experience anguish and disappointment by being unable to reach the world of *satori*. However, truth and enlightenment are right next to you. It is the manipulated mind that pushes them away."

Jōshō Shinsai Zenji Goroku
趙州真際禅

Jōshō Shinsai Zenji Goroku, commonly referred to as the *Jōshō Roku*, is a series of lecture documents or teachings by the eminent priest Jōshō Shinsai趙州従諗 (778–898), which were collected by his disciples shortly after his death, and henceforth disseminated. The document was and continues to be popular and much valued in Zen temples. Ordained as a monk when young, Jōshō became a disciple of the famous monk Nansen Fugan 南泉普願, with whom he stayed for some forty years. Recorded in the *Jōshō Roku* are the many teacher–disciple discussions (*koan*) held between Nansen and Jōshō, and it is evident that from those earliest days Jōshō's ability was almost equal to that of Nansen. He did not make any pilgrimages but stayed with Nansen for further training and maintaining discipline even after obtaining *satori*. Although he was considered a preeminent teacher, he maintained a humble stance in the search for improvement by saying, "He may be only seven years old but if that child has some superior knowledge, then I will humbly ask for teaching." Jōshō's teachings contain no theory, reason or ideology derived from the classics. Instead, his methods were tailor made for each situation, with daily activities being the main source of *koan*. Many important *koan* from the treatise appear in the *Mumonkan* 無門関 and the *Hekiganroku* 臨済錄.

Rinzairoku
臨済錄

"The Sayings of Master Rinzai" is a record of Rinzai Gigen 臨済義玄 (d. 866), founder of the Rinzai sect of Zen Buddhism, and was written by his disciples. It is an example of the encounter-dialogue genre and contains a series of predictions based on his teachings, episodes from his training and from his teaching career, including cross-examinations with his students, and records of pilgrimages. It is one of the main texts in the Rinzai school of Zen. Rinzai Gigen demanded genuine insight into the scriptures (sutras) and a life lived by the insight gained. The main theme of his teaching, and of the treatise, is *buji* 無事 (*bu*= negation; *ji*=the events, problems and suffering of daily life). To achieve *buji*, life should be lived without artifice or manipulation; it should remain natural by returning to one's original self and eliminating all restraints within. The person who has reached a state of *buji* is commonly a person who does not scheme or plot actions, a state contained in the eight-ideogram *zengo* "Face In Face Out Meet Person Kill All" (page 159). This admonishment to the disciple monks was that when seeking the right direction in thought and action, one must be disciplined and shake off all influences.

Freedom for one's spirit and soul is of primary importance. If one's focus and discipline are on the study of *butsu do* (Buddhist teaching), eventually the mind will be tightly bound to the studies. Therefore, one has to remove all learning and influences and then one will become *mui no shinjin* 無位の真人 (*shinjin*=spiritually naked person; *mui*=no rank).

Obaku San Dansai Zenji Denshin Hōyō
黄檗山断際禅師伝心法要

Commonly known as the *Denshin Hōyō* 伝心法要, this treatise comprises a collection of notes by the disciples of Ōbaku Kiun 黄檗希運, well known for the lectures he offered at the Ryuko-ji Temple and for being

the disciple and successor of Hyakujo Ekai 百丈懐海, a great Zen master, and later mentor of Rinzai Gigen, founder of the Rinzai Zen sect in Japan. Although the theoretical explanations of reality in the treatise are so abstruse that beginners will find them challenging, the underlying theme is that Zen philosophy must be direct in its message. *Denshin* 伝心 means that Zen cannot be taught through dialogue and literature; instead, understanding must come from "heart-to-heart communication" between a mentor and his disciples. *Denshin Hōyō* thus stresses the importance of recognizing that "this heart is the Buddha." There are no divisions between the Buddha and commoners and to search elsewhere, especially in Buddhist literature, is fruitless. It is best to use heart and soul to find Buddha, and to not become attached to any one thing. When one's heart is free from restraints, Buddha will naturally surface within it. Later Ōbaku established Ōbaku-ji Temple, where he continued his teaching of Zen. Much of his fame is attributed to having Haikyu 裴休, originally a high-ranking government official, as a disciple. It was Haikyu who organized and edited Ōbaku's teachings for the *Denshin Hōyō* around 900 CE.

Bukkaengo Zenji Hekiganroku
仏果圜悟禅師碧巌録

Better known as either *One Hundred Koan of the Hekiganroku* or the *Blue Cliff Record*, these 100 public cases (*koan*) and their explanations were selected and compiled by Secho Juken 雪竇重顯 (980–1052), a monk from the Unmon sect 雲門宗, one of the five sects of Chan (Zen) in China, from a collection of 1,700 *koan* called *Keitoku Dento Roku* 景德伝灯録. Introductions, remarks and commentaries by Engo Kakkin 圜悟克勤 (1063–1135) supplement Juken's verses and comments on the *koan*. The compilation is of fundamental importance for the study of *koan* in the Rinzai school of Zen because it reveals what enlightenment is, what the enlightened life is,

and how the early patriarchs and masters struggled with it, attained it, actualized it and accomplished it. However, the *Hekiganroku* is a challenge to those without indepth knowledge of Zen classic literature. It requires guidance, additional explanations and the actual practice of Zen in order to fully digest the abundant information it contains. Many of the *koan* are still used today in Zen instruction and in scrolls displayed in tea rooms and elsewhere. Among the more widely *koan* incorporated in *ichigyo mono* are *Doku Za Dai Yū Hō* ("Alone Seated on the Great Summit") (page 121) and *Nichi Nichi Kore Kō Jitsu* ("Every Day Is a Good Day") (page 125).

Kidō Osho Goroku
虚堂和尚語録

Of the ten volumes that make up this book, commonly known as the *Kido Roku*, seven of them were compiled by the disciples of Kidō Chigu 虚堂智愚 (1184–1269) during his lifetime, while the other three volumes were assembled after he entered "eternal tranquility." The ten volumes contain Kidō's teaching documents and his Zen poetry. The Japanese Rinzai sect regards the *Kidō Roku* as one of the seven most important teaching manuals for Zen even though some of the material in this substantial multi-volume book is difficult to understand. Yet many of Kidō's famous sayings are well known and revered as *ichigyo mono*. Several of Kidō's disciples built the foundation for the Rinzai sect of Zen Buddhism in Japan, including Nampo Shōmyo 南浦紹明, Kidō's successor ("Because of you, my teaching of Zen will spread across the land of Japan"), Shuho Myocho 宗峯妙超, who established the Daitoku-ji temple, and Sekizan Eigan 関山慧玄, who founded the Myoshin-ji.

Shobogenzo
正法眼蔵

In Japan, the term *Shobogenzo* refers, among other things, to the titles of two books composed by the Japanese Zen mas-

ter Dogen Zenji 開祖道元 (1200–53), the founder of the Japanese Soto Zen sect. *Shōbō* ("the correct Buddhist teaching") and *genzo* (*gen*=eyes; *zo*=warehouse) suggest that everything is enveloped and placed in the "warehouse" of these two volumes. The first volume, the *Shinji Shobogenzo*, also known as the *Mana Shobogenzo*, completed in 1235, is a collection of 310 *koan* and is written in Chinese, the language of the original texts from which the *koan* are taken. The later *Kana Shobogenzo*, written between 1231 and 1253 and encapsulating the essence of Dogen's teaching, comprises an overlapping assortment of 95 essays and commentaries written in Japanese that Dogen gave to his disciples either as sermons or in writing. They encompass the core of Buddhist Dharma doctrine through a wide range of topics relevant to those who practice Zen Buddhism in monasteries as well as in lay life. Dogen discusses matters relating to daily behavior, proper training and religious ceremonial as well as issues involving the master–disciple relationship. He also explores the deeper meaning of the *koan* anecdotes, which often puzzle readers by their seeming illogicality and contrariness. Today many scholars continue to give annotated explanations of the manuals. The treatises have also have been translated into many foreign languages.

Daito Kokushi Goroku
大燈國師録

At the close of the Kamakura period, Shuho Myocho 宗峯妙超, usually known as Daito Kokushi, built a small hut in Shino, a village on the outskirts of Kyoto, which he named Daitoku-ji—the genesis of the temple by the same name in Kyoto today. While living there, he taught many young monks as disciples. Myocho's way of guiding people in Zen Buddhism was highly respected and praised, and he developed many outstanding Zen practitioners. Among them were Sekizan Eigen, founding abbot of Myoshin-ji; Tetto Gikō,

the first chief abbot of the newly built Dai-toku-ji; and Hakuin Eikaku, who is considered to be the reviver of the Rinzai sect. Myocho came to be acknowledged and supported by the emperors Hanazono and Go-daigo as the rightful leader of the Rinzai sect. Daitoku-ji also became the place where *chado* masters, including Sen No Rikyu, went to study Zen, a practice that continues to this day. *Daito Kokushi Goroku* (*kokushi*=highest title bequeathed by the Imperial court; *koku*=country; *shi*=teacher) is the first volume of a trilogy by Shuho Myocho and covers his teaching activities from 1331 to 1336. The second volume contains material relating to his teaching activities at Sūfuku-ji in Kyushu and later at Daitoku-ji, and the third volume, *Sansho Goyo* 参詳悟要, is about teaching and other documents. Although the three volumes are not easy to digest, they have been highly praised by monks and scholars from China and are regarded as amongst the best introductory manuals related to *zengo*.

Kyōun Shū
狂雲集

The *Kyōun Shū* is an anthology of Chinese poetry written for a Japanese audience by Ikkyu Sōjun 一休宗純 (1394–1481), an unconventional Japanese Zen Buddhist monk and poet, who became the 47th abbot of Daitoku-ji in 1474 at the age of 81 (he resigned after only nine days). The nickname he gave himself—Kyōun 狂雲 (*kyō*=crazy or insane; *un*= cloud—"child of crazy clouds") reflects the eccentric personality and outrageous lifestyle of this renegade monk and self-proclaimed profligate as he moved from temple to temple. Purportedly the son of Emperor Gokomadsu 後小松天皇 and a low-ranking court noblewoman, he was placed in Ankoku-ji, a Rinzai Zen temple in Kyoto, when he was five, where he learned about Chinese poetry, art and literature. After stays of a few years at various other temples, where he became disillusioned with the leadership and lack of *zazen* practice, he became an itinerant priest, working to live Zen outside of formal religious institutions, propagating a Zen doctrine stripped of dogma and scholarship. He was highly influential in many spheres of Japanese art and literature, including the tea ceremony, Noh drama, ink painting, calligraphy and poetry, and did much to infuse them with Zen attitudes and ideals. Ikku's *Kyōun Shū*, sometimes referred to as the "Crazy Cloud Anthology" but more generally as "Confessions of a Monk's Transgressions," was very popular among fellow monks, *daimyo* and other culturally refined people who believed that his views on his bohemian lifestyle was a highly intelligent means of explaining the way of Zen. He is one of the most human and accessible of the great Zen masters of Japan.

For Further Reading

Hekigan Roku
Compiled by Yuanwu (1063–1135 CE). Translated as *The Blue Cliff Record.* Thomas Cleary and J.C. Cleary, trans. *The Blue Cliff Record.* Boston: Shambhala Publications, 1977.

Zen Letters: Teachings of Yuanwu
Thomas Cleary and J.C. Cleary, trans. Boston: Shambhala Publications, 1994.

The Mumonkan
R.H. Blyth, *Zen & Zen Classics, Vol. 4.* Tokyo: Hokuseido Press, 1966.

Zen Sand: The Book of Capping Phrases for Koan Practice
Victor Sogen Hori, compiler, transl., annotator. Honolulu: Univ. of Hawai'i Press, 2003.

Zen and the Art of Calligraphy: The Essence of Sho
Omori Sogen and Terayama Kastujo; John Stevens, transl. London: Penguin, 1983.

The Unfettered Mind: Writings of the Zen Master to and for the

Sword Master
(Takuan Zenji wrote the statement *Sei Fū Shū Chiku O Ugokasu*, "Fresh Breeze Affects Serene Bamboo"; see page 132.) Sōhō Takuan; William Scott Wilson, transl. Tokyo: Kodansha International, 1986.

Shin Shogen
This is the classic reference for shodo artists: a 1394-page book detailing examples of the various ways kanji have been written by artists through the ages. First published in 1917 as "Go tai ji rui," it is still in print and available, currently in its 5th edition. Look for it in academic reference libraries, or contact one of its two Japanese publishers: 1-15-16 Sotokanda Chiyoda-ku, Tokyo; tel. 81-3-3251-0706. Nigensha, 2-2 Jinbo-cho, Kanda, Chiyada-ku, Tokyo; tel. 81-3-5395-0511

Glossary

Bodhisattva one who practices the teachings of Buddhism in both religious and secular ways and vows compassionately to save all beings before realizing final enlightenment for oneself

bokki *Bo*=sumi; *[k]ki*=energy

bokuseki calligraphy in *sumi* (black ink) by Zen priests

Book of Yuima A sutra that shows us the mysterious identity of various things and ultimate reality; based upon the dialogue between the layman Vimalakirti and Manjusri Bodhisattva

buji (in Zen) without encumbrances

bussho or ***busshin*** Buddha nature; the potential to realize enlightenment innate in all beings. A person with *bussho* offers mercy and compassion to all.

chado *cha*=tea; *do*=way

chanoyu "The Way of Tea": *cha*=tea; *no*=of or for; *yu*=hot water

daimyo feudal lord

furyu monji the basic training method in Zen Buddhism of not relying on words in discussion or in literature

gyosho the semi-cursive writing style

hiragana phonetic script which was developed from the *sosho* or cursive style of writing

ichigyo mono a well-known statement

from the treatises of Zen monks, selected for the purpose of enrichment

inkan when used for a *bokuseki*: seal or "chop" which officially indicates the name of the creator and his position in the Zen temple

kaisho formal, square or printed writing style

kambo a seal used to symbolize that the space between it and the artist's signature seal was a creative space which no one may touch (by adding, subtracting or cutting apart). In ancient China *kambo* originally meant "checkpoint."

kanji the Japanese term for Chinese ideograms

katakana phonetic script which was developed from the *kaisho* or "print" style of writing

katsujitai woodblock style of printing where an ideogram is designed to fit a circumscribed space

ki or ***chi*** concentrated energy

kihaku dynamism of energy

koan enigmatic statement taken from the treatises of Zen monks to be used as a question for monks in training to ponder, in order to help reach enlightenment

Mumonkan an abbreviation for *Zenshu Mumonkan*, a collection containing 48 koans and commentaries, written by Wumen Huikai (1183–1260)

nijimi ink seeping or "bleeding" into surrounding areas

roshi Elder Zen Master: an honorific title

samu *sa*=created; *mu*=job: fatigue work in a temple such as sweeping the grounds, gathering firewood, etc.

samurai a feudal warrior who honored the rules of society

satori enlightenment

sho writing

shodo *sho*=writing; *do*=way; the Japanese

art of calligraphy

sosho cursive writing style; also known as running or "grass" style

sumi ink; *boku* in Chinese. It is made from soot created by burning certain vegetable oils or sap from trees such as pine, which is then mixed with animal glue and made either in liquid or stick form.

sumi-e Japanese black ink painting

suzuri grinding stone used to prepare ink from an ink stick

tensho ideograms designed for seals and for other carvings, e.g., on a stone tablet

tokonoma an alcove space especially built to display art objects in a Japanese-style room. A wide variety of *tokonoma* exists, ranging from very simple to grand.

washi handmade Japanese paper made from the bark of either kozo or mitsumata bushes. (Inexpensive paper is made instead from rice straw or bamboo fibers.)

zazen seated silent meditation in full or half lotus position

zengo a one-line statement from Zen philosophy

zenji an honorific title used in Zen Buddhism, literally meaning Zen master or teacher

Acknowledgments

This project would not have been possible without the expertise, support and generosity of many people, and I would like to thank them all very sincerely for helping to bring this book to fruition.

First and foremost, I would like to express my deepest gratitude to Gengo Akiba Roshi, Former Superintendent General of the Soto sect of Zen in North America, who served as advisor for the Zen statements included in this book. Although Akiba Roshi is currently deeply involved in a project to build an authentic Zen monastery in northern California, he made time to assist with the interpretation of some of the more difficult *zengo*. In addition, he provided many *bokuseki* for this book and gifted the Soto sect *bokuseki* that are reproduced in it. He also wrote a generous Foreword for the book.

The *bokuseki* from the Rinsai sect that appear in the book came from Keiundo of Asakusa, the second and third generation master craftsmen of the Aoki family. My tea ceremony mentor, Kosen Kishimoto, and a number of other friends kindly gave me *ichigyo mono* from their private collections.

I received great support for my activities concerning shodo at the university level and in the public domain from the late Eishi Sakuta, President of Naniwa Shodo Association, in Osaka, Japan, a longtime friend who supported my concept for this publication and was to have collaborated with me on it. His untimely death was a great loss to his family and friends and the many admirers of his work. His disciple, Shinya Fujiwara of Naniwa Shodo Association, artist and teacher, has been very helpful in providing technical support, especially in writing ideograms in *kaisho* for the lesson sections. He also provided the historical background for the Chinese ideograms.

I am grateful to my wife Alice who undertook the onerous task of assisting me in translating the manuscript into English.

Many people from the universities and from among the public at large, who have taken my classes over the years, have given me their support and encouragement in the compilation of this book and to them I give special thanks.

Finally, my thanks go to Eric Oey, Publisher and CEO of the Periplus Publishing Group, for undertaking the publication of my third book under the Tuttle imprint (the first two were *Ikebana* and *Sumi-e*), to Senior Editor Sandra Korinchak, and to the staff in the Singapore office for handling the design and production of this book.

"Books to Span the East and West"

Tuttle Publishing was founded in 1832 in the small New England town of Rutland, Vermont [USA]. Our core values remain as strong today as they were then—to publish best-in-class books which bring people together one page at a time. In 1948, we established a publishing office in Japan—and Tuttle is now a leader in publishing English-language books about the arts, languages and cultures of Asia. The world has become a much smaller place today and Asia's economic and cultural influence has grown. Yet the need for meaningful dialogue and information about this diverse region has never been greater. Over the past seven decades, Tuttle has published thousands of books on subjects ranging from martial arts and paper crafts to language learning and literature—and our talented authors, illustrators, designers and photographers have won many prestigious awards. We welcome you to explore the wealth of information available on Asia at **www.tuttlepublishing.com**.

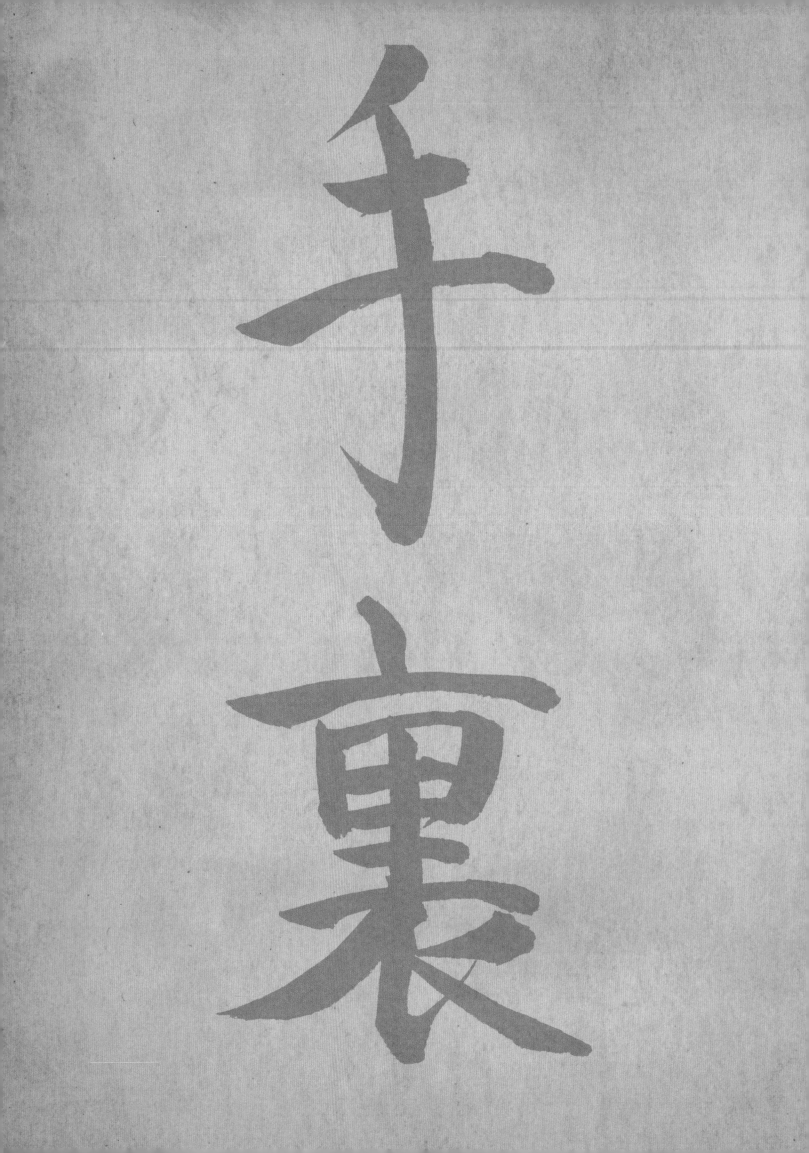